Price It Yourself!

ALSO BY JOE L. ROSSON AND HELAINE FENDELMAN

Treasures in Your Attic™: An Entertaining, Informative, Down-to-Earth Guide to a Wide Range of Collectibles and Antiques from the Hosts of the Popular Television Show Seen on PBS Stations

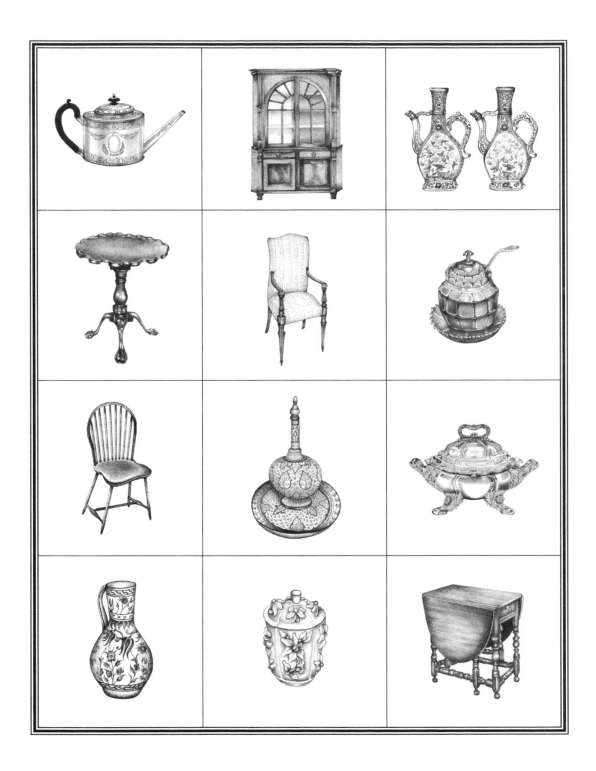

Price It Yourself!

THE DEFINITIVE, DOWN-TO-EARTH GUIDE TO
APPRAISING ANTIQUES AND COLLECTIBLES IN
YOUR HOME, AT AUCTIONS, ESTATE SALES, SHOPS,
AND YARD SALES

Joe L. Rosson and Helaine Fendelman

ILLUSTRATIONS BY ANNIE PARROTT

HarperResource
An Imprint of HarperCollinsPublishers

HarperCollins books may be purchased for educational, business,
or sales promotional use. For information, please write:
Special Markets Department, HarperCollins Publishers Inc.,
10 East 53rd Street, New York, New York 10022.

FIRST EDITION

Book design by Jennifer Ann Daddio
Illustrations by Annie Parrott

Library of Congress Cataloging-in-Publication Data

Rosson, Joe.
Price it yourself! / Joe L. Rosson and Helaine Fendelman ;
illustrations by Annie Parrott.—1st ed.
p. cm.
Includes bibliographical references and index.
ISBN 0-06-009684-5
1. Antiques—Collectors and collecting—United States.
I. Fendelman, Helaine W. II. Title

NK1125 .R6928 2003
745.1'075—dc21
2002027487

03 04 05 06 07 WBC/RRD 10 9 8 7 6 5 4 3

We would like to dedicate this book to our loyal Treasures in Your Attic™ *viewers and readers, and thank those who believe in us—especially Burt, Rick, Elaine, Bob, Jim, and Rob.*

Books are always collaborative efforts and ours is no exception. Thanks to Ronnie Bourgeault, Betsey Creekmore, David Gallager, Malcolm MacNeil, Vince Plescia, and Andrea Wolfand.

Contents

Foreword

We have known Helaine Fendelman for more than twenty years and we often meet at antiques shows where we all are buying. Her experience as a collector, dealer, teacher, newspaper columnist, author, and appraiser assures all that this book is by an expert who can pass on her expertise. She has appraised everything from tramp art picture frames to expensive Chippendale dining room sets during her years as a member and later as president of the Appraisers Association of America. Joe Rosson has written articles for many antiques and decorating publications. He writes a newspaper column about antiques, lectures, teaches, and has been an antiques appraiser for more than twenty-five years. Together they make the antiques world understandable.

Price It Yourself! answers the questions most frequently asked by collectors about value and history. They want to know: What's it worth? How old is it? Where did it come from? Is it in original condition? How much has been restored? Is it of the period? How rare is it? These are the questions often answered by a paid, professional appraiser, a person who has had years of experience and training in the antiques and collectibles field. Many times a collector wants a less formal answer to the basic questions. This book is a do-it-yourself guide that tells the average collector or the lucky one who inherited antiques and collectibles how to find the answers.

Some suggestions seem obvious, but might be overlooked by a collector. The authors advise you not to assume your antique is valuable because it is old; don't think bigger is better; don't believe all the family legends. Some suggestions could come only

from appraisers with years of experience: how to spot a value-lowering repair or a fake mark; how size helps tell the age of a teapot. This book is the place to learn how to do orderly research. Follow the guidelines included for appraising furniture, ceramics, silver, glass, even sports memorabilia, toys, and kitchen collectibles. A list of the better research books and periodicals is included at the end of book. An appraisal takes special knowledge and research time. *Price It Yourself!* is the book to help you determine the value of your belongings.

RALPH AND TERRY KOVEL
Authors of *Kovels' Antiques & Collectibles Price Lists*

Introduction

The prices of art and antiques are not engraved in stone. They are constantly changing, and there is no definitive book or electronic source that tracks this never-ending flux and flow with any accuracy. This book, however, is designed to be the first giant step toward understanding the intricacies of how an antique or related item is valued and how you can learn to price it yourself!

Pricing antiques and collectibles can be difficult even for professionals who do it every day. The process of assigning a realistic value to any object can be daunting because there are so many questions that need to be asked and answered and so many market influences that need to be assessed.

Professional appraisers deal in opinions that represent their understanding of what an object is worth in dollars and cents at that particular moment, and every written appraisal should contain a statement to that effect. These opinions are always based on careful research, experience, and a thorough awareness of current market values and trends.

The process of arriving at these opinions takes a great deal of time, effort, and guidance to learn. It is not unlike earning a postgraduate degree at a top-flight university, and those seeking to become "masters" or "doctors of antiques" must be very dedicated before they can truly become proficient in this incredibly complicated and wide-ranging field of study.

Both of us—Helaine and Joe—wanted very badly to be admitted to the ranks of the antiques scholars—the "cognoscenti" or the fellowship of connoisseurs—because we enjoyed the mental challenge and because we wanted to understand all the ins and outs of this difficult but fascinating body of knowledge. It took years of intense—almost obsessive—study and observation to learn what we needed to know about art, antiques, the business of understanding what items might be worth, and ultimately how to assign values.

We went to more museums, antiques auctions, and shops than we care to remember; we bought books by the literal ton, and we studied in libraries until we suffered from eyestrain. In the beginning we floundered and had to depend on trial and error to sort through the information we found to separate what was true from the half-truths and myths. With this book, we hope to save many of you from the frustrations we experienced and to illuminate some important informational pathways that we stumbled down in the dark.

Between us, we have now been valuing art and antiques for more than 50 years, and this half century of perfecting our craft has given us the ability to walk through the average American home and identify and price most of the objects in it. When we started, Helaine was trying to furnish a New York City apartment on a budget, and she accomplished her goal by claiming old objects that had been discarded on the street and by haunting junk and antiques shops looking for useful bargains.

Joe, on the other hand, had absolutely no interest in antiques until he happened to wander into an antiques shop, where he became fascinated with the historical background of the various objects that were being offered for sale. He bought an item for $15, then went to the library to find out exactly what he had purchased. This exercise is something he still finds himself doing.

It was necessity on the one hand and happenstance on the other that propelled us into the world of antiques. We soon found ourselves addicted

in the truest sense of the word—but we also found that we were "babes in the woods" or defenseless innocents in a world full of wolves waiting to take advantage of our lack of knowledge and to swallow us whole. Our only protection—and your only protection—is knowledge.

Over the years, both of us have spent all of our spare time inspecting merchandise, talking to dealers and "experts" in the field, and purchasing the art and antiques we like. In the beginning, we were not sure if our purchases were real or spurious, good buys or rotten deals, but gradually we learned from both our mistakes and our lucky finds.

A dealer once told Helaine and her husband, Burt, that the only way to learn about antiques was to "put your money on the line"—meaning they actually had to buy objects and live with them rather than just examine them at antiques shops and shows. Since painted American furniture appealed to them, they put this advice into practice and purchased a dressing table with a beautiful mustard-yellow surface.

Later, after doing a great deal of research and gaining more firsthand experience with genuine painted surfaces on American furniture, they came to the painful realization that although their dressing table was early 19th century, the paint was early 20th century. The mustardy coating that added so much to the dressing table's visual appeal and monetary value had been applied in the 1930s, but this piece with its fraudulent surface had taught Helaine and Burt so much that it had been well worth the initial investment.

Eventually, Helaine and Burt built an impressive collection of Americana but they also built an invaluable home library that could be used day or night for ready reference. They spent endless hours at public and private collections all over the country until, little by little, they had put together a priceless mental and visual "data bank" of information gained from oral sources, printed material, and "real-world" experiences.

Joe remembers the first experience he had with the actual appraisal process. More than 20 years ago, he was trying to learn about what he

thought was an exceptionally rare piece of American 18th-century porcelain. The available print sources that Joe consulted all confirmed that this porcelain bowl was what it appeared to be, but he had an uneasy feeling and decided to dig further.

He contacted several noted specialists in the field, and much to his disappointment, they all said the piece he owned was not what it was purported to be, and all the reference books on the subject were out-of-date and wrong. Perplexed by the disagreement of "experts," Joe took the piece to New York, where he contacted the head of the American ceramics department at one of the major international auction houses.

This individual had a sterling reputation as the premier appraiser in his field, and Joe hoped that he could provide a definitive answer. When Joe arrived, the appraiser examined the bowl for some time, then asked if he could keep it for a few weeks while he did research and consulted with his colleagues. The appraiser explained that he knew what it was supposed to be, but having never seen an example or held one in his hands, he wanted to give his evaluation the care and caution he felt such an item deserved.

Six weeks later, Joe got his bowl back with a carefully worded appraisal that said the bowl was not 18th-century American but was probably 19th-century Indochinese with a very low value. This news was a letdown for Joe, and it took him another five years of off-and-on research to confirm to his own satisfaction that the appraiser's opinion was indeed correct.

From this initial experience with a truly professional appraiser, Joe learned that appraising was not an easy task, that a formal appraisal is not something done off the top of your head, and that an "expert" opinion is only as good as the "expert" making it. As Joe went through the lengthy process of determining what his piece of porcelain was, he also learned that to be an appraiser you had to be part librarian, part detective, and on many occasions it does not hurt to be part psychic as well.

As much as we would like for there to be, there is no way to become an instant expert or even to come close to understanding the intricacies of

antiques and the antiques marketplace without investing a significant amount of time and energy—and sometimes money. Careful research and study is the only way to learn what we need to know about antiques, and eventually, to come to know what they are and what they are worth.

In this book we show you how to find reliable answers and how to evaluate an antique or piece of art so that it can be valued. The first step is to learn the various criteria for evaluating objects, and these will serve as a road map to guide you on your journey of discovery. We will provide this map and furnish you with the necessary tools to assess and price objects encountered in the antiques marketplace as well as items you already own.

We begin by exploring the mechanics of making value judgments, then move on to the nature of connoisseurship, or more simply put, what you need to know to be "in the know." We explore how to do the necessary research to find out what a given item is and how to make careful observations, then ask the hard questions to determine what something is worth.

In addition, we analyze why antiques can have more than one price and the circumstances that dictate the various levels as well as factors that add and subtract value. Perhaps most importantly, we provide a chapter on how to do research in the library and on the Internet.

In the second section, we present in-depth evaluations of items covering such categories as furniture, glass, pottery and porcelain, silver, and other objects such as clocks and textiles. These are practice appraisals, and we delineate the process and the information necessary to make a sound judgment about the value of each item being discussed. After determining an object's value, you can check your estimate with our assessment in the back of the book. Hopefully, this will serve as a valuable learning tool and provide a bit of fun.

In the third section, we provide an invaluable resource guide to help you find information and start your own home library. The references we find most useful in our research are listed by category and we give a brief indication of why they are important to the connoisseur/appraiser.

We have also included a list of periodicals that are the barometer of the antiques marketplace, giving vital insights into the latest trends—which prices are up, which are down, and what are the current directions of collector interest. Remember that the key to the antiques world is knowledge, and this knowledge is still best obtained through printed sources such as books and periodicals.

This book is for homeowners and collectors who wish to learn more about what they own or might want to purchase. It is also a book for anyone who desires to be an antiques dealer or appraiser and does not know how to begin the process of learning to assess professionally the value of items discovered in the everyday pursuit of doing business.

It is now time to start examining how to become a connoisseur, which is what you must become before it is possible to value art, antiques, and collectibles accurately.

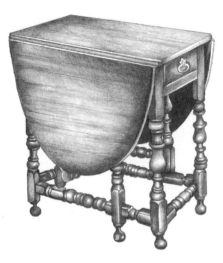

The
Mechanics
of Evaluation

Connoisseurship: What You Need to Know to Be in the Know

Connoisseurs come in a thousand different varieties. There are connoisseurs of fine wine and connoisseurs of 1950s furniture. There are connoisseurs who know and appreciate Old Master paintings and there are connoisseurs who are well versed on vintage kitchen equipment and appliances.

But before we go any further, it is important not to be put off by the word "connoisseur" or "connoisseurship." These are simply terms for the ability to make critical judgments about objects that are encountered at antiques shows, antiques auctions, flea markets, and perhaps most importantly, in our own homes. Simply put, if it is your goal to be able to evaluate antiques, or if you just want to find out the value of the beautiful objects left to you by your grandmother, you need to develop good connoisseurship skills.

Although some fortunate individuals learn connoisseurship at their parents' proverbial knees, nobody is actually born a connoisseur. One dictionary defines a connoisseur as someone who "understands the details, techniques, or principles of art and is competent to act as a critical judge." What makes someone a connoisseur is "connoisseurship," which can only be achieved through hard work, study, and years of experience.

The Essential Elements of an Appraisal

An appraisal is nothing more than a formal exercise in connoisseurship, and illustrating how the process works can be very instructive. Not long ago, Joe had the task of appraising the contents of a home. On the mantel there was a pair of late-18th-century Chinese porcelain figures in the form of phoenix birds. They were 16 inches tall and in pristine condition.

This description seems deceptively simple, but it contains six factors that are essential in order to start any evaluation: (1) the material or materials used to make the item; (2) the country of origin; (3) age; (4) size; (5) condition; and (6) the object's original function or purpose.

Determining what material an object is made from can be more difficult than it sounds. We get hundreds of letters every year from people who are not sure what the differences are between glass and porcelain, brass and bronze, or ivory and bone or plastic. Sometimes the problem is that the original maker meant to deceive or the intent was to make a less costly look-alike by employing a substitute for a more costly material.

Pair of late-18th-century Chinese porcelain figures of phoenix birds.

For instance, it can be very difficult to distinguish between real ivory and a celluloid that was intentionally made to look like ivory. The celluloid attempt to replicate both the creamy color and the wavy grain of natural ivory and gives itself away visually only because the grain pattern in the plastic replica is too regular to have been created naturally. Sometimes only a hot needle pressed onto an inconspicuous place (this should be used only as a *last* resort) can reveal whether the piece is real

ivory or merely celluloid because the real ivory will not be affected by the hot pin and the plastic will soften or melt.

This sort of determination often presents a real challenge for the student connoisseur/appraiser who must determine if a piece is made from solid bronze or a bronze coating over white metal; silver or silver plate; jade or some other, less valuable hard stone; pottery or porcelain; and so forth. In most cases, these determinations can be made by careful observations and a few simple tests aided by a good magnifying glass and a magnet (to check the iron content of metal).

In the case of the pair of birds, there is no doubt that they were made from porcelain, but how do we *know* the material is porcelain? Well, birds such as these are supposed to be porcelain, but it behooves the connoisseur to know how to distinguish porcelain from other products made from clay such as earthenware and stoneware.

These birds are very thickly potted, which means they are not translucent as many people think real porcelain is supposed to be. This lack of the ability to permit transmission of light did not greatly trouble Chinese potters, and their porcelain is often not translucent at all. The litmus test here is that the bodies of these birds cannot be scratched with a steel knife. This means they are Chinese-style hard paste porcelain, not pottery or soft paste porcelain, which both have very soft bodies that are easily scratched with a steel-bladed knife.

Two of the main questions we are frequently asked are: What is it? and How was it used? Answering these queries often involves knowing a great deal about the way our ancestors lived and the kinds of furniture, accessories, and equipment they used in their homes.

Our Victorian forebears, for example, seemed to need a utensil for every dining purpose. Within a set of silver flatware there might be such mystifying objects as butter picks, ice-cream forks, food pushers, horseradish spoons, sardine forks, poached egg servers, bread forks, marrow scoops, waffle servers, crumb knives, and chocolate muddlers, to name just

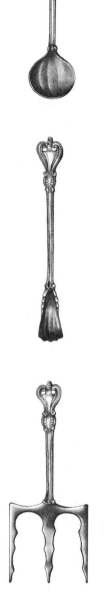

Chocolate muddler in Old Colonial pattern by Towle.

Horseradish spoon in Old Colonial pattern by Towle.

Bread fork in Old Colonial pattern by Towle.

a few items that are no longer in common use. Knowing what these are and what they are supposed to look like requires a little studying and a good reference book (see Part III).

There is no question that this pair of Chinese phoenix birds are purely ornamental. They had no use other than to be decorative; but at this point, an important corollary question arises: What kind of birds are they? Asian potters created many representations of winged creatures, including pheasants, hawks, peacocks, cranes, cockerels, parakeets, and parrots, as well as models of the mythological phoenix. It is critical to know exactly what kind of birds these were intended to be because there can be a vast difference in rarity and price between a parrot and a hawk or between a crane and a phoenix.

The next hurdle to overcome is the object's country of origin, which can be a difficult attribution to make, especially when it comes to Asian antiques. Telling the difference between English and American objects and between English and Continental European items is something that has to be learned through experience; but with some training of the eye, it is really not all that difficult in most instances.

However, for many Westerners, learning to tell the difference between Chinese and Japanese (and, to a lesser extent, Korean) artifacts is a serious challenge. This formidable task can only be met by an intense study of a wide variety of objects from each of these countries. This will bring familiarity, which will teach the eyes to detect the subtle differences among them almost immediately.

In this instance, the pair of phoenix birds are undoubtedly Chinese because they are documentable. Many books feature a pair identical to these, which is one of the most important reasons either to have access to a good university or public library or to have an extensive collection of books at home. Even some cursory research reveals that the form of these birds is Chinese, the coloration is Chinese, and the way they were made is Chinese.

The next crucial consideration is the age, and this can be a real problem to establish in Asian antiques. These birds are not marked, which means the potter did not tell us when these birds were supposed to have been made or by whom. Marks on objects can be very helpful, but they are merely a clue to origins and time of manufacture and should only be used as a starting place for research. They should not, however, be taken as infallible guides.

Those who want to be connoisseurs/appraisers must not rely too heavily on marks because at best they can be misleading and, at worst, they lie. The same family who had the pair of phoenixes we are examining also had about a half-dozen porcelain pieces clearly marked with the familiar Sevres logo, and all were late 19th- and early-20th-century fakes (nice fakes, but fakes nonetheless). The deceased family members had purchased them thinking they were buying genuine Sevres and had passed this misinformation on to their heirs.

They had believed the mark and gone no further in their investigation, and as a result, they bought goods that were not what they were purported to be. A rule that should be chiseled in stone is that marks of all sorts should be used for confirmation of attribution and little else.

The marks found on Chinese pottery and porcelain are especially unreliable, and they have fooled many appraisers who do not specialize in this area. In fact, Chinese marks are probably

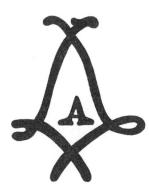

This interlaced L's mark was adopted by the Sevres factory in 1753, which is the same year in which they relocated from Vincennes. The L's are the monogram of King Louis XV, and the A inside the mark is the date letter for 1753. This mark is widely faked.

less dependable than the marks found on any other kind of pottery or porcelain and should always be taken with a whole bucket full of salt, not just a grain.

The Chinese have long used marks as tributes to earlier times. If, for example, a maker in the late 19th or early 20th century happened to be working in the style of the late 18th century, he might mark his piece with the characters associated with the Emperor Qianlong (1736–1795) as a way of paying homage to this earlier time.

Fakers of Chinese ceramics (of which there are no shortage) felt free to use whatever mark they felt would deceive. Manufacturers of late-19th- and 20th-century Chinese ceramic "junk" also used whatever mark they wished. Thus, absolutely no Chinese mark can be taken at face value, but this is not necessarily a bad thing because it allows collectors to focus on other factors in making a judgment about origin and age and not waste time being unduly influenced by the mark.

Luckily, the two birds under examination were not marked. If they had been, Joe would have been positive from the outset that they were fakes because only fakes of this type were ever marked. But what was their age? On careful inspection, he decided they were indeed 18th century for a variety of reasons including the way they were made and the way they were colored.

Deciding the age of an object can be a problem. It is easy to get caught up in the wishful thinking trap—that is: "It is supposed to be 250 years old. I want it to be 250 years old, so it is 250 years old." This kind of thinking gets a lot of antiques buyers, budding scholars, and even seasoned veterans into a lot of trouble and can cause some real disappointments when authenticity is finally established.

Surprisingly, many decisions about how old an item happens to be can be based on commonsense observations. For this pair of phoenixes, the observer first notices that the pieces are essentially handmade. Yes, there is mold work, but the assembling and finishing were done by hand, as was the

application of color. In other words, there are no signs of modern manufac-
turing work such as badly disguised seam lines.

Next, the investigator checks to make sure that the material the birds
are made from is correct—for example, no modern, pure white, flawless
porcelain. Then the pieces should be carefully inspected for wear. After all,
this pair of birds has supposedly been around for more than 200 years; at
the very least, they should have some short, random scratches on their
bases and perhaps some rubbed enamel. These signs of wear can indicate
genuine age and are very hard to imitate convincingly.

Last, the color of the enamels needs to be evaluated very closely.
Enamels from the 18th century have a distinct quality, as do the enamel
colors that were used in other centuries. Unfortunately, the only way to tell
the difference is actually to have seen old pieces in museums, in fine
antiques galleries, or in collections being sold by one of the more reliable
international auction houses.

It is clear that this determination of age requires a very careful inspec-
tion. While this is being done, the size should be noted and the condition
carefully judged. We are going to skip over size for just a moment and take
a brief look at the importance of condition.

It cannot be stated too strongly that condition is often the linchpin of
value. Any piece being evaluated must have its overall condition assessed
carefully because flaws such as slight chips, hairline cracks, rubbing of
color, or a missing part can be disastrous to value. Once the condition is
noted, the proper importance must be given to any defects. In furniture, for
example, replaced hardware and drawer slides are far less serious than a
refinishing job that completely strips away the original surface.

In pottery and porcelain, a crack is usually more serious than a chip
(unless the chip is big and unsightly), and rubbed gilding that is used pri-
marily for accentuation is usually less serious than rubbed enamel that was
used to make the actual decoration. Fortunately, these birds are in pristine
condition with just the right amount of wear and no defects worth noting.

As we stated, this pair of phoenix birds is 16 inches tall. This is significant because if they had been just 6 inches taller, they would have been worth in excess of $50,000 at retail. This 16-inch pair is far more typical than the larger, more imposing 22-inch size, and the smaller variety brings about half the price of the larger version.

So far we have discussed just the basics that need to be considered when placing a value on an antique. This pair of phoenixes has a relatively high value because the birds are rare, vividly colored, strongly molded, in superb condition, and from the highly regarded Qianlong period (1736–1795). Nineteenth-century examples are much less highly regarded by serious collectors, and a 24-inch-tall pair of phoenixes from this later time frame would be worth approximately one-third the value of the 16-inch pair from the mid- to late-18th century.

Certainly, these variables are a lot to think about, but it is this multifocused attention to detail that good connoisseurship requires. This sort of exercise can be fun as well as enlightening. To make the process work, Joe had to call on a lot of experience in the field and a large number of reference books that he checked and rechecked as he worked his way toward the ultimate conclusion. You may not be able to do this right away, but in order to begin, you must understand the procedures, know the questions to ask, and have a grasp of what the answers mean when you get them. There are also some basic "do not" principles that need to be kept in mind at all times.

The No-No's of Valuing Art and Antiques

- *Do not assume that something is valuable simply because it is old.* This is one of the main misconceptions that confronts connoisseurs-in-training, and it is one of the hardest ideas to unlearn. Time after time, we are told, "This must be valuable

because it is over 100 years old." When we look at the object being referred to, it is indeed 100 years old, but it is a common piece of 19th-century flotsam and jetsam that has washed up on the shores of the 21st century. It has little or no interest to collectors, and its value is very limited at the present time and will remain that way for the foreseeable future.

- *Do not be overly impressed by names and labels.* It is amazing how people respond to names such as "Tiffany," "Ming Dynasty," and "John Henry Belter," among others. Some people have a difficult time understanding that there are genuine examples of Ming Dynasty porcelain that are worth less than $250 each, and there are pieces of Tiffany glass and silver that can be brought for a few hundred dollars. Important names that refer to maker, style, or time period may greatly add to an item's desirability; but in the final analysis, it is the artistry, rarity, and condition that are the most significant factors. Helaine tells the story of being in a rural North Carolina antiques shop where she found a side chair that had obviously been made by the renowned New York City Victorian furniture maker John Henry Belter. Some of his pieces bring significant dollars, and this piece was priced at a mere $150. Such a rare find at this very nominal price was enough to make her heart pound and almost enough to make her pick up the chair and rush to the cashier. But before she made the purchase, her connoisseurship skills kicked in and it occurred to her that this was just a side chair with run-of-the-mill decoration, not an exceptional piece. In good condition, such a piece was probably worth a little over $1,500, which is really quite a lot for most Victorian side chairs. Closer inspection, however, revealed that this chair was in very poor condition, with pieces of laminated wood missing, a seriously degraded finish, and damage to the carving with small

chunks missing. The cost of restoring this chair to any semblance of its former glory would have been high. Helaine left it where it was despite its lofty association with such a famous American cabinetmaker.

- *Do not assume that bigger is always better.* In the story of the phoenix figures we learned that bigger was indeed better, but this is not always the case. Sometimes miniatures are more desirable than their full-sized cousins. Unusually large pieces of furniture that are too tall to fit under the ceilings of modern homes or too massive to be integrated into the scale of present-day dwellings can be devalued because of their size. For the most part, real value is determined by a combination of factors, and size is only one small component of the equation. Usually, quality of workmanship, the content and quality of the decoration, overall condition, and the rarity of the form are somewhat more important. Joe once knew an appraiser who thought that if a vase were 6 inches tall and worth $100, a 12-inch-tall example would be worth $200. Pricing antiques just does not work this way.

- *Do not assume that value judgments remain constant or that prices always go up.* When assigning value to an object either critically or monetarily, it is important to know that the antiques market is governed somewhat by the dictates of fad and fashion. It is also important to keep in mind that the assessment of connoisseurs changes from time to time, and quite often the judgment of these learned individuals is based at least partially on what is in fashion at the moment. There was a time when such items as Arts and Crafts furniture, majolica pottery, and Art Nouveau lighting (think Tiffany lamps) were completely out of fashion. During the 1950s and '60s, those in the know sneered at them and their value was very modest. Now that has

changed and critical judgment favors these items—for the time being, at least.

• *Do not rely on deductive reasoning.* This is really a tough point because we have been taught all of our lives that this sort of mental process works if we follow the intellectual rules. But in judging antiques, this process can be very dangerous. Take, for example, the need to judge two pieces of American art pottery by the Roseville Pottery Company. Both are vases and both are from the same era: circa 1904. One is hand-painted with lovely flowers against a rich brown background; at 13 inches tall, it is almost 3 inches taller than the other vase, which is just 10½ inches tall. The first vase is part of the Roseville's famous Rozane Royal line, while the other is from a grouping called Mongol. The Mongol piece is not painted at all and its only adornment is a red glaze. Placing these two pieces side by side and applying a little logic, you might be led to believe that the larger, hand-painted piece is more valuable, both monetarily and aesthetically, than the simple red vase. After all, the brown one is very attractive and is intricately and beautifully hand-painted. However, this would be the wrong conclusion! The Rozane Royal vase is worth approximately $500, whereas the Mongol piece should be valued at $1,500 plus, depending on the actual shape and quality of the glaze. The Mongol vase is much more valuable because it is much rarer than the Rozane Royal, which was produced in relatively large quantities. Using the principles of connoisseurship rather than deductive reasoning and logic, the budding appraiser should know that there are other things that depress the value of the Rozane Royal vase. First, brown-glazed American art pottery is out of fashion at the moment and there is not a huge demand for this sort of ware. Second, the brown vase is painted with flowers, which is a

very common decoration. If it had been painted with the portrait of a person or the image of an animal, its value and desirability to collectors would have been much, much higher. Third, the Mongol vase has a very beautiful glaze that was very difficult to achieve; to a pottery connoisseur, this piece is magnificent in its simplicity.

- *Do not be misled by your own taste.* We have an acquaintance who was browsing through a very upscale antiques shop. The owner loved French antiques, reveled in the neoclassical taste, and was known for his expensive wares. As our browser perused the shop, he discovered a table in an out-of-the-way corner that held a sizable collection of glass. No piece was priced more than $50, and the browser quickly became a serious customer and bought nearly the entire contents of the table. As he was writing the check, he quizzed the proprietor as to how the glassware had ended up in the shop. The gentleman replied that the collection was from his uncle's estate and he simply wanted to be rid of it because the glassware did not appeal to his taste. The customer was delighted because he had just bought a large number of pieces of very valuable art glass made by such companies as Tiffany, Steuben, and Thomas Webb. It was a terrible mistake on the part of the shop owner, but it is one that is not all that uncommon. Joe, for example, has a great deal of difficulty with military items. They do not appeal to him at all, but he has learned not to dismiss these items out of hand just because he does not understand them and they do not appeal to his personal taste. He knows all too well that such items can be surprisingly valuable and that there are large numbers of dedicated collectors who do appreciate these items greatly.

- *Do not rush to judgment.* It is important that the connoisseur be

patient and take a little time to understand the objects that he or she is examining. This is perhaps best illustrated by a pie-crust tea table that appeared for sale in a Florida auction. It was a very beautiful piece and the auction goers inspected it—some with great care, others rather cursorily. It was supposed to be American Chippendale circa 1760, but it was just too perfect, and almost everyone in the audience judged it to be a particularly finely made but later "centennial" (see Chapter 2) copy. When the bidding ended at $1,000, the table belonged to a man who felt that the conventional wisdom was wrong and that this was indeed a genuine circa 1760 tea table that had somehow managed to survive in pristine, original condition. This is a fairly uncommon circumstance, but the opinion of the buyer turned out to be the correct one. A few months later when the table was resold, it brought over $1 million. To make the judgment that produced such a financial windfall, the buyer of the table had to know exactly how a circa 1760 table should have been made and how an original finish should look after 240 years. Perhaps most importantly, he knew not to dismiss this or any other item without a comprehensive examination. It was a thorough and thoughtful exercise in connoisseurship that really paid off!

• *Do not accept something as being true without substantiating the facts.* It is hard for many of us to realize, but sometimes what we read in books and what we are told by so-called "experts" is not correct. For years, one of the acknowledged scholars in the field of ceramics identified Chinese Export porcelain as being the product of a small English porcelain factory named Lowestoft. He published this stunning piece of misinformation and the name "Lowestoft" became widely attached to the products that we now know were made in China primarily in the 18th

and 19th centuries. For decades, this incorrect information was taken as gospel and can be found in numerous books and articles written before the end of World War II. In many cases, the scholarship in the world of antiques is often not what it should be, and many times when the author of the book or the purveyor of the information is a collector, he or she has an agenda. If, for instance, a collector is writing a book about a field in which he or she collects, the importance of items in his or her collection might be exaggerated with the intent of inflating their value. Conversely, if there is an item the author does not own, its importance may be ignored so as to decrease interest and price. To be a connoisseur, you must be aware that checking and cross-referencing source material is absolutely essential. We are surprised at how many times we find pieces of information scattered around a number of references; to get the whole picture, all those factual nuggets need to be gathered, compared, and evaluated.

- *Do not accept oral history as fact.* As appraisers, we also approach an item by asking the owner what is known about the piece, and, if it is a family piece, what its history is. Not surprisingly, the information we get this way is not always accurate. As we are writing this book, Joe is doing an appraisal, and the last item that was shown to him was a silver-plated ladle with an inscription engraved on the back: "Jesse James to Emma—1902." When his client showed him this piece, Joe patiently listened as she recounted how Jesse James, the famous outlaw, had come to the small town in Tennessee and dated her aunt. The ladle was a memento of the occasion, and it was now a cherished family heirloom. As the story was being told, Joe was reasonably sure that this person must have been some other Jesse James, but he could not be absolutely sure. A little later, research told him that

the famous Jesse James had been murdered in 1882; thus, a long-cherished piece of romantic family history vanished in an instant. This unquestioned acceptance of misinformation is very common, and it requires all the diplomacy an appraiser can muster to break the bad news. The point here is that if you are an appraiser or someone interested in antiques, you cannot take oral history at face value—ever. Purchasers should never be swayed by family history unless it is backed up with documentation and a thorough, critical inspection.

The Good, Better, Best Analysis

One of the most important things that a budding connoisseur must learn to do is to make a well-reasoned, nonsubjective analysis based on a standard of good, better, and best. We cannot count how many times we have gone into a home and been told with great pride that something is "really fine" because it is an example of this or that. Upon inspection, however, we find that the "really fine" piece is a very ordinary example that is not worth nearly as much, either monetarily or aesthetically, as the owner had hoped.

A good example might be an English sterling silver teapot from the 18th century. There is a vast variety of these teapots available, and to make a judgment of a specific specimen's overall worth, a connoisseur must understand the factors that make the teapot either a good, better, or best piece.

Before beginning a good, better, best analysis, it is wise to know as much as possible about the general history of the item under examination. In this case, it is necessary to know that tea was probably not introduced into England until the mid-17th century. Samuel Pepys, the famous diarist, reports drinking his first cup in September 1660. We can therefore

deduce that it would be very unusual to find an English sterling silver teapot that dates from before the first decade of the 1700s.

In the case of a silver teapot, it is very important to know how a genuine example should be marked and where. Most English teapots are marked on the base, but some are marked on the side. Depending on the era in which the teapot was made, there should be either four or five "punches" or stamped impressions on the main body of the piece. These are generally called hallmarks.

It is critical to know that all separate parts of the teapot that are sterling silver also need to be marked with at least a lion passant and a maker's mark and that a whole set with four or five marks is rare. This rule applies to the lid, the handle, and the finial; and, if the marks are missing, these components may be replacements.

To begin the process of making a good, better, best analysis, it is often appropriate to determine the age of the piece because it is generally misleading to compare items that are not of the same type and from the same approximate time period. In the case of the 18th-century English teapot, it is helpful to know that early teapots are smaller than their later counterparts because tea was extremely expensive at the time. Therefore, teapots that are larger than a good-sized orange were probably made no earlier than the mid- to late 18th century; an early-18th-century date of manufacture is highly unlikely.

Shape can offer a significant clue in determining age. Early English teapots are often pear shaped but as time passed, the body lost the neck and became more spherical. During the mid-18th century, teapots became an inverted pear shape, and late in the century the pots were oval. The last clue to look for is that during the first three-quarters of the 18th century only four marks were used on silver pieces, but a fifth mark was added in 1784.

The first four marks are the lion passant to denote purity of the metal,

Lion passant.

Sheffield town mark.

Date letter.

Maker's mark.

*Sovereign's
head mark.*

a town mark to signify where the piece was made, a date letter to document
the year it was crafted, and a maker's mark. The fifth mark added in 1784
was that of a sovereign's head to attest that a tax on wrought silver had
been paid. This last mark was in use until 1890; after that, only four marks
were used once again.

The three pots we want to evaluate here are oval in shape, so immediately
we suspect they are post-1780. Teapot #1 has four marks that signify it was
made in London in 1780 by William
Grundy. It is quite plain, with a beaded
edge around the top and shoulder, and
it has an ebony finial and handle.

Teapot #2 has the same oval shape
and five marks that tell us the piece

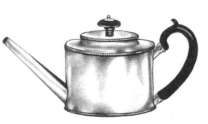

*This sterling silver
teapot bears hallmarks
that identify it as
having been made in
London in 1780 by
William Grundy.
It is teapot #1.*

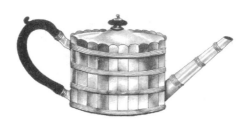

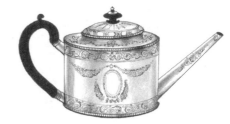

This sterling silver teapot bears hall-marks that identify it as having been made in London in 1791 by John Townsend. It is teapot #2.

This sterling silver teapot bears hall-marks that identify it as having been made in London in 1784 by Hester Bateman. It is teapot #3.

was made in London in 1791 by John Townsend. It is an unusual design and was made to resemble a barrel with engraved staves and hoops. Like teapot #1, it has an ebony handle and finial.

Teapot #3 is also oval and has five marks, which, after looking them up in a reference book (see Part III), indicate that the pot was made in London in 1784 by Hester Bateman. This particular example is intricately festooned with bright-cut decorations and has an ebony handle and finial.

Before beginning the actual good, better, best analysis, it is prudent to make sure that all the items under consideration are "of the period," meaning that they were made when they were supposed to have been made and are not reproductions or fakes.

There are relatively small numbers of actual fakes of late-18th-century English sterling silver but there are reproductions that are clearly marked with late-19th- and 20th-century hallmarks. They should not fool you if you have a good reference book (see Part III). Out-and-out fakes of much rarer and more expensive English teapots of the early 18th century are known to exist, but these are generally fairly crude pieces made from old tankard mugs.

The fake potential with teapot #3 is focused around the Hester Bateman maker's mark. In the case of any piece of English sterling silver pur-

portedly made by one of the great names in British silversmithing (such as Paul de Lamerie, Paul Storr, and yes, Hester Bateman), it is critical to make sure that the mark on the piece is original.

Unscrupulous individuals have been known to find a sterling teaspoon or some other small, inconsequential item made by one of these important makers and then cut out the perfectly authentic maker's hallmark. Next, they find a significant piece of silver made by a talented but less highly regarded silversmith, remove the maker's mark, and replace it with the more famous maker's insignia.

With only a cursory inspection, this can make the piece appear to have significantly more value than it actually has. Luckily, this kind of fraud is generally easy to detect by huffing or blowing breath on the mark. If this reveals that the maker's insignia (or any of the other marks for that matter) is encircled by a barely visible line, then some kind of "switcharoo" has probably taken place. Another clue to hallmark hanky-panky is if one of the marks is a different size or a different scale from the others found on the object being inspected.

In the case of teapot #3, examination reveals that the Hester Bateman hallmarks are genuine and the elaborate decoration also seems to be original to the piece. This latter consideration is yet another factor that must be taken into account. The problem here is that our ancestors sometimes took their old silver pieces to the silversmith to be "updated" and made more fashionable. This can mean that a relatively plain late-18th-century teapot can end up with the rather florid, overblown decoration popular during the Victorian era. This kind of revamping can cause a large deduction to be taken from the value of the item and can greatly alter the way the piece is regarded by serious collectors and connoisseurs.

Condition can change the good, better, best equation. Not long ago, Helaine was perusing an antiques show and saw a teapot similar to #2 with the barrel stave decoration. It was an interesting piece, but its handle was broken off, its spout was severely bent, and there were noticeable dents and

dings. For a connoisseur, this kind of damage would preclude the pot from being considered as even a good piece.

Serious damage such as this happens, and the person making the assessment must make sure that some carefully hidden catastrophe has not happened to the object being examined. Repairs of dents can usually be detected with fingers, and this kind of mend is much more acceptable (as a general rule) than replaced parts such as handles, spouts, and lids. Often these newer parts can be spotted because the craftsmanship of the replacement does not quite come up to that of the original. The replacement component might also have a different patina from the rest of the original parts, or the place where the old and the new were joined may be detectable, or the marks on the replacement might differ from those on the body.

Another important aspect of condition as it relates to silver is the state of being of the marks. These little indentions are actually the pedigree of the silver object. If they are obliterated or unreadable due to damage, repair, or eons of excessive polishing, the history and lineage of the piece is greatly compromised and its interest to collectors is significantly decreased. Again, many connoisseurs would not consider such a piece with unreadable marks to be even a good example.

Polishing—or more specifically, overpolishing to a shiny bright surface—is the great enemy of sterling silver, and many pieces have been ruined forever by overzealous cleaning. We have just discussed marks being literally rubbed away and how seriously damaging that can be, but it is also a very serious price deduction when the design is worn down by too much polishing.

In the case of teapot #3, for example, much of its glory is in the bright-cut engravings. If these were badly eroded, this pot would lose much of its appeal to connoisseurs. Serious collectors and connoisseurs like the wonderfully soft patina that years of *careful* and *judicious* polishing can give a

piece, and an exceptional patina consisting of tiny, hardly noticeable "scratches" caused by a soft cloth can boost the appeal of a piece because it speaks of the passage of time and the great love of the owners. In addition, it should be mentioned that connoisseurs recoil in horror when they find an antique piece of sterling silver that has been buffed on a mechanical wheel or coated with lacquer to keep it from tarnishing.

As we suspect, many of you already know that the "good" teapot is #1. This designation is given because it is rather plain and undistinguished and by a maker who is not a household name to most silver collectors. It should be valued at approximately $3,500 for insurance purposes.

The "better" pot may be a little harder to pick out, but it is #2, which is the rather unusual barrel-shaped example. This is a very desirable pot, but it does not have the preferred bright-cut decoration; and, again, its maker is not well known to most silver enthusiasts. The value is about $4,000.

The "best" pot is the Hester Bateman. It is the best not only because she is one of the most sought after of all the English silversmiths but because the bright-cut decoration is so fine and so typical of the tastes of the day. Its value is approximately $6,000 (a virtually identical pot by a different maker would be only a "better" pot and valued at $4,000).

At this point, we must issue a warning about comparing "apples and oranges" when doing a good, better, best analysis. An example might be if a budding connoisseur is confronted with a drum-shaped teapot that is round and cylindrical rather than oval. It has hallmarks that say it was made sometime in the 1760 to 1780 period, has an ivory handle and perhaps an ivory finial, and is by a maker with a less than famous name.

The impulse is to look at this plain round teapot, compare it erroneously to the #1 example we discuss, and decide that it, too, must be a "good" teapot rather than a "better" or a "best." After all, the two teapots do look remarkably alike except one is round and the other is oval, and the round one is perhaps 10 years older. Some may argue that the ivory handle

and finial raise the round example to a slightly higher level, but this is not the case.

This teapot is a "better" example because the drum-shaped teapot from this era is considered to be the most desirable of all the pots made during the reign of George III. The plain example is worth approximately $6,000 and is considered to be only a "better" item because drum teapots with bright-cut decorations are regarded as being "best," and these can be worth as much as $8,000 plus.

If you dismiss a drum-shaped teapot with no real decoration as being a "plain Jane" worth $3,500 because that is the value of the relatively unadorned oval teapot of virtually the same period, you are making a grave mistake in connoisseurship. You are comparing apples and oranges and making a seriously incorrect evaluation.

Actually, this drum teapot presents another "apples and oranges" problem because the so-called drum teapot might not be a teapot at all! These drum-shaped vessels can look very much like argyles, which are a very rare type of gravy container that either has a hot water jacket around the outer perimeter of the inside of the pot or a cylindrical device in the center that holds hot charcoal, a heated iron, or boiling water.

This device is credited to a Duke of Argyle, who did not like his gravy arriving cold in the dining room after it had made the long journey from the faraway kitchen. The earliest examples are from the 1750s, but specimens from the 1770s and 1780s (the time of our drum teapots) are more likely to be found. Most of these argyles from the 1770s and 1780s look exactly like teapots until their inner workings are examined. Moneywise, argyles are only slightly more valuable than drum teapots of the same style and period, but connoisseurs do not make these comparison errors.

Connoisseurship requires being aware of a great many factors. Those doing evaluations and assessments must keep asking questions and looking for answers even if the answers are inconvenient or displeasing. The assessment process that we have outlined can be used to gain an understanding

of any piece of art or any antique. There is a lot to know before you are actually in the know, but the process of gaining knowledge is not all that hard. It merely requires time and persistence. Much of the rest is common sense, the ability to observe what is in front of your eyes, and the skill to do the necessary research, which we discuss in depth in Chapter 3.

Getting to Know
All About It:
The Appraisal Process

Observation is the key that opens the front door to connoisseurship, but making good observations is not always as easy as it sounds. Helaine remembers examining a late-18th-century bow-back Windsor side chair. She had already pegged it as a "better" example because it had a rather undistinguished plank seat. She liked the stance of the chair with its splayed or akimbo legs, and she appreciated the quality of the bulbous turnings, but the real question of value centered around the chair's painted surface.

From 4 feet away, the chair appeared to have old black paint that was very badly worn, and it looked as if it might be the original pigment. An up-close examination, however, told a very different story. Peeking through the black paint were small patches of what looked like gray porch paint, and suddenly Helaine knew that both the gray and the black were 20th-century additions.

Interestingly, the owner of the chair had never noticed the gray and thought that the black was the original color. The owner was afraid to touch the chair because the black was flaking off at an alarming rate. Looking even closer, Helaine soon discovered patches of green paint, which turned out to be the original paint that had covered this chair when it was first made in New England in the early 19th century.

Again, the owner had never seen the green paint, even after living with the chair for many years. Helaine's careful observations not only established that green was the original color but that the chair had never been refinished—it had just been repainted. Although this was not the best circumstance, it was better than the chair having been stripped. The difference in value between a stripped "better" Windsor chair and one that has been repainted is significant. In this case, if the chair had been stripped and refinished to a bland honey color (the very thought sends shivers down both our spines), its retail value would not have been much above $500; but repainted, with vestiges of original paint still remaining, the value is more than twice that figure.

The Examination Process

A good examination must never be rushed. The piece must be viewed from all angles: from up and down and from side to side. It must be seen from far away to judge its overall proportions and it must be studied up close so that no detail, however minor, is overlooked.

As the examination progresses, the examiner must make mental and/or written notes of such characteristics as size, color, the materials used in construction, construction details, type of decoration, signatures or identifying marks, and the quality of the workmanship. Once they are made, however, these observations should never be taken at face value because there are always hard questions that need to be asked.

The most important of these hard questions is: How do I know it is old? This is such a big question that books have been written on the subject, but we are going to address this complicated issue with brief and general discussions arranged by the categories of furniture, glass, silver, pottery, and porcelain. These explorations are designed to demonstrate the process of deciding how old a piece might be and they are not meant to be an end-all

and be-all guide. For more detailed information on specific areas, please consult the resource guide in Part III.

FURNITURE

When attempting to evaluate the age of a piece of furniture, the first consideration that needs to be addressed is whether or not it is an old form. Consider the coffee table, which is a form that did not exist much before the 1920s, so while there may be "old" coffee tables, there will be no "antique" ones until at least the second quarter of the 21st century.

If you happen to encounter a coffee table that appears to be Victorian in origin, you can be assured that it started out life as a somewhat taller table and was cut down to coffee table height at a later date when these types of tables came into fashion. We encounter many people who own these "Victorian" coffee tables and believe that they are authentic until we explain to them that their piece of furniture has been so seriously altered from its original form that its value and interest to collectors has been greatly compromised.

Understanding the forms that furniture has taken over the centuries is critical to being able to make judgments about how old a particular piece might be. The budding connoisseur/appraiser must immerse himself or herself in the vast body of literature that has been written about this subject in a variety of good reference books. There is no other way to tap into and absorb the information about furniture periods, styles, and methods of manufacture that must be available for recall at any moment.

Knowing a wide variety of tidbits can be very useful when it is time to make an evaluation—for example, the roundabout or corner chair did not originate until the William and Mary period (1690–1730); the cabriole leg on English and American furniture did not appear until the Queen Anne era (1720–1730); and the tea table did not come into use until the beverage was introduced, which, as we have already said, was in the mid-17th cen-

tury. In addition, it is valuable to be able to look at a sofa or settee and know instantly that this form was completely new during the reign of Queen Anne and before the 19th century it was found only in wealthy homes. Thus, 18th-century sofas are fairly rare; 19th-century examples are much less so.

It is the very form of the sofa that starts the wheels turning in the mind of the connoisseur/appraiser. The reasoning here is that if 18th-century sofas are very rare, then any sofa that purports to be of that time frame should be examined very carefully because the odds alone say it may very well be a reproduction. When approaching a piece of furniture for evaluation, it is important to be able to look at its style and determine the period in which it *should* have been made. If, for example, the piece is from the Victorian era, you will have to be familiar with all the substyles that were popular during that very protracted period of time (1837–1901) and when each one was in vogue.

Among the most important of these are the *Gothic* substyle, which consists of items loosely patterned after Gothic architecture, with pointed arches and tracery (pre-Victorian examples were made as early as 1820, but most are circa 1840); the *Rococo* or *Louis XV* substyle (popular 1840–1865), with its cabriole legs, marble tops, luscious curves, and elaborate flora and fauna carvings; and the *Renaissance Revival* substyle (popular from 1850 to 1885), with its massive forms and elaborate carvings influenced by the Italian Renaissance's interest in Greek and Roman culture.

Within these three substyles are found most of the really valuable pieces of Victorian furniture, but there are several other Victorian styles that are also significant in one sense or another. Perhaps the most frequently encountered is called *Eastlake* (popular 1870–1895), which takes its name from English architect Charles Locke Eastlake, who rejected conventional Victorian furniture as being too flimsy and too fussy. He proposed a more rectilinear profile decorated with machine-executed geometric designs.

Ironically, Eastlake furniture was far more popular in the United States than in England, but in America his ideas were essentially cheapened and corrupted. As a result, most Eastlake furniture is boxy and unattractive, and even more than 100 years later, it has only a limited interest to collectors.

However, within the somewhat denigrated Eastlake style, there is a subgroup that *is* highly regarded. Called the *American Aesthetic Movement*, these pieces of furniture were made by very talented craftsmen such as New York's Herter Brothers and Kimbel and Cabus. Like Eastlake, many Aesthetic Movement pieces are basically rectilinear; but unlike mainstream Eastlake, they were made much more interesting by the addition of elaborately inlaid or painted surfaces.

Contrasting woods were used on many pieces of Aesthetic Movement furniture, and much of the decoration was in the Japanese taste as interpreted by non-Asians. Elegantly detailed pieces of furniture in this style by one of the top makers are considered to be among the best of the best of all Victorian furniture. All this and more must be in the mind when a piece of supposed Victorian furniture is encountered. But just because it is in this form does not make it Victorian.

In a recent appraisal, Joe was asked to evaluate a partial Victorian parlor set consisting of a sofa, a lady's armchair, and a gentleman's armchair. All the pieces were in the Rococo style and, at first glance, appeared to date from the 1860s.

As Joe began to make his evaluation, the owner said, "Oh, by the way, the lady's chair is a reproduction." The room was dark and this fact was not readily apparent in the dim light, but when Joe looked closely he could tell that the lady's chair was indeed a reproduction probably made in the 1960s. The color of the walnut was lighter than the other pieces (wooden surfaces exposed to air tend to darken with age, which is known as gaining a patina) and the carving was softer, simpler, and not as well done as the very similar carving on the originals.

It is easy to make assumptions in a situation like this and these may

lead to serious mistakes. The form of this lady's chair was absolutely right, but it had no significant age. Many connoisseurs/appraisers do not expect to see reproductions of Victorian furniture because this style was not popular with collectors until the mid-1970s. Yet Victorian furniture was widely reproduced in the 1960s and later, and mid- to late-20th-century pieces do exist in large numbers. Making assumptions can lead to serious mistakes. So beware, and use form and style as clues to age rather than as an infallible guide.

Almost every form, type, and style of furniture known has been reproduced at one time or another. Some are frauds meant to deceive, and these can be very difficult to detect, especially those that were made from old wood or constructed more than a century ago. They sometimes require minute inspection and extensive research and sleuthing, but some detail or other will always give them away. Other reproductions are designed just to recall a bygone era. They are much easier to spot because furniture makers generally get the old forms wrong, and many times there is a mixing together of totally different styles to make a piece look "old" to the uninformed or only marginally informed eye. Knowing what genuine old forms are supposed to look like will allow the connoisseur to recognize these reproductions immediately.

Proportions of vintage reproductions are frequently wrong, and the sizes of newer pieces are incorrect in many cases. Two examples are that reproduction secretaries are often shorter than their 18th-century prototypes, and fake chairs are commonly taller and narrower than their earlier counterparts.

According to Helaine's friend, New York antiques dealer Eli Buk, looking at many different kinds of antiques triggers a reflex process in your memory bank. After seeing a vast variety of pieces, the student connoisseur builds a virtual visual inventory in his or her head that generates an "Aha! I have seen this before!" response when a similar item is encountered. It allows for a productive comparison between what has been seen in the past

and what is being seen now, which can lead to a very valuable learning experience.

THAT UNCOMFORTABLE FEELING

As time goes by and experience grows, the appraiser/connoisseur should develop a sense that will allow him or her to tell if something is "wrong" from across the room. This feeling of "wrongness" is generally due to problems in size and proportion or abnormalities in form and style.

OF THE PERIOD AND CENTENNIAL

If a connoisseur/appraiser is asked to judge the age of a Chippendale-style chest, there are many possibilities as to when it actually might have been made. This very distinctive style has been popular from the mid-18th century until the present time. It is sometimes hard for those who are in the process of learning to separate very old objects in this style from similar items that are only moderately old or fairly new.

A Chippendale-style chest might be of the period, meaning that it was made during the 1755–1790 era when Chippendale furniture was first made; or it might be a provincial piece made as late as the 1830s in a region that was somewhat removed from the nation's fashion centers of the day (e.g., Philadelphia, Boston, New York, Charleston, or Newport). In the more out-of-the-way or "frontier" locales, fashions such as Chippendale-style furniture tended to arrive later and linger longer than they did in the bigger cities or centers of great wealth.

Joe once helped conduct an estate sale in a small town in West Virginia just a little west of the great Valley of Virginia that runs down Virginia's western edge. Some of the furniture in the house was Chippendale style, but it was attributable to a particular craftsman who was known to have worked in the area in the 1820s and 1830s.

Joe had a problem with calling this furniture period Chippendale,

but local collectors and connoisseurs did not. To them, it was of-the-period Chippendale because it was from the time of the first production made in their area and was from the workshop of a cabinetmaker whose work was well known and much desired. Joe was a bit surprised when the contents of the house were sold at auction and a rather simple four-drawer Chippendale-style chest circa 1825 brought almost $30,000!

We doubt that the price on this particular piece could have been duplicated in New York, Philadelphia, or Boston, but objects such as this can mean a great deal to the people who live in the area in which the piece originated. Appraisers must know this and take it into account when preparing their appraisal. In addition to period and provincial pieces, appraisers/connoisseurs need to be aware that there are centennial Chippendale pieces made approximately 100 years after the style was initially in vogue.

Chippendale-style furniture came into vogue once again around the time of the Centennial Exposition held in Philadelphia in 1876. Much of this furniture is very elaborate, often largely handmade, and is really an attempt to pay homage to the past. Its high quality has gained a great deal of respect among collectors and both prices and appreciation for centennial Chippendale furniture are rising steadily as are the prices and appreciation for other types of "revival" furniture made at this time in various other well-known 17th- and 18th-century styles.

Chippendale-style pieces made in the 1870s are sometimes classified as being part of the Colonial Revival, which some say lasted from the 1870s through the 1940s. We recognize that there was indeed a Colonial Revival that lasted over that period of time, but for the purposes of our discussion, we want to break this very long span of years into three distinct segments. The first group consists of pieces from the 19th century, which we have already briefly discussed. The second group consists of Chippendale-style pieces made during the first quarter and early second quarter of the 20th century, and the third is the Chippendale type of furniture made after 1930.

Chippendale-style furniture from the early 20th century was made largely in a factory setting with a limited amount of actual handwork going into its construction. However, by the standards of the early 21st century, much of it was very beautifully made, but no connoisseur or collector with even a modicum of experience would mistake it for its 18th-century cousins or value it in the same monetary or aesthetic bracket.

These pieces (most of which are circa 1920) are beginning to gain significant favor with those who are interested in "old" pieces for use in the home, but these examples are a long way down the connoisseur appreciation chain that starts with 18th-century of-the-period pieces, then progresses to the provincial pieces, which may be as late as the 1830s, and moves on to the very high-quality revival pieces of the 1870s.

Many current connoisseurs would draw the line here and classify most of the 20th-century-made examples as being beyond the pale. They would call these pieces reproductions and disdain them almost as much as they do the later Chippendale-style pieces, which were entirely factory made from the 1930s to the present.

Those who are somewhat less purist in their approach seek out these later Chippendale reproduction pieces because they can be high quality, very attractive, and relatively inexpensive when compared to new furniture. Helaine is quick to point out that there are serious collectors who are currently interested in such things as Colonial Williamsburg reproductions, and it is not unusual to find individuals who treasure their examples of post–World War II custom-made Chippendale furniture.

Faced with this long progression of Chippendale and Chippendale-style furniture, the appraiser/connoisseur must be able to place an object of this type into the actual time frame in which it was made. Someone doing an evaluation must know the characteristics to look for that say a certain chair or other object was made in the 1770s, the 1870s, the 1920s, or—heaven forbid—the 1970s. It may seem fairly complicated, but

knowing about certain aspects of furniture construction can help tremendously.

CONSTRUCTION DETAILS AND SIGNS OF WEAR

One construction detail to look for that can be very telling is the shape of the marks left by the saw in cutting the wood. Seeing the slight curve of a circular saw mark is always a bad sign in a piece of furniture that was supposed to have been made before 1830. The straighter, slightly irregular striations of a bow saw are much more comforting; but the very straight, very regular tracks left by a band saw are a contraindication of significant age.

Typical striations left by a bow saw.

If you are confronted with a Chippendale chest, chair, or any other piece of old furniture, one of the first things to do is to look for the proper signs of wear. Ask yourself: How was this piece used? Then begin examining all the surfaces to make sure that the wear is in places where normal use would have occurred. For example, there should be wear around handles and knobs where hands repeatedly went through the act of opening and closing the drawer or door. Unless they have been replaced, there should also be a great deal of wear on drawer runners, since the drawers were incessantly pulled out and pushed in.

Typical striations left by a circular saw.

Typical striations left by a band saw.

Look at the medial stretchers under chair seats to see if feet and shoe heels scraped them on a regular basis, and make sure chair legs or feet have seen heavy use. These are just a few of the places to inspect, but common sense should help determine the places to look for other kinds of wear on furniture parts.

At this point, the examiner should have an idea as to whether the piece being investigated is new or old. If the form and wear are right, the next concern is determining if the construction is right. One of the first things to do is to turn a piece around and look at the back. If it is made in two parts, such as the top and bottom of a secretary or a corner cupboard, make sure that the boards in the top half match the boards in the bottom half. If they do not, it is very possible that there has been a "marriage" of two pieces that did not start out life together.

Keep in mind that if a piece of furniture was meant to spend its life pushed up against a wall, craftsmen who worked before the early 19th century would not have spent much time and trouble finishing a surface that would never show. On many fine pieces of 18th-century French furniture, for example, the back does not look much better than a packing crate and the inside of the drawers can be rather crude. Reproductions of these pieces almost always have backs that are better finished than the originals, and the drawer carcasses are often less crudely made.

In addition, 18th-century craftsmen did not finish the backs of feet and legs in the same way as the fronts, which would show. Fingers can often pick up the telltale carving tool marks that the maker did not bother to smooth away because they would never be seen in the course of normal use. Reproductions usually have surfaces that are uniformly finished and fingers will only detect smoothness and perfection.

There are all kinds of little construction details that say "original" rather than "reproduction." For instance, look at the back of an 18th-century chair and notice the way the splat is made. If the back edge around

the outside of the splat has been beveled, it is said to have been "silhouetted," which is a good sign of possible 18th-century construction.

When the chair is turned around, look at the way the splat was fitted into the back seat rail. Where the splat and the seat rail join, there should be a raised tab into which the splat fits. This is called a "shoe," and on 18th-century pieces the shoe should be a separate piece resting on top of the seat rail. If the shoe and the back chair rail are one piece, the chair being inspected is probably a reproduction.

Another giveaway is the weight of a piece of furniture. In the 18th and early 19th centuries, furniture was frequently made from very dense, very heavy Santo Domingan, Cuban, or Honduran mahogany, but later reproductions were made from African, Asian, or South American mahogany, which is less dense and therefore lighter. Keep in mind that as wood ages, it loses moisture and weight; but still, 18th-century furniture made from the earlier types of mahogany will always be heavier and have a different grain from the pieces made from the African, Asian, or South American varieties of this tropical wood.

Another easy way to spot a fake is to look at the lumber from which it was made. Boards used in the 18th century and earlier were generally quite wide because they were cut from larger trees. If, for instance, the item under inspection is a tea table and the boards are less than 20 inches wide, that is a cause for immediate suspicion. Sometimes 18th-century tabletops were made from just one board and two is about the limit. Later pieces were made from narrower pieces of lumber and tops have multiple boards of uniform width. Lumber from the 19th and 20th centuries is thinner than 18th-century lumber.

It is a good idea to examine the carving on a piece of furniture very carefully. Carving from the 18th century tends to be strong, detailed, and deep, whereas the carvings on reproductions are shallower or flatter and less detailed. Where elements are repeated, they show a sameness that

would never have been found in earlier carving. It is also important to be aware that occasionally authentic period pieces have had carving added at a later time to enhance their value. A close examination, however, will show these later carvings to have the failings listed above.

These are some of the things that should be passing through a connoisseur's head as he or she tries to answer the question: Is it old? We want to emphasize that there is no shortcut to answering this question, no single element that can be examined to give the definitive answer.

Joe once had a student who was convinced that if she just learned about the nails used in the construction of furniture over the years she would always be able to date the piece she was evaluating. *Wrong!* She failed to take into account that furniture repairers and furniture fakers keep supplies of old nails and old wood to make acceptable-looking repairs and—in the case of the fakers—good-looking but thoroughly unacceptable fakes.

Judging the age of a piece of furniture on just one element is always a mistake, and the appraiser must look at the whole picture rather than focus on just one detail. If there is an element that looks newer than the rest of the object, the connoisseur/appraiser must ask why it is there. Is it a repair? Does it suggest a later alteration? Or does this inconsistency call into question the age of the entire piece?

GLASS

We do not wish to sound like a broken record, but one of the major indications of age on any antique is wear, and when trying to determine the age of a piece of glass, the first thing to do is to check the various parts for signs of use and telltale abrasions. Glass surfaces are relatively soft, so short, shallow scratches can occur very quickly. Even on pieces that are just a few years old, there should be at least a small amount of wear if the piece has been moved around or cleaned with any regularity.

As age increases, so should the number of scratches. Keep in mind,

however, that these should be short, shallow, and run in random directions. The presence of numerous long, deep, parallel scratch marks is a cause for alarm and probably indicates that there has been an attempt to make a new or newer piece look older than it actually is.

These scratches may be very difficult to see and occur only on areas that come in contact with other surfaces. The bottoms of some glass pieces are shaped so that only limited areas come into contact with the flat surfaces on which the object rests. This is particularly true of footed items in which the area of contact may be no wider than a few strands of hair. In these cases, examination requires great care, good eyes aided on occasion by a magnifying glass, and strong natural or incandescent light.

In addition to looking for scratches on the bottoms of glass objects, areas of contact between a separate lid and the body of a glass item should be checked for both scratches and small impact chips. Fakers seldom think to "age" these places, and this can provide a substantial clue. Next, check the decoration, if any, for signs of wear. For example, the gilding on handles almost always should be worn. Absolutely perfect gilding on handles is possible if the object was not picked up to any great extent, but pristine gilding usually suggests that the piece is either not old or the handles have been regilded—and neither of these circumstances is a plus. Painted, enameled, or mineral-stained decoration should be thoroughly examined for wear, discoloration caused by years of accumulated grime, and minor losses. Anything that has been regularly handled and/or cleaned should show clear indications of usage.

We would like to be able to say that—as in furniture—examining a glass object's form may be a big help in determining its age, but generally this is not the case. The overall shape of a piece of glass is not difficult for a skilled modern craftsman to copy, and the only time the configuration of an item under examination really helps is when the piece was made by a company that produced a catalog of its wares.

Company catalogs are very useful for identifying the work of such

manufacturers as Steuben, Fenton, Imperial, Cambridge, Heisey, Dugan, Fostoria, Westmoreland, and others. These heavily illustrated compendiums often tell an appraiser the time frame in which a piece was made and can provide other historic details such as the forms of related items, the line name, and the various colors the company might have used to make similar pieces.

Look at the construction of the piece of glass that is under examination.

- If mold seams are found, the piece was almost certainly made after the 1830s. Most molded-on handles are post-1827.
- If a seam mark goes all the way to the top of a bottle's lip, the bottle could not have been made before about 1910. If the seam stops just below the lip, it was made after 1890; and if it stops on the shoulder of the bottle, it was made before 1880.
- If the base and body of a piece of glass were made separately and then joined together with a thin disc of glass called a "wafer," the piece was made before 1870.
- If a piece of glass has a flat bottom that was not created by mechanical means (e.g., the bottom was not ground down on a wheel), it was made after 1850.
- If a piece of glass is *perfectly* clear with absolutely no bubbles or other imperfections, it is most likely post-1880.

While trying to ascertain the age of a piece of glass, be sure to pick it up to gauge the weight, because there is often a disparity between new and old pieces. New cut glass, for example, is generally lighter than pieces of similar size made during the American Brilliant period (1880–1910); and "Early American" blown glass (pre-1870) is almost always lighter than the 20th-century reproductions made in Mexico, Czechoslovakia, and the United States.

Pay close attention to the color of the glass object being evaluated. An example of this might be old bottles, which were made in a relatively limited number of colors such as aqua, clear colorless, several shades of green, amber, dark brown, black, sapphire blue, cobalt blue, and amethyst. The black and dark brown bottles are almost always relatively early, with many being 18th or early- to mid-19th century. Reproduction bottles, however, can be found in a wide variety of "weird" colors that were never used in the originals.

WARNING NOTE

It is never a good idea to decide whether an object is old or an original based on just one factor. Occasionally, truly old bottles will be found in an unusual color that makes them a rare and valuable find. Dismissing the bottle simply because the color is out of the ordinary would be a big mistake. A decision about its age should be based on a variety of factors, including how it was made and signs of surface wear.

It is always a good idea to make sure that original pieces of glass were made in the color exhibited by the example being evaluated. From 1931 to 1946 and from 1951 to 1953, A. H. Heisey & Company of Newark, Ohio, made a pattern called Ipswich, which was based on Comet, a much earlier pattern made by the Boston and Sandwich Glass Company. The vast majority of all Comet pieces were made in clear colorless glass (some rare colored pieces are thought to exist), but Heisey's Ipswich came in Moongleam (green), Flamingo (pink), Sahara (yellow), Alexandrite (lavender in natural light, greenish blue in fluorescent light), cobalt blue, and crystal.

In 1957, Heisey went out of business and sold some of its molds to the Imperial Glass Company of Bellaire, Ohio, which produced Ipswich from these molds, and it was still marked with the Heisey H in a diamond trademark until around 1969. The Ipswich pieces made by Heisey are much more desirable to collectors than the ones made by Imperial, and in

*An Ipswich pattern
tumbler originally
made by the
A. H. Heisey
Company of
Newark, Ohio.*

many cases, the only way to tell the difference is by the color. Imperial made Ipswich in amber, verde, antique blue, heather, mandarin gold, moonlight blue, and milk glass.

Internal imperfections may be found in some pieces of glass. There are some who, upon observing a multitude of bubbles, dark streaks, or particles of sand in glass, assume that these are signs of age. In many cases, they are not. Early glass (pre-1850) is generally of good quality, and while imperfections such as the ones listed above can be found, they are not widespread throughout the body of the glass. In fact, when large quantities of these flaws are seen, warning flags should go up suggesting that the piece being examined was really made to deceive in the 20th or even 21st centuries.

THE TREACHERY OF SIGNATURES

Never—and we mean *never*—determine the age of a piece of glass based on a signature alone! There are far, far more spuriously signed pieces of glass out there than there are genuine pieces with genuine signatures.

Joe remembers with a certain distaste an auction company located in a town not far from where he now lives. Every month a "hauler" would bring a large truckload of merchandise from New England to sell. Every month there were always at least a dozen pieces of glass signed "Steuben," "Hawkes," "Loetz," or "Tiffany," and every one of these items was a fraudulently signed fake. What made these fakes so insidious was that the false signatures were placed on genuinely old pieces of glass that were the products of less desired or simply unknown makers.

In the case of "Loetz" and "Tiffany," all that was needed to make these fake signatures was a diamond point or electric pen to write the magic name on the bottom of the piece of glass. In the case of "Steuben" and "Hawkes," an easily made rubber stamp copying the company's actual

trademark and a little hydrofluoric acid to etch the stamp's image into the surface of the glass would do the trick.

This practice is shameful, but it is also rampant and very easy to do. Over the years, hundreds if not thousands of these fakes have gone through the auction with few complaints or cries of discovery and indignation, and in all likelihood, those pieces are still out there fooling the unwary. Of course, the big problem is that if large numbers of deceitfully signed pieces went through this one small auction company in the south, think of how many others entered the marketplace under similar circumstances all across the country. The number is enormous and gives every appraiser pause.

HINTS FOR SPOTTING REPRODUCTION GLASS

We are going to examine four types of highly collectible glassware in which deceit is rampant and outline some ways that new examples can be separated from old. These areas are cut glass, cameo glass, Depression glass, and 19th-century heat-shaded art glass.

AMERICAN BRILLIANT PERIOD CUT GLASS

By cut glass we mean American Brilliant period cut glass, which was made between about 1880 and 1910. The decorations on the pieces that were cut during this period were accomplished by cutting grooves into the glass surface with a steel, copper, or iron wheel. The idea was to facet the surface so that it would reflect and refract light in much the same way that a jewel is faceted to accomplish the same purpose.

After the initial cutting, however, the surface of the decoration was gray and frosted and would not refract light. This meant that these areas had to be polished laboriously using a succession of stone, wood, and cork wheels until they were perfectly clear and sparkling.

On old examples, this was very carefully done. The late-19th- and early-20th-century craftsmen did not miss spots and leave some frosted

areas unpolished. Modern manufacturing techniques are not so meticulous, and frequently areas are found on these new pieces that were left unpolished. They are a sure sign of a reproduction.

Another easy way to tell a piece of American Brilliant period cut glass from a modern fake is to examine the edges. Many old pieces will have a rim that is decorated all around with notches or "teeth," and on old examples, these teeth will be blunted and will not have sharp points. On new pieces, the points will not be blunted, and in many cases, will be uncomfortably sharp.

Earlier we wrote about how bubbles and imperfections in glass objects do not necessarily, as many suppose, indicate an old piece, and new cut glass is an excellent example of this. Vintage American Brilliant period cut glass is almost invariably found without bubbles, but a *few* small bubbles can be found from time to time in the new products that are being made in Turkey, Romania, the Czech Republic, and China.

We hope we have established the importance of a thorough examination for wear on any piece of cut glass being examined for age. As the inspection of the object proceeds, check to make sure that the glass body is of uniform thickness. Older pieces tend to be very uniform in this regard, but new specimens may have thick bottoms or bulges in the middle that decrease in thickness as they taper outward or upward.

CAMEO GLASS

Reproduction cameo glass has become a real problem on the modern marketplace. Some years ago, Joe was contacted by an individual who had just come home from a business trip to California, where he and his wife had bought a half-dozen pieces of cameo glass.

Cameo glass is a very special type of artistically made glass that is primarily associated with the Art Nouveau and Art Deco periods of the late 19th and early 20th centuries. It was made by layering different colors of glass, then carving through the various strata to form a multicolored pic-

ture or image in much the same way that the color layers of a shell are carved through to make a piece of cameo jewelry.

Joe's client had purchased his cameo glass in a very posh shop in a prestigious section of Los Angeles, and the buyer was very happy until the dealer from whom he had made the purchases called and said that he had other pieces for sale and would like to fly across the country to show them to his newfound favorite customer. Such eagerness immediately raised the man's suspicions, and he called Joe in to evaluate what he had bought. Two of the smaller items turned out to be genuine, but all of the larger, more elaborate and expensive pieces were brand-new fakes. This incensed the gentleman so much that he telephoned a friend in law enforcement, then called the dealer in California and told him to bring his merchandise to Tennessee. The police officer unofficially monitored this meeting and, to make a long story short, the defrauded customer got his money back and the ersatz cameo glass dealer had some serious explaining to do.

Fake cameo glass is turning up with great regularity in antiques shops and malls across the nation, and great care should be taken when confronted with any piece marked Gallé, Schneider, Daum Nancy, Legras, Muller Frères, Richard or Thomas Webb (among others). Suspicion should be aroused immediately if the signature is in a place so prominent that it competes with the decoration. If it happens to occur on the top half of a vase where it would be impossible to miss, this is cause for alarm because most genuine marks on old cameo glass are more discreetly placed.

Another cause for concern might be if the main body of the glass object is made from either clear colorless or varicolored mottled glass. Although some old examples were made using this type of glass, they are rather unusual. Pieces that use either of these glass bases are likely (but not certainly) to be reproductions.

Examine the bottom of the cameo piece to find out what sort of pontil is there. Old pieces should have smooth, polished pontils or bottoms that have been ground entirely flat. A *pontil* is a roughly circular feature found

in the center of the bottom of a piece of glass. It is caused by the removal of the *punty rod,* which was used as a handle to hold the hot piece of glass while the finishing work (i.e., attaching handles, opening the top, and so forth) was being done. When the rod was broken off, it left a jagged scar that was either polished into a coin-shaped circle or removed by grinding the entire bottom flat.

Old pieces of cameo glass that are larger than 2 inches tall should have a ground pontil or a bottom that has been ground completely flat. Reproductions generally do not have either of these but may have a molded depression in the center of the bottom that resembles a pontil but is not.

After looking at the pontil, examine the lip around the top. Old pieces should have fire-polished tops that are smooth and rounded. New pieces generally have tops that have been ground flat with fairly sharp—or at least crisp—edges on both the inside and the outside.

One last warning: if you find a piece of cameo glass signed Gallé and the initials TIP are also present, that piece is undoubtedly a reproduction made in Romania in recent years (TIP is a Romanian designation for *type* or *style,* meaning the piece is Gallé type and not an original). Unfortunately, unscrupulous people have been known to grind the TIP off, leaving only the name Gallé.

DEPRESSION GLASS

Appraisers trying to evaluate examples of Depression glass really need to be on their toes, and they need a good reference book or two. Unlike cut glass and cameo glass, there are no across-the-board attributes that will help separate old from new in this huge and highly popular category.

Making an age determination can be especially difficult for Jadeite (an opaque green glassware first made in the 1930s) because there is absolutely no definitive way to distinguish a large portion of the new Jadeite from the old. In this subcategory of Depression glass, surface wear and evidence as

to when a particular piece came into the possession of its original owner are often the only clues to an item's age.

The characteristics that tell appraisers which specimen is old and which is new are different and very specific for each pattern of Depression glass. The only general statements we can make are that the bottoms on old tumblers tend to be thicker than the bottoms on new examples, and the glass in reproduction salt and pepper shakers is generally thicker than it is in genuine old pieces. This is not much to go on, and Depression glass is one area where experience in handling lots of old items can be very important. As a general rule, however, we think appraisers need to be automatically suspicious of rare or highly desired forms of Depression glass such as biscuit jars, child-sized items, and butter dishes.

Reproduced Depression glass patterns generally have characteristics that give them away, but they are different for each pattern. In the Adam butter dish, for example, old items have four arrows in the outer edge of the design that are impressed into the bottom plate. These point to the notched corners, but in the repros, the arrows point to the center of the flat sides. Another example might be the Madrid butter dish. In the originals, the mold seam on the lid's knob runs in a horizontal manner that is parallel to the top of the dish; on the repros, this seam is vertical.

These are just two of the vast number of details that appraisers and collectors need to know to be able to tell the differences between new and old Depression glass. All of this information is available in printed sources (see Part III). All that is required to answer the question "Is it old?" is a little research.

19TH-CENTURY HEAT-SHADED ART GLASS

The last type of glassware that we are going to examine for indications of age is 19th-century heat-shaded art glass, and for our purposes, we will limit the discussion to Burmese. There is a great deal of interest in this type of glassware and many items are masquerading as old.

Burmese is a Victorian art glass that shades from a soft yellow to a delicate salmon pink. This type of glass is made using uranium and gold as coloring agents. When the piece is first made, it is all yellow (a hue caused by the uranium). At some point, a portion of the item is placed into the furnace and the reheated section turns pink (a hue caused by the gold). In original pieces, the line of demarcation between these two colors should not be visible and the colors should just blend together. In reproductions, there can be a very visible line between the pink and the yellow, but this may not be the case if the new piece is made using the old technique.

We use the terms *soft* and *delicate* to describe the colors of original Burmese, but on reproductions the colors are often much more strident. In one group, the pink looks like petrified bubble gum, and on other specimens, the pink looks like a particularly poisonous rash.

When examining a piece of Burmese or almost any other piece of 19th-century art glass, it is always important to pay special attention to the handle. Old examples will have handles that are very comfortable and convenient to use, because they were designed to be functional. Handles on reproduction pieces, however, are often just decorative and were not meant to be utilitarian. A hand will not fit comfortably through them or the handles will be placed in such a manner that they are awkward to use.

Another strong hint indicating a fake piece of Burmese is the lack of a polished pontil. Of course, some small pieces such as salt and pepper shakers will not have a pontil; but on most larger pieces, if there is no pontil or if the pontil is rough and craggy, it is almost certainly not more than a few years old. Also, if the piece has a very noticeable frosted pontil, it is probably a reproduction.

One clue that applies to many types of 19th-century art glass is that when craftsmen were using their crimping tool to create a ruffled edge around the top of a piece of glass, they did not, as a general rule, allow tool marks to show on the finished product. On reproductions, there is often a

straight line visible down the middle of the bottom of the U-shaped ruffle. This is a mark left by the crimping tool and a dead giveaway that the piece is not old.

One last thing to keep in mind: old Burmese is always a one-layer glass. If the piece under examination has two layers or a clear glass ruffle around the rim, it is not an original.

SILVER

Answering the question of how old a piece of silver is can be a very easy task. The English silver that appraisers and collectors encounter on a day-to-day basis is always dated, and there are many books (see Part III) that make it very plain how to break the code. Fakes and frauds in sterling silver are not encountered often, but we discuss in Chapter 1 how they can be unmasked.

It is important, however, not to assume that just because a set of English hallmarks appears on a piece of sterling silver the object is old. For the most part, the hallmarks that were in use in the 18th century were also in use in the 19th, the 20th, and are still employed in the 21st.

Unfortunately, most references do not give the English dating codes used in recent times because the main focus of these books is to identify old or antique silver. This omission can leave a little ambiguity in the mind of someone trying to judge the date of a particular piece of English sterling silver made in the past 50 years or so. Still, if one of these listings of hallmarks is consulted and the date mark does not appear, it can be inferred safely that the item being assessed is later rather than earlier, and is, in fact, quite modern.

The problem of dating a piece with pinpoint accuracy is a little more difficult with American silver. Some companies such as Gorham and Reed and Barton have put date marks on their wares for a very long time, but most others have not. Pre–Civil War American silver is generally marked with only the initials or the name of the maker. The word *sterling*

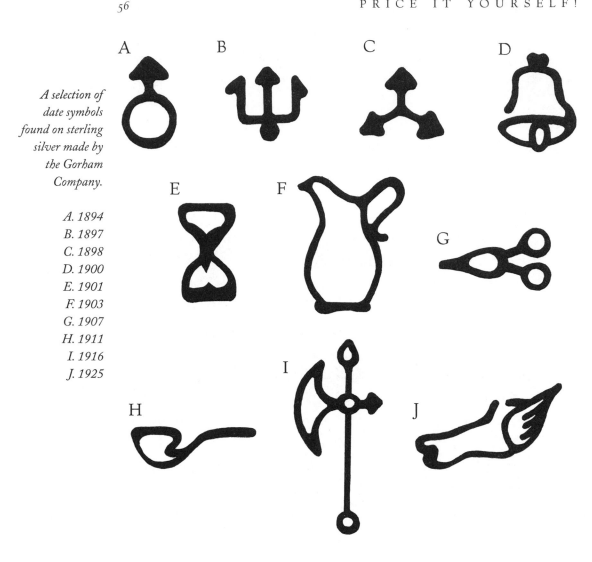

A selection of date symbols found on sterling silver made by the Gorham Company.

A. 1894
B. 1897
C. 1898
D. 1900
E. 1901
F. 1903
G. 1907
H. 1911
I. 1916
J. 1925

will definitely not be on pieces of this vintage, and marks such as Coin, Pure Coin, Premium, Standard, or Dollar might appear instead. The term *sterling* does not appear on American silver until the 1860s, and this word can be a real clue to time of manufacture.

Fakes among pieces of American silver are not a serious problem unless the piece is purported to be by a famous maker or to be of early Colonial origin (pre-1750). A growing number of fake pieces signed Tiffany have

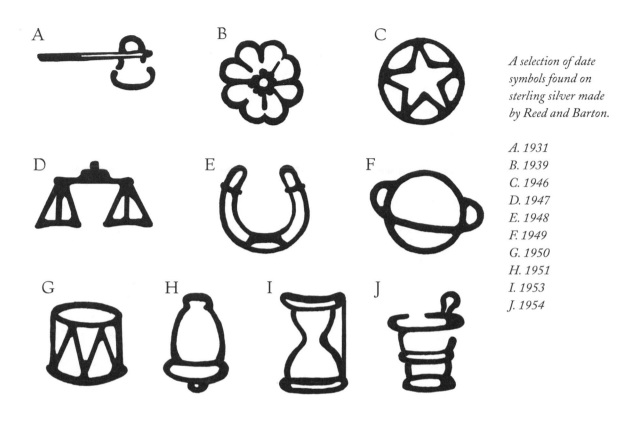

A selection of date symbols found on sterling silver made by Reed and Barton.

A. 1931
B. 1939
C. 1946
D. 1947
E. 1948
F. 1949
G. 1950
H. 1951
I. 1953
J. 1954

been reported, and no piece signed by such silversmithing legends as Paul Revere, Myer Myers, Peter Van Dyck, John Coney, John Edwards, Jeremiah Dummer, Joseph Richardson, Jacob Hurd, or by the partnership of John Hull and Robert Sanderson (among others) should be taken at face value.

Such items need a great deal of study by a specialist, who will conduct a rigorous examination of everything from the item's construction to its silver content before making a judgment about age and authenticity. The incidents of fake American Colonial silver are significant enough that this sort of evaluation requires the attention of an authority in this area and should not be attempted by an appraiser who does not have a great deal of experience in this specific field.

Finding a notable piece of undocumented pre-1750 American Colonial silver by a famous maker is about as likely as waking up one morning and finding aliens from outer space repairing their flying saucer in your backyard. Such an event may be possible—we suppose—but it is highly unlikely.

To be sure, a genuine Paul Revere teaspoon might turn up to be evaluated, but then the question arises: Which Paul Revere made it? Many people do not know that there were actually three 18th- and early-19th-century Boston silversmiths by this name, and they all used marks that were similar enough to one another to be confusing to the nonspecialist. The first Paul Revere (1702–1754) was born Apollos Rivoire but anglicized his name to the one that is now so familiar in American history. It was this Paul Revere whose son was the famous patriot, Paul Revere II (1735–1807), and he in turn had a son, Paul Revere III (1760–1813), who, like his father and grandfather, was also in the silver-making trade.

Any item by any one of these three makers is highly desirable, but one by Paul Revere II is almost an historical icon and should have a provenance—or a history of ownership that stretches back over the years since it was originally made. A lack of this sort of record is grounds for immediate suspicion, and this applies to all pieces made by important makers of the American Colonial period.

Occasionally, appraisers are confronted with Continental European silver, which can be difficult to identify and to assign the proper age because the marks can be rather obscure and mysterious. Many late-19th- and 20th-century items are clearly marked .800 or .835 (a good indication of Continental European origin), but earlier examples tend to have hallmarks that can be very difficult to find because they are often rather small and sometimes are hidden among the decorations.

Finding these may be trying, distinguishing what they are may produce a blinding headache, and discovering their place of origin and date of use may try the patience of a saint; but with the help of a reference book or two, these things can be accomplished with a little perseverance. Helaine hates the time

and eyestrain it takes to peer at a tiny mark and then spend hours sifting through page after page of illustrated text to find a match. That is what it takes, however, and when the answer is found, it makes her feel like a master detective who has just used her wits to catch a clever and elusive serial killer.

In recent years, a large number of certain types of silver items have been reproduced, and they can bedevil appraisers. One of the most vexing is silver-plated (not sterling silver) figural napkin rings. These feature a variety of subjects, including a goat, stork, boy or cherub pulling a cart, or some other device with a napkin ring in the back. The best of the old ones can have values that approach the $2,000 level, which has been an incentive for some to pass off new fakes as being genuine originals.

Without a close examination, many of the new napkin rings can be real foolers, but the informed eye can generally spot them upon closer inspection. Be suspicious of any napkin ring that features moving parts such as wheels or examples that have three-dimensional cherubs, animals, or children as part of their design. Many of these have been faked.

New, Victorian-appearing napkin rings usually give themselves away because the details are not as good as they are on old examples. The faces of children can look a little like they have melted and become soft and blurry, the harness on a dog pulling a ring is not as realistic as it was on the old version (the cinch strap may be missing), or the engraved flowers around the outside of a ring are indistinct and show very little depth.

New napkin rings are often very clumsily molded and they can show pits and imperfections that are never found on old pieces. In many instances, the manufacturers of fakes have attempted to cover up these faux pas by filing or grinding down the outside and inside surfaces. The resulting striations are usually very visible and a sure sign that the piece is a fake. Lately, we have seen a whole group of very cute napkin rings that give themselves away because their bases are very thin and flimsy. These bases have been stamped out in a manner that is never found on old examples, which are generally cast and quite substantial.

As we have said about other types of antiques, appraisers should never trust a mark entirely, and napkin rings are no exception. In the beginning, fake napkin rings tended not to be marked, but now there has been an attempt to use the insignia employed by the original makers such as Tufts, Meriden, Wilcox, and Rogers Brothers. But, as a general rule, the original marks were stamped in using a die, which means they are impressed; the marks on repros are largely molded on, which means they are raised.

There are all kinds of items that are currently being made to look like they are old but are not. Objects with the sensuous curves of Art Nouveau design are favorites, and include match safes, needle cases, thimbles, pincushions, and cigar cutters. These items are being made because collectors are extremely interested in old examples and there is a market for new look-alikes. Like the silver-plated napkin rings, much of the new sterling silver is cast. This manufacturing method makes the pieces heavier than the older examples, which can be rather lightweight in comparison. Also, like the silver-plated napkin rings, the casting often produces a product with a surface that is less perfect than the originals. In many cases, there are pits and protrusions and little imperfections on the new items that are often fixed with a little grinding. Looking for the signs of this kind of finishing procedure will sometimes tell the tale.

POTTERY AND PORCELAIN

This field of study is huge, and deciding whether a particular piece is old can be a big challenge. Joe specializes in this field and even after years of intense study he admits that he, too, can make a mistake.

UNMASKING A FAKE

A few years ago, Joe was in an antiques shop and found a delightful covered cup that appeared to be 18th-century French soft paste porcelain. Working on the principle that it is never wise to judge the age of any

antique by the marks found on it, Joe went
through an extensive examination, starting
with signs of wear. It seemed to be exactly
what would be expected. Where the rim of
the lid met the inside of the cup, the beauti-
fully warm white glaze had been rubbed
away by what looked like centuries (two and
a half centuries to be exact) of use. There
was a small amount of damage, which was
also very comforting.

*This covered cup is
an extremely
well done fake. It
is an exact copy of
a piece originally
made by the French
Mennecy-Villeroy
factory in the first
half of the 18th
century.*

 The color of the glaze was very impor-
tant; Joe would have been instantly suspi-
cious if it had been too white and too glassy, but it was very mellow and
looked the way it should have. The glaze was also lightly crazed and there
were dark iron specks here and there to signify that the porcelain had not
been refined as much as it would have been in modern wares. All of these
were good signs.

 Next the decoration, which consisted of hand-applied leaves and flow-
ers, was studied and it turned out to be exquisitely handmade with won-
derfully detailed modeling. At this point, Joe looked at the marks and
decided they appeared to be correct for the first quarter of the 18th century.
The price was right (less than $200), so Joe bought the cup because he felt
that there was a good shot that it was old—but even if it was not old, it was
a fairly good buy.

 After getting the covered cup home, Joe consulted one of the standard
references on the subject; and lo and behold, say hallelujah, he found the
piece pictured and the statement that there had been few reproductions of
this type of ware. Everything was looking good, but Joe decided to make
the final acid test. He took a steel-bladed knife and tried to place a small
scratch in the porcelain on the footrim. Joe knew that if the knife scratched
the body, it was soft paste and probably a genuine piece, but if it did not, it

was hard paste and a fake, because all of the reproductions had been made in hard paste (i.e., Chinese-style porcelain that uses kaolin as opposed to soft paste, which is made with such substances as glass, soapstone, and bone ash).

As the knife moved across the surface of the porcelain, Joe's heart fell because a gray streak was left behind, which meant that the body of the covered jar had removed some of the steel from the knife blade. A quick swipe of the finger and the gray streak disappeared, leaving not the slightest hint of a scratch behind. The cup was a fake—an incredibly good fake but a fake nonetheless. It had been made by the Samson Company in Paris in the late 19th century and was collectible in its own right. Samson is famous for its reproductions and its blue and white Delft (Dutch tin-glazed earthenware) is said to be as good as the original product. The reproductions are distinguishable from the old mainly because the Samson copies bear that company's mark.

The lesson here is that most of the reproductions of European soft-paste porcelain are easily detectable because they were made with a different type of porcelain, and the test to tell the difference is very easy to do. Many of these soft-paste pieces are unmarked, but when they are, the mark itself can be a clue to age.

Chelsea is a famous English soft-paste factory, and between 1752 and 1756, they marked their pieces with an anchor painted in red. The original marks were tiny, less than a quarter inch in length. When these pieces were extensively reproduced in the late 19th and early 20th centuries, they were not only made in the wrong kind of porcelain (i.e., hard paste), but the red anchor mark was much, much too big. The fakers did not want anyone to miss the mark, so they made it big, and now it is an instant guidepost for appraisers/connoisseurs.

Many who are reading this information may think this sort of item never turns up, but it does. We find it in antique malls, we find it in box lots at auction, and we find it on dusty shelves in estates. We have found 18th-

century European porcelain in New York State; we have found it in Tennessee; we have found it in Florida; we have found it in Iowa; we have found it in Arizona. To be sure, it does not appear every day or every month, but it can be discovered almost anywhere at any time.

COMMONLY ENCOUNTERED FAKES
OF MORE RECENT VINTAGE

Most of us, however, are more concerned with judging the age of more recent pieces of pottery and porcelain. The marketplaces in the United States seem to be bursting at the seams with ersatz American art pottery, fraudulent R. S. Prussia, and imitation Nippon.

Separating new from old pottery is not difficult. All that is really required is that the appraiser be acquainted with what old examples look like, then the new production will jump out and scream *fake* every time it is encountered. This is because the colors are always wrong, the look of the surface is always wrong, and the quality is always wrong!

Fakes of American art pottery have been around for a very long time. In the mid-1970s, there were some excellent counterfeit pieces of Rookwood that were (and are) very hard to distinguish from old examples. Luckily, this production was somewhat limited, and to the best of our knowledge, only a small honey jug and a 9-inch vase were made. These were usually artist signed M.A.D. (for Matthew A. Daley), and the ones we have seen were painted with birds and dated 1899.

Reports are that they were made in both Italy and Japan. Unfortunately, we see these pieces for sale in antiques shops and shows from time to time and they are rather convincing. The best way to spot these fakes is by the decoration (birds soaring among clouds) and the artist's signature and date. This can be tricky, since similar genuine examples are known to exist.

One of the first things to do when examining a piece of American art pottery and trying to determine its age is to look at the mark, then check to

see exactly how the old marks should look. One focus should be on how the marks were applied. For example, new Grueby is often marked with a blue stamp that is a very good replica of the lotus-shaped original mark. But on old Grueby, the lotus with *Grueby Faience Co. Boston U.S.A.* is always impressed into the clay; the difference between old and new is readily apparent if you know that an inked stamp is always wrong.

Fulper pottery is also being reproduced, and again, the new mark is different from the old. The new logo is the word *Fulper* in a rectangle with 90-degree corners and the word *Tile* below. The word *Tile* never appears on old pieces, and the corners on the old mark are rounded.

Rookwood pottery has been reproduced in recent times. Some of the reproductions were made using the original molds and the original glaze formulas. The famous impressed RP mark surrounded by flames is found on these pieces, but original pieces have an impressed date below the RP mark in Roman numerals or no date at all on items made between 1886 and 1900. The recent production has the RP mark and the flames impressed into the bottom, but the date is in Arabic numbers (i.e., 1986 and so forth) and is engraved, not impressed.

Other Rookwood fakes have marks that look odd to anyone who is familiar with the marks on genuinely old pieces. For example, the flames above the RP are just straight lines on the fraudulent pieces, whereas they undulate a bit on real Rookwood. Also, fake Rookwood marks seldom have the precise, uniform look that is characteristic of the old mark.

Currently, the antiques market is flooded with Roseville art pottery that is being made in China. The marks on the new pottery differ slightly from the old, but this characteristic is not the big tip-off in our opinion. We can generally spot the new Roseville from across a large room because the colors are darker and muddier than the colors used on the originals (Helaine says the new colors are "yucky"-looking, and she has a point).

Almost every type of late-19th and early- to mid-20th-century American art pottery has been either faked or reproduced. To separate the old

from the new, all that is really necessary is that the appraiser be familiar with what old pieces really look like and know how genuine pieces were marked. It is also helpful to know that if someone has made a mold from an old piece and is using it to make replicas, the new pieces will be slightly smaller than the originals and the details will not be quite as sharp.

R. S. PRUSSIA

Ever since we can remember, unscrupulous individuals have been trying to rip off the public with older pieces that have had fake R. S. Prussia marks applied to their bases. When Joe first started out, he remembers that sheets of fake marks were being sold; all that was required was that one be applied to the bottom of an unmarked porcelain or pottery item and—according to some sources—baked in a household oven.

The mark itself looked fairly authentic, but it was generally placed on items that could not possibly be R. S. Prussia. It was also placed on top of the ceramic body (usually on top of an original glaze) where a simple scrape of a fingernail would pick up the edges of the mark and declare it a fake, since all genuine R. S. Prussia marks were applied under the glaze and a fingernail would slide across with no sensation of a change in texture.

One other easy clue to detecting fake R. S. Prussia is that most impostor pieces do not have a period after the word *Prussia,* whereas all genuine pieces do. This is not a hard-and-fast rule, but it does work a majority of the time and can be an easy way to eliminate a fraud.

THE PERILS OF RELYING TOO MUCH ON MARKS

We would like to mount our soapbox and preach for a moment on a subject that we have previously mentioned, but it requires reinforcement. In our brief discussion of detecting R. S. Prussia fakes, we emphasized analysis of marks, which we believe is useful as an adjunct means of detection, but it is not the main method of inspection that appraisers and connoisseurs should use.

It is critical that those who are seriously interested in learning about and evaluating art and antiques always keep in mind that marks and signatures are the *least* reliable way to judge the age and the origins of any piece. If you do not have a clue (and believe us, we often find ourselves in that situation), a mark or a signature may provide a *beginning* point, but ideally a mark or a signature should be used only as confirmation of identity and should never be the *only* piece of evidence on which an evaluation is based.

The only accurate way to assess any antique, piece of art, or collectible is to know what examples in the particular genre actually look like. To do this, you must consult texts on the subject, go to museums to see examples on display, and go to antiques shows and reputable auctions to view genuine items being offered for sale.

Handling as many genuine objects as possible is the surest and quickest way to understanding what genuine objects should look and feel like. Viewing in museums even without touching is also helpful, and reading about the items is indispensable. The point is that all that is really required to tell genuine R. S. Prussia from fake is to have seen and handled a number of genuine pieces and to have become very familiar with the subject by studying the set of books authored by Mary Gaston (see Part III).

This approach is nearly foolproof. Identifying marks are just presenting you with a shortcut that may yield a less than satisfactory result. Yes, we look for the period after *Prussia* in the mark; yes, we rub our thumbnail over the logo, but we also know what real R. S. Prussia should look like—and we know what the fakes look like because we have seen them for sale and we have seen them in the catalogs of the wholesalers who market them.

If the piece at hand happens to be unmarked—as many of them are—we know to go to Gaston's books to check for the shape, the mold configuration, and the decoration before making a judgment about whether a particular piece is genuine or fake.

NIPPON

Another type of porcelain that is widely collected is generally marked *Nippon*. This ware was made in Japan between 1891 and 1921, and it is marked. Under the McKinley Tariff Act of 1890, items exported to the United States had to be marked with the country of origin. In this case, Nippon was the Japanese name for their country, so it appeared on pieces made in that locale until the Treasury Department made them change to either *Japan* or *Made in Japan* in 1921.

Reproductions of Nippon have been around for a very long time, but historically the fakes have been easy to spot because they looked nothing like old pieces and they had marks on them that were never used on old pieces (most notably a mark composed of an upside-down wreath with an hourglass inside). In more recent times, however, some very convincing fakes have been made that are very close copies of old wares.

These pieces can be detected because they are not marked and they have gilding that is either much shinier than the original or marred by imperfections. In addition, the insides of vessels are not entirely glazed (i.e., covered with a glassy, smooth coating) the way the interiors of old examples would be, which can be a quick tip-off.

The helpful details in this chapter only touch the surface of how professionals determine age. Many connoisseurs who are primarily interested in such concepts as history and rarity may find this process sufficiently meets their needs, but it is generally not enough for appraisers and collectors who also want to understand an item's value. There are, however, many other variables that can affect this elusive notion of monetary worth.

Chapter 3

Reality Check: Factors That Add and Subtract Value

How much is it worth? is a much trickier and less straightforward question than it sounds. Monetary value can be expressed in dollars and cents, but sentimental value—which is sometimes the most significant standard of worth—cannot be calculated in any currency except that of the heart.

Sometimes items that might sell for less than $100 on the open market are "priceless" to the owner because they have become part of the very fabric of family life. We have, for example, seen sentiment enthrone a piece of bread carried by an ancestor during battles of the Civil War as a relic of incalculable worth. To the family, this piece of hardtack transcended the concept of dollars and cents—and, of course, it does.

Sentimental value can never be quantified in terms of money and it is foolish for anyone to try. All that can be done is to say that if a similar item were offered for sale, it would realize X amount in dollars, and that figure is usually very small in comparison to the emotional currency that has been invested in the item over a long period of time. This is truly a thankless task.

When determining monetary value, there are at least seven factors that can be influential. They can be the lucky seven or the unlucky seven, depending on how they happen to impact the particular object being

examined. The first and most important of these variables is condition. This is followed by quality of workmanship or artistry, rarity, current circumstances in the marketplace, whether a piece is by a known maker, provenance, and regionality. We proceed topic by topic and examine how each criterion may add or subtract value.

Condition

No one who has been interested in antiques for more than 5 minutes can be unaware of the role condition plays in the value of any antique. On our television show, *Treasures in Your Attic™*, we preach the importance of objects being in a pristine state of preservation like it was the nightly sermonette. Similar admonishments can be heard on every other television show devoted to collecting and in similarly focused magazines, newspapers, and radio shows. On most occasions, these discourses are very negative, because the focus seems always to be on how a chip, a crack, a rubbed paint job, a missing part, or a refinished surface (yes, in most cases, that is considered to be damage) has lowered or destroyed the value of what would otherwise be a fine and valuable object.

CONDITION AS A POSITIVE FACTOR

Earlier, we mentioned a Chippendale piecrust tea table that was bought in Florida for $1,000 and later sold in New York for over $1 million. We brought this up in conjunction with the idea that the person who bought the table got such a bargain because he was able to recognize what it was. What we did not dwell on was that the piece was in absolutely pristine condition, with its original finish, and that even its legs and feet had not been scarred by the careless use of a vacuum cleaner.

It is surmised that this perfect condition is the main reason why many

of the bidders in Florida passed it by. They felt that a 240-year-old table could not have survived in this condition and therefore was not of the period, so they did not aggressively bid on it. When it was resold, the next set of buyers knew that the table was genuine and a rare form, but it was the absolutely perfect condition that propelled the price over the $1 million mark.

Another example is Delft earthenware from the 16th, 17th, and 18th centuries (Delft spelled with a capital D was made in Holland; delft with a lowercase d was made in England). This ware has a very fragile body that is easily chipped or cracked, and the white tin glaze is prone to flaking. Over the centuries, examples of this kind of pottery often have sustained significant damage, so collectors have come to expect a certain amount of imperfection.

Buyers pay respectable dollars for significantly damaged pieces but will pay a premium for a perfect or near-perfect example. For instance, an early-18th-century English delft "blue dash" charger with the image of Adam and Eve standing on either side of the "Tree of Knowledge" might bring $2,000 or just a bit more, even if it has sustained major damage such as literally being broken in half and repaired. You may be thinking this is a lot of money for an earthenware plate that has been broken in half. It is, but an above-average example of an Adam and Eve charger with only minor chips and condition problems might fetch $10,000. However, if this item came up for sale in nearly pristine condition far above what collectors would expect to find, the price might be closer to $18,000!

CONDITION AS A NEGATIVE FACTOR

In the world of valuing art and antiques, condition can work for you, but more often than not it works against you. Right now a client of Helaine's has a rare mid-19th-century Minton pilgrim flask decorated in the delft manner. It is exquisitely painted in mid-18th-century style with an ideal-

ized landscape populated with a woman and her small child. There are no chips or cracks, but there is some minor paint flaking to the solid-color areas on the handles and lip, which does not affect the exquisite pictorial decoration in any way whatsoever.

In perfect condition, this rare, high-quality flask is worth over $1,000 at retail, but Helaine's client has not been able to get an offer above $25. Unfortunately, almost any kind of damage—even this easily repairable damage—can reduce the value of an antique by a significant amount.

Some kinds of damage, however, are more forgivable than others. In this example, paint flaking on ceramics scares the bejeebers out of collectors, and saying that a piece has a "slight case" of paint flaking is a bit like saying the dead man had a slight case of the Ebola virus.

CONDITION PROBLEMS WITH LIMITED IMPACT

On a piece of furniture, if the hardware on the drawer fronts has been replaced, collectors go "tut-tut" and think that it's a shame that the originals are no longer there. But the deduction in value is fairly minor and in the range of about 10 percent, or perhaps a bit more if the replacements are inappropriate or if the installation of the later hardware required significant alterations to the drawer fronts.

The reasoning here is that the hardware is prone to wear because it is in constant use, and it is a bit unusual for original hardware to have lasted for 200 years. Therefore, on furniture made before about 1830, replacement hardware is relatively common. Finding a piece with its original hardware is actually a plus factor when doing an evaluation.

Chair seats and upholstery are other areas where collectors expect to see replacements. The rule is that an upholstered chair seat that sees regular use needs to be replaced once every generation, which is about every 30 years. Few upholstered chairs that have survived for 100 years or more have their original seats, and few upholstered antique chairs are covered with

their original fabric. Thus, there is very little deduction (about 10 percent) for nonoriginal chair bottoms or replacement upholstery unless the replacements are poorly done or totally unattractive; then the decrease can be up to 40 percent.

Keep in mind, however, that an 18th- or early-19th-century chair with its original upholstery in decent condition will make a collector's heart flutter and that this can greatly increase the value of the chair on which it is found—especially if the upholstery is very fine quality or has handmade needlework decoration.

NEGATIVE ASPECTS OF REFINISHING

We hope everyone knows by now that removing an original finish from a piece of furniture can whack its value down by half or more. As appraisers, when we see a fine piece of furniture that has been "skinned" and a bright, shiny new finish put on the old carcass, we want to bow our heads and say a little prayer for the deceased.

Not long ago, Joe was in a home that had some wonderful New England antiques. Unfortunately, all the painted tin had been repainted (a big no-no) and many pieces of the old furniture had been refinished to a fare-thee-well. In the kitchen, however, Joe discovered an incredible circa 1760 dresser cupboard with its original red paint and original hardware. It took his breath away. The surface was marred and dirty, but it was largely intact, and it had a glorious warm and mellow appearance that eloquently spoke of 240 years of history. While Joe was gawking at this unexpected treasure, the owner asked if she should replace the hardware because one of the bail handles was missing.

The answer was immediate and emphatic: "Do not touch it! Leave it exactly the way it is and protect its surface because this is the most valuable piece you own." This came as something of a surprise to the owner, who was using the piece as a kitchen cabinet to store everything from bread and

cereal to spices, never dreaming that it was worth $30,000 to $35,000 largely because of its painted surface.

It should be kept in mind, however, that when the painted surface is not original, this can constitute a major deduction. Joe had a client who had a house full of Victorian furniture. Sadly, this individual fancied herself a "decorator" and had read in an interior design magazine that black lacquered finishes were fashionable, so she had most of her old pieces painted a shiny black. She was outraged when Joe told her that she had almost completely destroyed the value of her furniture not only because the finish was "wrong" for the pieces but because the black paint was virtually impossible to remove completely.

For wicker furniture, the natural wicker is the most desirable finish, and paint—especially paint that has been repeatedly applied—is a deduction. Nonoriginal paint on turn-of-the-20th-century oak furniture is also a deduction; this is one time when a careful removal will actually increase the value.

For old furniture, the original surface is integral to the value of the piece. Even on 20th-century objects such as the Arts and Crafts furniture made by Gustav Stickley, the destruction of the original finish is tragic. Most antique furniture with a degraded surface can be fixed with a simple cleaning or other nondestructive procedure that does not adversely affect the value. This kind of care should be attempted before more drastic (and destructive) measures are employed.

SILVER

Denting and pitting of the surface of old silver is always a big deduction, and monograms can be a serious problem as well. Collectors tend to like the fancy and flamboyant coats of arms that were impressively engraved on silver in days gone by. These are "monograms" for the nobility and they can increase the value of a piece of silver not only because the designs can be

very decorative but because they give the items provenance, which we discuss later in this chapter. Collectors also tend to forgive the smaller, less grand images of unicorns, deer, and other devices that were used by upper-crust houses (mainly English) as identifying marks on their silver for much the same reason.

As of this moment, however, collectors do not forgive the initials of lesser folk that commonly have been engraved in silver from the mid-18th century to this day. There has been an attempt in recent years to try to convince the public that these intertwined initials are decoration, but so far few collectors are buying into this point of view, and the presence of monograms is still considered to be a deduction.

Other factors that create a lessening of the value of silver are centered around the act of cleaning and polishing. We have already mentioned that seriously rubbed or obliterated marks are a big minus. We should add that silver that has been buffed to a high shine on a mechanical wheel or covered with a lacquer coating to keep it from tarnishing has also been "damaged" and the value reduced. Aggressive polishing that removes the dark areas that were put on when a silver item was being crafted to accent the design and give it depth lessens the value as well.

Glass

Damage to glass is generally fairly evident. Chips, cracks, and rubbed gilding are all easy to spot and are obvious deductions to varying degrees. The problem for the appraiser occurs when certain very hard-to-spot repairs have occurred. One of these might be a very shallow chip to the rim or lip of a vessel that has been removed by grinding down the lip or rim to create a smooth surface. If original gilding is not disturbed and if the height and proportions of the piece are not noticeably changed, such chips are hard to detect and do not significantly affect the value of the piece.

Detecting these repairs is not all that difficult in most cases. The orig-

inal rims and lips of most fine glass were fire-polished and very smooth, but this is a risky step to take when doing a repair, and most people who do this sort of work do not fire-polish. This means at the very least there should be some grinding marks and other telltale signs of the repair process.

One of the most insidious problems appraisers face when determining the actual condition of a piece of glass occurs in paperweights. These little globes of glass can be very valuable, but they were meant to be used, and sometimes the tops of their glass domes have become seriously scratched and cloudy. This, of course, is a huge deduction, but in many instances, attempts have been made to repair this defect by polishing the top. If it is done well and does not change the overall shape of the paperweight, it can greatly increase the value of a previously damaged piece. If it is done poorly and flattened surfaces are detectable, there is a major decrease in value.

POTTERY AND PORCELAIN

In most cases, collectors will accept nothing short of perfection in pottery and porcelain, but there are a few exceptions. In ancient Chinese ceramics, for example, a limited amount of damage is acceptable, especially if perfect examples are not available. In fact, rule #1 in the condition game is that if pieces in perfect condition are available, then any item that is in less than perfect condition is greatly devalued. But if perfect examples do not exist, then imperfect pieces are more highly regarded and acceptable to collectors.

Ancient Chinese ceramics made before the Song Dynasty (960–1279) are known primarily through archaeology, the accidental uncovering of grave sites during construction, and grave robbing by vandals. Since these pieces have been buried for more than 1,000 years, a certain amount of damage is expected due to chemicals in the soil, groundwater, earth movement, and other miscellaneous mishaps. The most valuable pieces are those that have suffered the least damage, and a very rare piece in extraordinary condition can fetch an extraordinary price. This same situation

applies to the ceramics of other ancient cultures such as the Incas, Aztecs, or Egyptians.

A modicum of damage can be somewhat excusable on some American utilitarian pottery made during the 18th and 19th centuries. On plain, undecorated (or sparsely decorated), run-of-the-mill examples, damage is deadly and can make one of these pieces practically worthless. But on finely decorated examples such as face jugs or stoneware storage jars decorated with rare and elaborate cobalt blue painting, a little damage (emphasis on the word *little*) will not deter a determined collector from paying significant dollars for a prime specimen, especially if that piece is perceived to be a fine, one-of-a-kind item.

On finer European porcelain, almost no damage is acceptable except for the loss of delicate protruding fingers, flower petals, and bits of ribbon on figure groups made during the 18th and early 19th centuries. Collectors call these "expected losses," and as long as they do not diminish the overall aesthetic appeal, the deduction for these tiny missing fragments is not all that great—but there is a deduction.

Appraisers should spend a great deal of time making careful inspections to make sure they have discovered *all* condition problems. This procedure can involve the use of magnifying glasses, flashlights, and black lights to aid trained eyes in viewing every detail with suspicion. We know appraisers who make use of fluoroscope and x-ray technology, and many times, this high-tech approach has paid off by revealing cleverly disguised damage.

Joe remembers buying an American art pottery vase with a rare painting of a cavalier. It was a wonderful buy at $800—in fact, it was too good to be true. Every inspection, however, failed to turn up any damage, until it was noticed that some of the brush strokes near the base ran in a different direction from the other brush strokes found on the piece. Further examination revealed that the vase had been drilled to be a lamp, and at a later time, the hole was artistically filled in and painted over with the intention of deceiving some unwary buyer.

The drilled hole reduced the value of the vase by one-half to two-thirds and turned a very desirable piece into a liability. Joe managed to get his money back by selling the vase to someone who loved the piece and did not mind the repaired hole. In the process, he learned the important lesson that damage can be insidious and can hide in plain sight. There is no such thing as being too wary when examining a piece for condition problems.

Quality of Workmanship or Artistry

It would be hard to overstate how important quality of workmanship or artistic merit is in adding value to an antique or work of art. For the appraiser, the collector, the antiques dealer, and the connoisseur being able to judge the intrinsic merit of an object is the crux of what they do.

Every artist or craftsman typically turns out work that is "average" for him or her, producing a transcendent "masterpiece" only every now and then. In a less lofty sense, many manufacturers make ordinary models, then they turn out a "deluxe" edition that takes good design and superior craftsmanship to the ultimate level achievable by the maker. Learning to distinguish between the ordinary and the extraordinary is the heart of connoisseurship and is central to making a decision about value.

METHODS OF EVALUATION

To evaluate aesthetic pluses and minuses, the person making the assessment must know what the standards of excellence are for the particular item being judged. This requires a great deal of very close study and hands-on experience. It may even take years before the eye and the mind are trained sufficiently to make this kind of evaluation with accuracy and confidence.

Unfortunately, being able to appreciate an object's artistic merit can be

difficult, because there are different criteria for every category of item being studied. If, for example, an appraiser encounters a jug in an estate and identifies it as a Turkish Islamic ceramic known as Iznik (after the place where it was made), he or she must be able to distinguish between a merely desirable specimen and one that has exceptional quality. This type of pottery usually has a color scheme of red, blue, green, and maybe black against a white background. The best examples are from the 16th and very early 17th centuries; as the 17th century progressed, the artistic quality declined dramatically because this colorful pottery was so popular that the potters took shortcuts to be able to fill all their orders.

The pieces with the most artistic merit should be elegantly potted. In the case of the jug being evaluated, the later piece will look almost exactly like its almost identical cousin on first glance, but it will be about an inch shorter, which makes it look a bit squatty.

The color palette of the best examples will be brilliant and very beautiful. The several shades of blue will be vibrant, and the background will be a warm, pure white. The colors on the later, far less desirable pieces will be less brilliant and sometimes even a bit muddy. On the later examples, the paint-ing will be less spontaneously done and may be lacking in style. The colors may also have run to one degree or another. If both jugs are in rela-tively perfect condition, the more artistically desirable jug from the late 16th or early 17th cen-tury should be valued at about $4,000, whereas the slightly later piece with the lesser artistic merit should be valued at approximately one-quarter that figure.

Iznik jug from 16th-century Turkey.

There are so many ins and outs in this evalu-ation process that it is very difficult for someone without a lot of experience and intense training to make these judgments with any reliability. It is

easy, for example, to find yourself trying to judge apples by comparing them to oranges. It is a terrible mistake to try to assess Asian art by Western standards, to judge American furniture of the 18th century by the standards of British furniture of the same era, or to evaluate the merits of a painting of one artist by the criteria of another who painted during the same period in a similar style.

It is important to understand the artistic merits within any category. For instance, any piece of Tiffany gold Favrile glass is much less desirable and far less valuable than an example of his much more artistically made reactive or laminated glass. Also, a Gorham Martelé tea set is always going to be far superior in workmanship and value to a production-line tea set of the same era with the same number of pieces. Martelé, incidentally, is Gorham's trade name for their highest-quality Art Nouveau–inspired silver that was made from metal that is purer silver than sterling (i.e., approximately 95 percent pure silver versus 92.5 percent for sterling). The name was taken from the French word for "hand-hammered," and each piece of Martelé was indeed handmade.

Along the same lines, an average Victorian sofa can be bought at retail for less than $2,000, but a top-of-the-line example by a superb craftsman such as John Henry Belter can bring a price 25 times that amount or more. Every category of antiques that can be thought of works like this, and when examining any object, the appraiser/connoisseur must be thinking about the role that artistry plays in the value of that particular item.

Always keep in mind that the best of the best can bring much higher prices than might be predicted through the application of logic and even market data research. These items are the "crown jewels" that every collector is seeking. There is often a willingness to pay whatever it takes to own this premier object and a sense that another one like it may not turn up in the near future. These factors can goad potential buyers into something very much like a feeding frenzy. In this situation, all the appraiser can do is carefully research the category and find any similar items that may have

sold in the recent past, then project that information forward into the current moment. It takes a little marketplace savvy to get this right. This intuitive knowing of what the market will do is learned only over time.

Rarity

Like condition, rarity is a two-edged sword that can work to increase the value of an object, but it can also work to decrease it. We will not belabor the obvious fact that rarity is an important factor in increasing the value of an antique. However, determining what is rare can be more difficult than might be supposed. Helaine remembers going to an auction where they were selling a collection of Grape and Cable carnival glass by Northwood. Helaine has little personal interest in carnival glass and she barely paid attention as a green tumbler sold for $50, a marigold sugar bowl sold for the same amount, and an amethyst cookie jar brought $350. She thought the cookie jar might have been a "good buy" (it wasn't; its retail value is only about $450), but then a green spittoon came up.

Helaine, who had become acclimatized to the undramatic bidding and the relatively low prices, was astonished when the bidding zoomed over the $3,000 mark and continued to climb. The bidding finally stopped at $7,500. Helaine later discovered that the spittoon is one of the few pieces in this pattern that is quite rare and very valuable.

The point here is that Helaine knew what Northwood Grape and Cable was, she knew that it is a commonly found pattern, and she knew that most of it sells below the $500 level. What she did not know and had to look up was which pieces among this large grouping were rare, because there is no way to know this information intuitively or to arrive at it through any kind of logical process. The information must be acquired through a reference source.

After doing her homework, Helaine discovered that among the 50-plus shapes found in Northwood Grape and Cable, only the spittoon, cup and saucer, tankard pitcher, whimsey hat pin holder, orange bowl with Blackberry interior, and ferner (i.e., a container designed to hold a fern or other houseplant) are considered to be rare forms. She also found out that other, more common shapes can become quite expensive when they are found in an unusual (i.e., rare) color. A good example is the small punch bowl and base, which is $350 when found in marigold, but in aqua opalescent, it reportedly sells for over $100,000!

RARITY AS A NEGATIVE

It may come as a surprise to some, but there are actually instances in which rarity can have a negative rather than a positive influence on value. This occurs when something is so rare and unusual that it is off the collecting "radarscope" and goes begging in the marketplace because it is not recognized for what it is. Perhaps this point is best illustrated by the story of a friend of ours who is quite an accomplished collector of American art. A few years ago, he found a framed piece that intrigued him. Within the frame there was a teardrop-shaped piece of fabric that had been decorated with an applied needlework image of a bewigged gentleman in late-18th-century costume.

Our friend is quite a researcher, so he attacked this piece with a vengeance and finally found something quite similar in a very old issue of *The Magazine Antiques* that was identified as a George Washington mourning epaulet worn at the time of our first president's demise in 1799. Using this information as a starting point, he soon found a collector of these mourning epaulets who was also a scholar in the field—maybe the only scholar in the field. An exchange of letters and photographs produced the results that the piece appeared to be genuine, but our friend wanted to know more and he wanted to know its value.

He asked the opinion of several Americana appraisers, who had no idea what this piece of cloth might be. The best opinion was that it was a pen wipe worth only a modest amount of money. The moral of this story is that an exceedingly rare object such as this George Washington mourning epaulet (and we believe that is what it is and that it is genuine) has significant value only if it is recognized for what it is—and sometimes that is far more difficult than it sounds.

In order for this piece to realize its full value, it must be offered to individuals who understand what it is, its historical importance, and its *rarity*. Everyone else—which is the vast majority of the collecting public—will think it is of small importance and worth $200 or less. This lack of recognition and the difficulty of finding the proper market where the item is appreciated is why extreme rarity can sometimes be a minus.

Current Circumstances in the Marketplace

There are many factors that can cause the prices of antiques to go up and down, ranging from the general state of the economy to changes in public taste. Sometimes the elements that suppress values can seem rather minor, but even such things as changes in the color palettes used in interior design can have a negative effect.

Many of us remember the time when avocado green was all the rage. It was so pervasive that it could be found on everything from refrigerators to toilet seats. When this hue fell from grace, it was as if there were an attempt to banish the color green from the house permanently. As a result, it became very hard to sell green glass, green ceramics, or any chair with a green fabric cover, and prices on these chromically challenged items became somewhat depressed.

In recent years, brown and orange have been out of favor, and there is no way to know how long this will last. To be sure, green eventually came

back into favor and reds and blues seem to be popular all the time, but there is no way of knowing what is actually *in* without paying very close attention to the current trends.

There was an article in the *Wall Street Journal* by Alexandra Peers, who was reporting on changing market conditions in early 2002. Ms. Peers began her article by saying, "Sorry, Ken. It's looking like Barbie, like many of us, has peaked at 40." She went on to report that the price of vintage Barbie dolls has declined by as much as two-thirds in recent auctions, and the prices of Hummel figures, Beanie Babies (no surprise there), and Bakelite jewelry have gone down as well.

This is no real surprise because the prices of antiques frequently fluctuate as a normal course of events. Last year's prices are not necessarily this year's prices, and any antiques appraiser or connoisseur interested in dollar values knows that only fresh data can be trusted. It is a distressing fact of life, but to a significant degree, fashion and fad control the prices in the art, antiques, and collectibles market.

Last, but certainly not least, another aspect that can adversely affect the value of antiques in the marketplace is the introduction of reproductions. Consumers feel very secure buying vintage items as long as there are no fakes and reproductions to cloud the authenticity issue, but as soon as new items appear for sale, doubts creep in and confidence—and prices—erode.

Whether a Piece Is Anonymous

There is a certain amount of rejoicing when a name, signature, or paper label is found on any antique or piece of art. The monetary value of a signature cannot be overestimated on a painting or piece of sculpture, and an authentic Tiffany signature on an article of glass, silver, or other metal ware is almost magical. Collectors can go into literal paroxysms of

joy over a signature on an 18th or early- to mid-19th-century piece of furniture, and an object that is supposed to be signed but is not can be suspect.

Anonymity is anathema to collectors, who want to know exactly who made a piece and when. The presence of signatures or identifying marks is so important to enhancing an object's value that these insignia have been faked ever since collecting became a popular hobby. In fact, there are far more fake marks and signatures out there than there are genuine ones. Appraisers should never take any kind of signature at face value.

In many cases, a false signature is placed on an item to misdirect the attention of potential buyers, but they can also misdirect the attention of some appraisers and connoisseurs. No mark should be taken at face value. If a piece has a Tiffany (glass and metals), Belter (furniture), Sevres (porcelain), or Bateman (silver) signature (among many others), it is essential to know what genuine examples look like before trying to decide whether the mark itself is genuine or spurious.

Genuine marks and signatures can enhance the value of an object by as much as 25 to 50 percent over an identical unmarked example. In some cases, however, the diminishment of the value of an unsigned piece is a little less spectacular. For example, collectors expect to find a certain amount of unmarked porcelain made by both the Schlegelmilch Company (R. S. Prussia) and Royal Bayreuth. Most experienced collectors who can identify the products of these particular companies on sight will devalue the unmarked specimens more in the range of 10 to 15 percent.

The lack of signature is more of a serious problem with other types of wares. It is not universally known, but some early Tiffany glass was not signed. This is a fairly rare occurrence, but the lack of a signature may mean that these pieces are not even identified as the work of this prominent and highly sought after studio. Only a true specialist can verify these unsigned pieces as being genuine Tiffany. Thus, a perfectly genuine but unsigned piece may not be properly recognized and subsequently may be

valued for far less than it is actually worth. In fact, the expectation that real Tiffany glass should be signed is so strong that it would be difficult to convince all but the most expert collectors in this field that a piece of unsigned Tiffany-type glass is actually the product of that company.

Provenance

One dictionary defines this word as merely meaning something's place of origin. It is derived from the Latin words meaning "to come forth," which is probably a little more illuminating for our purposes. To those interested in antiques, a provenance is a *provable* history of where a certain object has been.

The other day, Joe was sitting in his office when a telephone call came in from a young woman who wanted to know if the office chairs used by Orville and Wilbur Wright while they were building the first airplane in Dayton, Ohio, might have some extraordinary value. Taking a deep breath, Joe answered that they should—*but* only if it could be proven that these chairs had once belonged to these famous men.

When asked how she knew these were Orville and Wilbur's chairs, the woman replied that the knowledge was based on the memory of an elderly relative. There were no pictures, no letters, no inventories, and not a single shred of tangible evidence that these chairs once belonged to this famous aviation duo.

With conclusive proof, the chairs conjure up incredible images of the Wright brothers sitting in their office planning, arguing, dreaming, innovating as they create the invention that would change the world. Without proof, these chairs are just vintage office furniture that could have belonged to anybody.

The documentation needed to provide a reliable provenance can be a very elusive thing. Family history is absolutely unreliable unless it is supported

with the kind of evidence that might stand up in court. Sometimes, however, even written documentation cannot be taken at face value.

Helaine recalls looking at a mid-19th-century photograph case that had had its original picture removed. Inside there were several creamy-white threads and glued to the back was a note. It told the story of Martha Washington's death in 1802 and how her maid had removed several pieces of fringe from the bedspread that covered her deathbed, preserving them as a precious keepsake.

The paper, the penmanship, and the color of the ink all suggested that this note had been written in the last half of the 19th century sometime after Martha Washington's death. This raised the question of whether the information was correct or a family myth. This piece had been separated from its original family and there was no way to know who wrote this note or when. This written provenance was very intriguing, but the inability to substantiate it made it practically meaningless.

For this provenance to have been worthwhile, Helaine would have had to know the name of the family to which the piece had originally belonged, and, more importantly, the name of the woman who was supposedly Martha Washington's maid. Knowing this information, some further research could have been done to add more credibility to the written legend.

All kinds of associations related to provenance can add value to art and antiques. Items that once belonged to heads of state, movie stars, infamous criminals, literary figures, sports stars, and royalty can have significantly more value than similar items that once belonged to ordinary people. However, determining how much this increase might be can be very tricky.

The world was flabbergasted when the effects of Jacqueline Kennedy Onassis and Marilyn Monroe brought amounts of money that were far, far, far above expectations. This may be because these ladies were and are legends, the closest we have to modern goddesses, or because both were touched by romance and tragedy in an almost mythic way. The emotions of the potential buyers were whipped into a frenzy by media hype, and the desire to possess

some of Jackie's and Marilyn's personal effects was akin to the desire to own a veritable holy relic—and, as we all know, these can be very expensive.

When the personal property of the Duchess of Windsor was sold, the pieces brought prices that were more in line with expectations. These objects engendered images of opulence, exquisite good taste, royalty in exile, and a throne given up for love. Still, the Duchess was not quite as magical as Jackie or Marilyn, and the prices paid, for the most part, reflected more the actual value of the items than the hugely inflated worth of sacred objects.

When Barbra Streisand sold some of her possessions, the prices were fair, but they did not receive the big celebrity boost in price that an appraiser doing an evaluation might expect. The Streisand name and fame—luminary as it is—did not seem to add a great deal of dollar value to the proceeds (and the facts that the great performer was still alive and had sold items at auction before probably did not help much, either).

Most collectors run into provenance when they are at an auction and find a note in the catalog that reads "ex-collection of the Marquis of Hoity-toity," or some such. If the collector mentioned and his or her collection is relatively unknown to connoisseurs, the boost to value of this kind of provenance is probably negligible. But if it is a famous and important collection, and if the collector were regarded by the cognoscenti as having a measure of expertise and connoisseurship, such a provenance can add significantly to an object's value. Unfortunately, this kind of provenance can be rather transient.

Years ago, we were responsible for selling a collection of Orientalia that had been in storage for almost 60 years. Before going into this black hole, the collection had been on loan to a famous American midwestern museum, and the original owner had acquired the objects from a man who was considered to be the leading expert in the field in the 1920s.

The pieces had a world-beating provenance when they went into storage in the 1930s, but when they came out in the 1990s, nobody remembered the

collector or the impeccable reputation of the source from which these objects had been acquired. The museum no longer had the records of the loan. At this point, the once sterling provenance had become a mere footnote, which the buyers did not take it into account when making their purchases.

Regionality

We are often amazed at how important regionality is to the value of an antique. Sometimes this factor can combine with provenance to deliver a powerful one-two punch to value. An example might be the memorabilia associated with a U.S. president such as Andrew Johnson. Until Bill Clinton's impeachment hearings and the inevitable comparison to the impeachment of Lincoln's successor, Andrew Johnson was not exactly a household name.

To be sure, collectors of presidential autographs were interested in his signature and other presidential memorabilia, which included the tickets to his impeachment trial in the Senate. Normally, these tickets sell on the national market for less than $500 each if they are in pristine condition, but when some were sold recently in Johnson's hometown of Greeneville, Tennessee, they brought almost three times that amount. It is probably the only place in the world where this could have happened.

Appraisers need to keep in mind that items relating to local celebrities probably have more value in the celebrity's hometown or home region than anywhere else. In the same vein, locally produced art often has more value where it was produced than anywhere else, as does locally made pottery, furniture, textiles, silver, and glass.

A case in point might be the ubiquitous coin silver teaspoon. Those that were produced in great quantities from the late 18th century through the mid-19th can generally be bought for as little as $20, with few selling for more than $45. This holds true until a coin silver teaspoon that was made in a certain city is offered for sale in that city. When this happens,

the price can triple or quadruple, depending on how highly regarded the silversmith happens to be. This increase in value tends to be the biggest for silver made in southern cities such as New Orleans and Charleston and silver made in smaller urban areas. The increase is somewhat smaller for silver made in large urban areas in the northeast such as Boston, Philadelphia, and New York City unless the maker is an important one or the spoon happens to be especially rare.

Regionality plays an important role in pricing any antique or piece of art. What brings high prices in Iowa might bring a lesser value in Los Angeles, and what is hot in New York City may be cold as a stone in Houston. Appraisers have to know the strengths and weaknesses of their local market and they must always keep in mind what kinds of items might have a greater value somewhere else.

Helaine recently had to have a heart-to-heart talk with a client who owned a partial Victorian parlor set (a sofa and two side chairs) that could be attributed to New Jersey cabinetmaker John Jeliff. In the market where this set was located, Helaine explained that the pieces would not be recognized or appreciated for what they were and would sell for far less than they were worth. The three pieces had to be sold to settle an estate and the decision had to be made by the client whether to go to the trouble to send them to the best market. Helaine explained that if the client chose the easy way and sold the pieces locally, they would probably bring less than $2,000 total, but if he chose to sell the furniture elsewhere, he could probably realize four to five times that amount.

Size—The Eighth Factor

If there is an eighth factor that might add or subtract value to a piece of art or an antique, it would be size. Yes, size does count—and in this case, too big can be bad, and small can be good.

Monumentally sized objects do attract a certain group of collectors, but if a piece is too big to fit into the scale of a modern home, its value can be compromised. Vases that are 5 to 6 feet tall are hard to place in homes with average-sized rooms, and pieces of furniture over 10 feet tall will not fit under most modern ceilings.

Big can be bad in another sense as well. Joe remembers a wonderful but massive 19th-century iron safe that had a very decorative door hand-painted with a scenic design. It was up for sale at an auction, and when it brought less than $500, Joe wondered why it sold for so little until he saw the new owners trying to take it home.

After much sweating, grunting, and groaning, they finally managed to lever it from a loading dock onto a truck only to have the safe literally crush the truck's bed and fall to the ground, where it stayed for some time. At that point, Joe understood fully why the safe was so inexpensive—but when the new owners figured in truck repairs, it was not cheap anymore.

If big is not always a plus, small is usually looked on with favor. Small pieces of furniture demand a premium because they fit into modern spaces. Small accessories are in demand because they take up so little space and large numbers can be acquired before they run the collector out of house and home. Keep in mind that it has been said that few people collect refrigerators, because after acquiring five or six, who has room to display them?

Chapter 4

Opinions and the Marketplace: Why an Item Has More Than One Price

We receive calls all the time from people who are confused by the nomenclature or terms they hear on television antiques appraisal shows. Sometimes the appraiser evaluating the object under consideration will say the "auction value is . . . ," or the "retail value is . . . ," or the "insurance replacement value is . . . ," and it is hard for most laypeople to understand exactly what is meant by all the different terminology.

Auction Value

Two terms seldom if ever used by professional appraisers are *auction value* and *retail value.* Auction value is usually used by someone involved with a particular auction house, and it is a value that is so subjective to the person using it that the price given has very little meaning outside the confines of his or her business. That is, the person doing the evaluation is saying, "This is the price that I feel this object would bring at my auction." It has nothing to do with the actual value of the item and would vary widely from one auction house to another.

Retail Value

Retail is a concept that most of us understand because we customarily shop at retail for clothes, new furniture, and other household goods. Retail implies a sale of a single item or a small quantity of items to a member of the public by a vendor who has bought the goods from another source and has added a markup to make a profit. Something like this happens every day in the art and antiques business, but appraisers generally do not express values in this manner.

Insurance Replacement

Instead, if appraisers want to describe the highest value an antique might have, they speak of *insurance replacement value.* Quoting ourselves from our first book, *Treasures in Your Attic™*, we define insurance replacement value as "the amount of money it would take to replace a given item if it were lost, stolen, or extensively damaged in some sort of disaster. This is the amount of money it would cost for someone to go out, find a comparable replacement piece, and purchase it from a retail source in the most appropriate marketplace, within a limited amount of time."

Appropriate Marketplace

The term *appropriate marketplace* is very important in the definition of insurance replacement value because it can greatly influence the price one way or the other. If, for example, an appraisal is being made of a diamond bracelet that was made by and purchased at Tiffany's, the insurance

replacement value would be what it would cost to have this replaced with comparable stones and workmanship at Tiffany's, not at Crazy Joe's Bargain Basement Discount Jewelry Emporium. Tiffany was where the bracelet was purchased, so this company or a comparable high-end jewelry company is the appropriate marketplace for its replacement.

Fair Market Value

The next value scale that appraisers use quite often is called *fair market value*. The Internal Revenue Service defines it as "the price that property would sell for on the open market between a willing buyer and a willing seller, with neither being required to act, and both having reasonable knowledge of the relevant facts."

This standard is very important because it forms the basis for estate, charitable contribution, resale, and equitable distribution appraisals. Estate appraisals occur only when someone has died, and as a general rule, the fair market value standard used to do this kind of appraisal is figured on the low side (40 percent of insurance replacement) because many times these items have to be sold in a limited amount of time in order to close the estate. On rare occasions, appraisers will interpret the fair market value a bit lower if the property is located in some out-of-the-way place where it cannot be sold easily.

An equitable distribution appraisal is normally associated with a divorce, and here the fair market value must be calculated with scrupulous fairness so that it does not favor either party. It should go without saying that appraisers are to be independent, unbiased evaluators at all times; but in some instances, this is difficult because the appraiser is generally working for one spouse or the other, and appraisers are always ethically bound to represent the best interest of the client. In this case, however, the best

interest of the client in the long run is an *equitable* distribution, so the appraiser must ignore any blandishments by the client to bend the fair market value standard in his or her favor.

When appraisers prepare a charitable contribution appraisal, they customarily interpret the fair market value standard as liberally as possible and tend to evaluate items at about 60 percent of their insurance replacement value. As long as the stated value is defensible, this falls within the Internal Revenue Services' guidelines, which is the governmental body with primary interest in this kind of evaluation.

Cash Value

There are some who call the fair market value the *cash value,* and this is not quite correct. Properly, the cash value should be called the marketable cash value (or resale value), and it is fair market value *minus* the expenses of selling the item or items. The expenses might include commissions (which may run as high as 40 percent), advertising, and moving costs.

At this point we have seen how an object might have more than one value depending on the type of appraisal that is being done and that within fair market value there are at least three different values that can be legitimate and appropriate. Confused? We hope not, but hang on, things are about to become more complicated—but we will try to make them as clear as possible.

Approaches to Determining Valuation

There are three ways to approach an appraisal. Each method produces a different value number. Realistically, two of these approaches are used infrequently, and for the purposes of this book we might not have to mention them, but we want to give the entire picture as much as possible.

COMPARATIVE MARKET DATA

The comparative market data approach is the method that most antiques appraisers use 9.9 times out of 10. This method of determining the value of an object is based on past prices realized for similar works by the same artist or factory or by comparing prices of similar objects created by artists or factories with comparable reputations.

This is where the research discussed in Chapter 5 comes in so handy, but unfortunately it is never a good idea to find just one comparative price and then base your opinion on that single piece of information. It is always a good idea to consult as many sources as can be found and build a sort of "ring" or "ballpark" of values around the object being evaluated.

If, for example, you are trying to establish the insurance replacement value of a Tiffany art glass bowl, there are easily dozens of books and web sites that will provide prices for similar pieces. But the appraiser must examine each price that is reported and determine what it means and its relevance to the actual piece under consideration.

The first question to ask is: Where did this price come from? This is important because if it is a price obtained from an auction house (as the vast majority will be), the value quoted might be the fair market value, and then the appraiser has to decide how this relates to the insurance replacement value he or she is trying to establish.

Auction prices can be quirky, to say the very least. In years gone by, when antiques auctions were mainly attended by antiques dealers, the prices realized were generally considered to be wholesale and fair market value, but now the general public has become very much involved in auction buying and the notion that an auction price is a wholesale price has blurred to some extent. However, auction prices are still considered to be fair market value prices by definition.

When trying to determine the insurance replacement value, the weight that should be placed on auction prices depends on who was in

attendance the day the item or items were sold, how eager the bidders were to own the merchandise, the sophistication and knowledge level of the participants, and where the auction was held. Anyone who has been to a number of auctions knows that there are always objects that bring far more than they are worth and pieces that for one reason or another bring far less.

Seasoned professionals realize that an auction usually produces the fair market value of what the entire floor of antiques is worth as an average, with the high prices and low prices balancing each other out. The more prestigious auction houses try to avoid the lower prices by creating *reserves*, which are prices below which an item will not sell (i.e., if a painting's reserve is $100,000, it must bring that price or it is not sold).

This means that if an appraiser is looking at just one value from an auction, he or she must decide if the price obtained is too high, too low, or just right, which is sort of like Goldilocks evaluating the porridge at the three bears' house (this one is too hot, this one is too cold, this one is jusssssssst right). To deal with this, appraisers have to build a ballpark of prices, meaning they must look at a number of values of similar items in similar condition to see where the trend is or where the average is, and what a realistic fair market value should be.

After all the data are compared and a defensible fair market value is ascertained from the auction prices, the appraiser looking for the insurance replacement value now has a difficult judgment call to make that revolves around the issue of retail markup. We have said that, as a general rule, fair market value is 40 to 60 percent of insurance replacement value, but this is only a guideline.

After antiques dealers have bought at auction, they normally mark their purchases up anywhere from 25 percent to as much as 400 percent, depending on the price paid and the dealer's perception of what the market will bear. To decide what a realistic insurance replacement value should be on an object that has a fair market value obtained from auction results, the

appraiser or person doing the evaluation must have a through understanding of the retail antiques market.

This requires a close study of the prices found on the vast array of items in antiques shows and shops. Both of us learned our trade by sitting through hundreds of auctions, then shopping more antiques shows than we can remember, and checking prices in antiques shop after antiques shop (be wary of the prices found in antiques malls as they can be uneven, and, therefore, unreliable).

This process may sound very exhausting, and it is, but it is also the sort of activity that people interested in antiques do as a matter of course. Over the years, a data bank is built up in the head. When an object presents itself for evaluation, the person who has thoroughly done his or her homework will know approximately what the fair market and insurance replacement values should be almost at a glance.

Cost Approach

The cost approach is used to value objects by determining how much it would cost to duplicate or re-create an identical item. It is never used to evaluate art or antiques because no one wants their Rembrandt valued by figuring out how much the canvas and paint would cost and how much a competent artist would charge on an hourly basis to slap on an exact copy of the image.

However, occasionally, homes have items in them made by friends or relatives that are neither art nor antique by the accepted definitions of the terms. Currently, Joe has to appraise a house that is full of furniture built by the client's father in the mid-20th century. These items cannot be appraised by the comparative market data approach because there are simply no legitimate comparisons to make because these items cannot be compared to mid-20th-century manufactured pieces.

The only option left to Joe is to use the cost approach, and in all

likelihood, this will present a problem because the family treasures these items and describes them as being "very valuable family heirlooms." Joe will have to explain to them that although they are very valuable family heirlooms, their value is primarily sentimental, not monetary. He is expecting that this information will be received like a rubber gun in an airport.

INCOME APPROACH

The last method of valuing personal property is really a pip. Again, it is seldom used by most appraisers and is very hard to quantify. It is called the income approach and involves valuing art or other items by how much future income they will produce through renting, leasing, or reproduction.

What springs to mind are some of the pieces sold at the Jackie Kennedy auction—mainly some of the faux or costume jewelry. It was reported at the time that some of the pieces were bought for the express purpose of reproducing them and selling them in mass quantities to the public as the "Jackie Kennedy pearl necklace." From this point of view, it makes sense to buy a $25 piece of costume jewelry for $5,000 if you are confident that it could very well generate megabucks in revenue for years to come. In other words, if the value of the piece of jewelry is calculated from the revenue it will generate by using the income perspective, the value of our hypothetical necklace is not the $25 it would be worth if the same piece belonged to someone else or the $5,000 that was paid for it at auction but the (say) $500,000 it might produce in future sales.

It makes us dizzy thinking of how a $25 necklace could be worth $500,000, but this is a prime example of how an item can have more than one price depending on the circumstances and how the value is calculated.

Sleuthing: Doing the Research

We discussed throughout the first four chapters the importance of research and how it is the key to both knowledge and success in the world of antiques. This is certainly not our favorite part of the job, but doing research is actually not as difficult as many people suppose. It does, however, require perseverance, patience, and time. Regrettably, there are no shortcuts, no simple "pills" that can be taken to provide organically all the information the appraiser/connoisseur will need to understand and evaluate antiques.

The process of gaining knowledge and information is cumulative. It takes place over a time span that can last anywhere from weeks to years to a lifetime, depending on just how knowledgeable the student of art and antiques wants to be. Together we have been students for 50 years and we hope to be students 50 years from now if we are granted the time and the mental acuity.

It seems that every third telephone call we receive and every fourth letter that comes in the mail contains a plaintive complaint that the caller or correspondent has tried in vain to find some sort of information about a particular item that he or she owns. Many have tried the Internet and a few have tried their local libraries, but both locations have produced less than satisfactory results.

The letters and phone calls are usually characterized by frustration, and those who are seeking information from us sometimes see us as their last resort. They have asked around and done what they consider to be extensive research and have found little or nothing in the way of illuminating information. In many instances, they have come to feel that what they possess is so unique that no one will be able to provide any information whatsoever to answer their questions about history and value. It often comes as a great surprise when we, because of our decades of experience, can (in a majority of cases) produce an answer off the top of our heads or by taking a quick peek in our personal libraries.

We can provide information in these instances, but we know that this is not really enough. What our questioners need to know is *how* to find the answers, and this chapter is our opportunity to impart that information. There is an old proverb that says, "Give a person a fish and you provide food for a day, but teach a person to catch fish and you provide food for a lifetime." We propose to teach you how to fish for and catch information primarily at the library and on the Internet.

It has become fashionable in recent years to do what passes for research solely on the Internet, but this is really difficult for those who are searching for information without a factual foundation. Navigating the Internet can be like sailing through unknown seas without a compass unless you have some basic information before beginning the voyage. It is important, for example, to know what the object you are trying to research is called, how old it might be, and the material from which it is made.

When trying to find information about an unfamiliar object, neither of us would jump onto the Internet and just start surfing. We know that many people do, but as many thousands have told us, this is not likely to be productive. We first go to our individual libraries and begin to pull out books. If the object is furniture, we go to our furniture books; if it is glass, we go to our glass books; if it is silver, we go to our silver books. Then we explore

until we have a clue about the item we are trying to research so that we can begin to narrow our investigation.

Unfortunately, most people are not going to have a large enough personal library to make this kind of initial fact-finding mission meaningful. This makes a trip to the local public library or a local college or university library an absolute necessity, but many people find these institutions daunting and not user-friendly.

Library Research

Even we find card or online catalogs daunting, and to our minds, what is on the shelves seldom matches up to what is in the files. We have always found it more productive just to go to the shelves and see what is there. We always seem to find unexpected things such as books that do not seem to be in the catalogs (at least not where we looked), and these books are often very illuminating. We know that many who are reading this are thinking, "That is easy for you to say, you two have been doing this for years, but how do we know where to go and where to begin?" We understand this point of view, but in reality, library research is far easier than might be expected.

PUBLIC LIBRARIES

Most public libraries use the Dewey Decimal System, which was invented by Melvil Dewey in 1871 and first published in 1876. It is still used in more than 90 percent of all public libraries, 25 percent of university libraries, and 20 percent of all special libraries. To use it effectively, all a researcher needs to know is that most of the books he or she is looking for will be in the 700 section, which is dedicated to The Arts: Fine and Decorative Arts.

We will not belabor this, but if you are looking for information on

antique ceramics, all you have to do is go to the 738 section and begin to browse. For example, porcelain is 738.2, and earthenware and stoneware is 738.3. If coins are the focus of the research, go to 737; clocks, 739.3; jewelry, 739.27; antiques in general, 745.1; toys, 745.592; glassware, 748.2; furniture, 749.

The Dewey Decimal system really is as simple and straightforward as it sounds, and once the appropriate section is found, there will often be a vast array of books from which to choose. If you are clueless, pull down a selection of 6 to 10 books and begin perusing them for photographs of something similar to the object that is being investigated. Once this has been done, the search for answers can be refined, and specific books can be selected from the shelves to provide more focused information. Interestingly, this process of skimming through a number of books can be a very important part of building a basic education about antiques in general.

While browsing through a selection of books and looking for nuggets of information to illuminate a specific item's origins and value, the researcher unavoidably begins to learn what related items in the field look like. This can be a very important bonus. If, for example, the piece under scrutiny is a piece of English porcelain, the quick exploration of a half-dozen books will inevitably provide some idea about what the entire category of English porcelain looks like. This may come in very handy at a later date, because the next time research must be done on English porcelain, the issue of where and how to begin will not be such a mystery.

Certainly, this process can be very time-consuming, but it can be well worth the time spent. Library research can be far more productive and much quicker than floundering on the Internet, going to site after site that appears to be promising but does not deliver the needed information. To be sure, sitting at home and navigating the Internet may be more comfortable and convenient, but it generally is also less productive.

Joe says that he has never read a book—or even skimmed a book, for

that matter—that has not made him money. He remembers getting a new price guide and skimming through it looking at the pictures. During this process, he noticed a kind of glass with which he was previously unfamiliar. Within the week, he had stumbled on a piece in an antiques mall that was like the one pictured in the book. It was priced at about 5 percent of its reported value, and, of course, he bought it. That transaction handsomely paid for both the book and the time he had spent glancing through it.

COLLEGE OR UNIVERSITY LIBRARIES

Up to now, we have been discussing using a public library, but many towns have college and university libraries that can be used by the public. Oftentimes, these libraries allow those not directly connected to the educational institution to check out books, but almost always, a fee is charged to join the library. This fee is usually fairly modest ($75–$125) and can be money that is very well spent.

Most university libraries use the Library of Congress classification system, which is nothing like the Dewey Decimal, but it is just as easy to use. Instead of a series of numbers, the Library of Congress System uses letters of the alphabet paired with numbers, and most people interested in antiques need never stray outside the NK section, which is the area devoted entirely to the decorative arts.

When you are in this section, it is rather like being in your own private antiques library, just as it is when you are in the 700 stack of a library that uses the Dewey Decimal System. In the Library of Congress System, if you are interested in furniture, go to NK2200 through NK2750, glass can be found in NK5100 through NK5440, and ceramics in NK3700 through NK4695.

If the goal is to research a piece of art, there is a slightly different destination involved in both commonly used library classification systems. For

the Library of Congress, information about paintings is located in ND, prints in NE, and sculpture in NB. The Dewey Decimal System puts paintings in 750, prints in 760, and sculpture in 730.

LIBRARIANS

If you get lost and do not want to thumb through a card catalog or try to navigate an online directory, there is always the librarian. These individuals are bloodhounds of knowledge and will guide you gladly. If you need a point or even a push in the right direction, a librarian will devote as much time as possible to helping you find the required information. Never hesitate to ask, because a librarian can facilitate a search as no other resource can.

Librarians are particularly valuable assets in the reference department of a library where books are kept entirely for reference purposes and are not allowed to circulate. This is usually the place to begin a search if the item being evaluated is a painting, a coin, or a stamp. Just walk up to the reference librarian and tell him or her what you are trying to do. The response will be instantaneous and the librarian will take you right to the books you need, show you how to use them, and tell you the type of information that can be found.

ADDITIONAL LIBRARY RESEARCH SOURCES

Libraries offer a variety of services that can be very helpful to individuals trying to do research. One of the most valuable of these services is the interlibrary loan system. Books on antiques are like comets: they are around for a relatively short time, then they go out of print and disappear—sometimes forever. This can make some very valuable resources very difficult to find, and many times a local public library or a even a university library may not have the specific book that is required.

Most libraries have an interlibrary loan desk or department. The personnel will find out which libraries have the book that is needed, then get it for the researcher within a short period of time. Sometimes there is a charge for this service, but it usually amounts to the cost of postage, which is a very small price to pay for invaluable knowledge.

READER'S GUIDE TO PERIODICAL LITERATURE

In the reference room a researcher will find the *Reader's Guide to Periodical Literature,* which can offer a road map to a gold mine of information. Listed by subject, these books survey the incredible range of topics covered in periodicals over a year's time. Many libraries will have actual copies of the periodicals referenced, and in other cases, they will be on microfilm. A microfilm reader is not all that hard to use (Helaine hates them because she gets motion sickness as the pages whiz by and says she will use one only as a last resort). Again, in the case of microfilm, the librarian will find what you want and may load the spool containing the information into a viewer. All you have to do is turn the crank, read, and learn.

This foray to the library should provide basic information about the item being researched. At this point, the person doing the investigation has two basic choices: either continue delving deeper in the library or look for the subject on the Internet.

Internet Research

Hopefully, the search through the library will yield information that will help in navigating the Internet. At the very least, it should indicate areas for search and key words that might prompt a profitable response. Always keep in mind that the more precise you are in entering search words, the better the information you will retrieve.

At the present time, the Internet is not all that it is cracked up to be for novice users, especially if all that is being done is throwing random key words and phrases out into the electronic vortex. This often leads nowhere and can be extremely frustrating. It can also produce misleading or erroneous results.

We do not wish to sound unnecessarily negative about the Internet, and we feel that the future possibilities of this resource are endless and beyond our perception. In fact, in the not too distant future, the contents of entire libraries should be available on the Internet for free use by anyone with access to a computer. When that day comes, it will be a great boon to researchers everywhere, but that day is not here yet.

Before continuing, it is important to make it clear that we mention a number of web sites that we feel are useful in various and sundry situations, but unfortunately web sites are often transient and can disappear just as quickly as they appear. This is the latest information available at the time we are writing, and we can only hope these sites will be around for years to come.

Most general searches on the web involve typing in a key word or phrase into a search field. Search engines (Google, Yahoo, Alta Vista, AOL Search, to name a few) typically index important words in a text such as titles, subtitles, headings, subheadings, and, in many cases, every word in the first 20 lines except commonly occurring words such as *a, an, and, the, is, or,* and so forth. Some so-called full-text indexing systems will index every word in a document, which means that if the person doing the research types in a word such as *sofa, chair,* or *glass vase,* he or she will get a scad of hits, but few of them will be to the point or very helpful.

Some computer search engines, such as Excite, use concept-based searching, which finds information based on strings of words that are about the subject being investigated. The search field might read something like "Nineteenth-century art glass, handblown, heat shaded, Burmese, Peach Blow, Peach Bloom, Amberina," which should produce

documents on this very specific subject. Again, to search efficiently, it is helpful to start in the library to know how to formulate a request for a search.

We are not going to delve into the mechanics of doing an Internet search because that can be far too complicated and is sure to put each and every reader to sleep. However, there are good guides available at http://www.lib.berkeley.edu/Teachinglib/Guides/Internet/Strategies.html or http://www.monash.com/spidap4.html. (The last period is punctuation, not part of the address.) In addition, Helaine found a useful book entitled *Art Information and the Internet, How to Find It, How to Use It*, by Lois Swan Jones, published by Oryx Press, and available from Gordon's Art Reference, 306 West Colorado Road, Phoenix, Arizona 85003; 1-800-892-4622 ($45 plus $4 shipping).

There are many times when the Internet can provide important information not available anywhere else. Not long ago, we were answering a letter from a woman who owned a credenza made by the Union Furniture Company of Jamestown, New York. The cabinet was very beautiful and was decorated in the Chinese manner with a black lacquer background and exquisitely detailed gold birds of prey flying among tree branches.

Upon consulting our libraries, we found there was indeed a Union Furniture Company in Jamestown, New York, but that was all the information available from printed sources. Without much hope of gaining additional information, Joe did a quick search on the Internet and got a list of some sites that seemed to have nothing to do with the company being investigated. One of the sites referred to a biography of Roger Tory Peterson (1908–1996), who was a famous artist, naturalist, and author of the very influential *Peterson's Field Guide to the Birds of Eastern and Central North America*. Joe has no idea why he read this biography, but near the bottom was the line, "At age 17, he went to work at the Union Furniture Factory in Jamestown, where he decorated Chinese lacquer cabinets."

We did not know whether to yell "Bingo!" or "Eureka!" but we felt we

had hit the information jackpot! This kind of quickly found, positive result on the Intenet is a bit serendipitous, but because it could only have happened on the Internet, it is an excellent reason for consulting the web when doing difficult research.

In preparing site information, we had a list of hundreds of web sites that might be useful in researching antiques. We spent several days plugging in web addresses and finding that for the most part what came up was absolutely useless. As an example, Joe logged onto a free site that bills itself as the "#1 question and answer site on the Internet" and "has held the #1 Antique Expert position longer than any expert." That sounded great, but when Joe looked at the answers to previous questions, he found they were fairly information-free. Of course, the big problem was that most of the questions being asked were so vague that only a truly gifted mind reader could have supplied answers that were even remotely useful. Every now and then, however, we did come up with a jewel that in certain instances could be very helpful. Unfortunately (from many people's point of view), most of the really worthwhile sites charge for their services and have to be joined.

We were recently introduced to a site that can be reached at www. curioscape.com. This site has been around since 1996 and currently contains a list of about 15,000 other sites that deal with antiques and collectibles. It ranks each site using input from users, and it allows searches by categories. In addition, it is a great place to find new sites that are just making their appearance on the web.

More times than not, the person trying to do research on the Internet finds what appears to be a really good site, then discovers that money must change hands before useful information will be dispensed. Not long ago, Joe was looking for information about an American artist and found a site called AskArt.com that looked like it might answer all of his questions. It offered both biographical information and auction prices, but when it got down to specifics about these important topics, the site required that the

researcher join for $19.50 per month or $9.50 for a 24-hour period. If you have a lot of art to research or if you research all the time (as we do), this is not a bad price, but few nonprofessionals are willing to pay. Most people want the information for free, which is understandable, but if you want free (in most instances), go to the public library!

There are a number of online art and antiques services designed for the professional appraiser, but they can be very expensive indeed. ArtFact.com bills itself as the world's largest online research tool of auction sales results for decorative arts, fine arts, and jewelry. This site provides serious information, but it also charges serious money. An annual subscription is $1,188, which allows for unlimited access to the site. Many consider it to be the best source of information. It is used by libraries, professional appraisers, and, perhaps most importantly in some instances, the Internal Revenue Service.

A less pricey Internet service might be Artnet.com, which is a fine-art auctions database claiming to have the most comprehensive illustrated electronic archives of fine-art auction records in the world. Individuals can conduct up to 9 searches a month for $29.95. The professional is charged $79.95 per month for up to 29 searches and corporations pay $199.95 for up to 79 searches.

Still another service claiming to have the world's largest data bank of art prices is Artprice.com. The fees to work on this site are $20 for 20 hits, $50 for 60 hits, and the price goes up from there to $500 for 1,000 hits. Since this company is French based, the customer's account is billed in euros for the equivalent of the dollar purchase.

For the most part, the information found on these sites is also available in book form, but these volumes can be very expensive. In addition, the data in the books tend to be a little older than the prices found on the best Internet sites such as ArtFact, Artnet, and Artprice.

As we have said—but it bears repeating—good free sites are really hard to find, but one that both of us love is the site for Advance Book Exchange,

www.abebooks.com. On this useful site, you type in the name of a book
and its author, and many more times than not, out will come a list of books
with this title and author that are for sale by various vendors. Also, in many
instances it will supply the year of the first edition, the condition, and the
retail price being asked. This is great for two reasons: first, it helps people
who are curious about the worth of a book they own; second, it is a quick
way to find and purchase a book—particularly an antiques reference
book—that is hard to locate or is out of print. Helaine feels that a similar
site, Bookfinder.com, is also very useful.

Some sites are helpful because they offer links to other sites that might be
promising. We just explored Ashop4antiques.com (try www.shop4antiques.
com/misc/research). It is a really interesting site with links that will take the
researcher to such places as the Antiques Roadshow, About.com, Kaleden
Online Price Guide, Schroeder's Antiques Price Guide on Line, and Whats-
ItWorthToYou.com, among others.

At first glance, we felt that a careful exploration of About.com might
be useful because it offers a variety of online price guides. Unfortunately,
our cursory exploration revealed that most of these guides were less than
helpful—but that is to be expected, especially if the researcher is looking
for very specific information. We did, however, find a valuable kernel or
two on several subjects including Irish Belleek, and we feel this site does
warrant further examination.

While we were surfing through the various links, we went to the
Schroeder's Price Guide site with great anticipation, only to find that it
costs $14.95 to join for a year. This fee gives the researcher access to prices
from Schroeder's last five editions covering 500 subjects and 200,000
items. We were a bit concerned because 3-, 4-, and 5-year-old prices can be
way out-of-date, but if this factor is taken into account, it might be a valu-
able resource.

It should also be mentioned that Ralph and Terry Kovel have an online

price guide that can be reached at <u>Kovels.com</u>. We found a plethora of information. Basically the guide is arranged alphabetically by category, and when we selected letter A, dozens of topics appeared. After we selected a topic, descriptive details about the items came up, and there was a large range of objects with a notation of the year in which the prices of these pieces were obtained. We thought that was excellent. However, to get the prices, you have to join the site, and although it was clearly stated that joining was absolutely free, we chose not to take this step. In all likelihood, Joe will join in the near future because he feels this will be a very useful resource.

AUCTION HOUSES

Some of the sites we found most informative—or at least interesting to explore—were the ones belonging to auction houses. These often included a photograph-rich catalog of the company's upcoming sales, with estimated prices. In many cases, they were instructive and potentially useful for two purposes. First, an exploration of one of these catalogs might reveal valuable information about an item being researched. Second, for those who want to sell an item, the catalogs have the potential to provide an idea about who to contact to accomplish this goal. Some of the auction house sites that might be most informative include:

- Butterfield's, 220 San Bruno Avenue, San Francisco, California; 1-415-861-7500; <u>www.butterfields.com</u>.
- Christie's, 20 Rockerfeller Plaza, New York, New York 10020; 1-212-636-2000; <u>www.christies.com</u>.
- Doyle, 175 East 87th Street, New York, New York 10128; 1-212-427-2730; <u>www.doylenewyork.com</u>.
- Garth's Auctions, 2690 Stratford Road, P.O. Box 369, Delaware, Ohio 43015; 1-614-362-4771; <u>www.garths.com</u>.

- Neal Auction Company, 4038 Magazine Street, New Orleans, Louisiana 70115; 1-504-899-5329; www.nealauctions.com.
- Northeast Auctions, 93 Pleasant Street, Portsmouth, New Hampshire 03801; 1-603-433-8400; www.northeastauctions.com.
- Phillips de Pury & Luxembourg, 3 West 57th Street, New York, New York 10019; 1-212-570-4830; www.phillips-auctions.com.
- Rago Auctions, 333 North Main Street, Lambertville, New Jersey 08530; 1-609-397-9674; www.ragoarts.com.
- Skinner's, 357 Main Street, Bolton, Massachusetts 01740; 1-978-779-6341; www.skinnerinc.com.
- Sloan's, 4920 Wyaconda Road, North Bethesda, Maryland 20852; 1-301-468-4911; www.sloanauction.com.
- Sotheby's, 1334 York Avenue, New York, New York 10021; 1-800-444-3709; www.sothebys.com.
- Treadway Gallery Inc., 2029 Madison Road, Cincinnati, Ohio 45208; 1-513-321-6742; www.treadwaygallery.com.

One of the best ways to find auction companies in a specific location is to access net-auctions.com/links1. This will produce (at least it did for us) a list of 880 auction companies arranged by state. To be sure, many of these were real estate, livestock, automobile, or even boat and marine equipment auctioneers, but there were plenty of art and antiques auctioneers listed as well.

Some of the best-known auction companies such as Christie's, Sotheby's, Skinner's, Butterfield's, and others can be invaluable for those who want to sell an item and have a digital camera. To be sure, the item should be a classic antique, collectible, or work of art and the owner should have reason to believe that the value would be approximately $2,000 or more.

There is absolutely no reason to send photographs of flotsam and jetsam

to one of these upscale auction sites because they will not provide useful information except to say that they do not deal with this level of merchandise. They also do not offer free appraisals online, but on receipt of good pictures of better-quality items, they will supply information as to what they feel the items are and how much they would bring at their auction.

To close our brief discussion of researching antiques online, we want to mention an idea that we have found on the web in several places. There is a suggestion that profitable research can be done by perusing the items being offered for sale on eBay.com. We are frankly horrified by this thought, but this statement should not be interpreted to mean that we do not like eBay.

e B A Y

There is no question that eBay is a boon to those who want to buy and sell—in fact, for the millions of people who use it each day, it is the greatest invention since the internal combustion engine. *But*, eBay is for buying and selling, not for doing research to find out what an antique or piece of art is and what it might be worth.

When we cruise through eBay, we sometimes laugh at the misinformation that is found in many of the ads, but there are other times when we gasp in disbelief because we are shocked at some of the more outrageous statements. We realize that many of the sellers on eBay are very savvy about their merchandise, but there is also a significant percentage of eBay sellers who have no real knowledge about antiques or what they are selling! This can lead to some very interesting claims. Those who are seeking information on eBay or any similar site must keep in mind that what they are reading in the item descriptions may not be 100 percent factual. *Caveat emptor*, or buyer beware! (as Helaine loves to say).

Museums

Museums are another place to do productive research. Most people visit a museum and walk through the public galleries absorbing the beauty, and, occasionally, the information, but there is another way to get a more up-close and personal experience that can be very valuable.

There are many museums throughout the United States that have study collections that can be viewed and even handled under certain circumstances. Some—for example, the Metropolitan Museum of Art in New York City and the Toledo Museum of Art in Toledo, Ohio—have placed many of their items that were formerly in storage in glass-shelved cases, making them available for study whenever the museum is open.

Not too many years ago, Joe remembers not knowing what a museum study collection was or how one might be used. He had wandered through the Toledo Museum of Art looking at their superb collection of American glass, and toward the end of his meandering, he saw a sign directing museum goers to the glass study collection. Not knowing what that was and curious as a child on Christmas morning, Joe went down the hall to explore.

He walked through the door and was immediately confronted with case after case laden with numerous pieces of American glass—in fact, there seemed to be far more pieces of glass in the study collection than there were on display elsewhere in the museum. It was a veritable wonderland of antique glass, and there was a great deal of information on each piece. This made the visit to the museum a very educational afternoon indeed.

The question arises, however, of how someone doing research might get a more hands-on experience and actually be allowed to touch a piece (or pieces). We asked the Toledo Museum of Art if this could be done. We were told that although it was not out of the question, it is an experi-

ence that is usually not made available to the general public for a couple of reasons. First (and most importantly), there are security concerns. Does the person who is going to be handling the piece know how to do it properly? Is the person responsible enough not to damage the item? Does the person making the request have a legitimate scholarly reason to do so or is it just idle curiosity—or worse, a plan to grab a valuable item and make a dash for the door. Second, frivolous requests tie up professional staff for long and unproductive periods of time. Absolutely no one is allowed to examine a piece physically without a curator present.

The people we spoke with at the Toledo Museum of Art treated our request for information with great kindness and promptness. They explained to us that a request for a physical examination of a piece (or pieces) in the study collection needed to be made through the museum's registrar's office, which can be reached by telephoning 1-419-255-8000 or 1-800-644-6862. In general, we were told that the person making the request needed to be an academic, a professional appraiser, or someone with similar credentials. But we also got the impression (and this may be subjective on our part) that a carefully thought-out application from a responsible private individual who would be able to give good, cogent reasons for actually needing to handle an object might be considered favorably.

The following list contains some of the museums across the nation that have study collections and the focus of those collections:

- American Folk Art Museum, New York, New York: American folk art
- The Henry Francis DuPont Winterthur Museum, Winterthur, Delaware: American furniture and decorative arts
- The Bayou Bend Collection, Houston, Texas: American furniture and decorative arts
- Shelburne Museum, Shelburne, Vermont: American furniture and decorative arts

- Art Institute of Chicago, Chicago, Illinois: American paintings
- Museum of Fine Arts, Boston, Massachusetts: American paintings
- Corning Museum of Glass, Corning, New York: glass
- Museum of International Folk Art, Santa Fe, New Mexico: international folk art
- The Philadelphia Museum of Art, Philadelphia, Pennsylvania: American furniture and decorative arts
- Samuel Kirk Museum, Baltimore, Maryland: silver
- Silver Museum, Meriden, Connecticut: silver
- Virginia Museum of Fine Arts, Richmond, Virginia: 20th-century decorative arts
- Mystic Seaport Museum, Mystic, Connecticut: whaling and scrimshaw
- Allentown Art Museum, Allentown, Pennsylvania: costumes and textiles
- American Textile History Museum, Lowell, Massachusetts: costumes and textiles
- Asian Art Museum, San Francisco, California: costumes and textiles
- George Eastman House, Rochester, New York: photographs

These are just a few of the museums that might be helpful to those who are interested in learning more about specific categories of art or antiques. Those who live near a museum not on this very abbreviated list should call the institution and ask if they have a study collection, what it contains, and how a member of the public may gain access.

Helaine hastens to add that almost every museum has items in storage, and someone who is researching a specific topic or item may be able to make an appointment with a museum curator, which may lead to the limited ability to view stored items. This type of meeting usually requires

preplanning and an email or letter request. Most museums are publicly funded, so they need to be responsive to requests from responsible individuals.

Do not expect curators or other museum personnel to discuss any kind of monetary value, because they will not, and, according to most museum rules, cannot. Generally, these professional individuals view such requests and the people who make them with some disdain. This is because their entire focus is on aesthetic or historic value, not on dollars and cents.

Antiques Shows

One of the best venues to research antiques in general is an antiques show. These events are excellent for learning what is on the market and at what price. These are so important that it is worthwhile to drive 200 miles to see a good one, and no person interested in learning about antiques or about how to value them should miss one.

Every booth in every antiques show is attended by a person who should know what he or she is selling, and if you approach them properly and at an appropriate time, these sellers can provide a world of information. It is never a good idea to use an antiques show as a research tool at the beginning or end of the event. At the opening of a show, sales can be brisk and dealers want to concentrate on the reason they came—to sell and to make money; and at the closing of a show, the vendors are thinking about packing up and going home, which can be a very arduous and tiring task.

Pick a time when business is slack to try to add to your personal antiques database. Helaine suggests taking a camera to an antiques show, and upon finding an interesting object, ask permission to take a photograph. Permission will not always be forthcoming, but if you are pleasant and show an interest in the item, the dealer may supply valuable information. Antiques dealers are proud of their stock and are often glad to tell all

about their prized possessions if the person making the inquiry shows the proper appreciation.

We recommend that this practice be done only at better antiques shows, because at lesser ones, the information may not be very reliable. This is also a process that should only be attempted with extreme caution at flea markets or antiques malls. The information gained there may be unreliable because, in many cases, the sellers in these places can be as much in the dark as you are. Of course, there are many very knowledgeable dealers who have booths at flea markets and antiques malls, but finding one at random may be chancy.

As we said in the last chapter—and this really bears repeating—any information that is gathered by talking to antiques dealers or from any other oral source needs to be checked out thoroughly. The job of building an accurate antiques database in the mind is difficult. Each piece of information must be verified before it is input in the memory bank. To do otherwise is to risk filling your head with myths, legends, half-truths, and misconceptions that can do more harm than good.

Mentoring

In the beginning of their learning process, many people try to find a mentor, who is usually a seasoned collector or an antiques dealer. This kind of mentoring frequently starts with a social relationship with someone who has been interested in art and antiques for years or with a business arrangement in which the budding enthusiast buys things from a dealer and asks for information about age and origin.

This relationship in any of its forms can be extremely important to the beginning appraiser/connoisseur, but again, the information received must not be taken at face value. Joe had a mentor who was a very knowledgeable antiques dealer. The two of them had long discussions about the relative

merits of the things the dealer was selling, and Joe began to learn the basics of evaluating antiques.

Joe had great respect for this lady (and still does), but he never let the learning process end when he left his mentor's place of business. He always did his homework; and on most occasions, he found that his mentor was correct with the information she provided, but once in a while, he discovered that she was incorrect. It was a great day for Joe when he realized that he could talk with his mentor as an equal and that he actually had begun to surpass her in his knowledge of art and antiques.

Auctions

Another place to do the kind of "research" that is critical to the antiques learning process is auctions. Often these marketplaces are the venues where antiques and art make their debut, or their entrance into the world, but they can also be primary schools for those who are interested in learning about these types of objects.

Let us warn you. If the auctions close at hand are smaller auctions (sometimes called country auctions) that do not catalog what they are selling, do not be unduly influenced by what is being said about these items. Do not accept everything the auctioneer says as being true—not because he or she is trying to deceive but because his or her knowledge about art and antiques may be very sketchy. Do not always believe what the audience members might be saying, either, because their knowledge might be less than adequate as well, and they may have a desire to deceive in order to get a better price on what they want to buy. Instead, the best course of action is just to observe and soak in what the various buyers and sellers actually *do!*

Larger auction houses that do produce catalogs and describe what they are selling in writing are a little different. They usually have a professional staff that examines objects and prepares descriptions that are fairly accurate

for the most part. Certainly, the information dispensed by these larger auction companies cannot be taken as holy writ because even here mistakes do happen. As a general rule, however, it is reasonably reliable.

Before an auction begins, there is always a preview in which an inspection of each item is permitted and encouraged. This is a splendid opportunity to handle an enormous variety of objects, some of which can be very fine and expensive. It is the perfect opportunity to open drawers or turn over tables to see how they are made. It is an ideal time to examine closely the markings found on examples of pottery or porcelain or inspect the characteristics of a piece of glass, a doll, an object made from silver or bronze, or any number of other items of interest.

For those interested in learning about antiques, this experience is very similar to being able to window-shop in Aladdin's treasure cave. Again, make your own observations in this situation, then do your own research to find out what objects actually are. Viewing all the objects being offered for sale is a very important part of going to an auction, but perhaps even more important is sitting through the sale from start to finish. This is the antiques market working at one of its most basic levels. Paying close attention to each and every price as the hammer falls can provide a great deal of information about the fair market value of what is being sold.

Joe feels that a great deal of the most valuable training he received happened at auctions. After going to hundreds of auctions and watching tens of thousands of items being sold, he eventually got to the point where he knew instinctively what an object should sell for at auction within a specific region of the country. In addition, this experience taught him the types of items that were interesting buyers at a particular point in time, which was also valuable information to acquire.

Walking through antiques shows and sitting through auctions is the best basic training on pricing that is available. It is an essential part of the learning and research process. There is no substitute for this kind of in-

the-trenches training. It cannot be replicated with 1,000 books or 10,000 searchers on the Internet.

AUCTION CATALOGS

One last aspect of auctions that can be significant for research is the auction catalogs produced by the larger auction houses. These catalogs usually cover a reasonably narrow area of collecting such as Continental silver, 20th-century decorative arts, Chinese pottery or porcelain, or American furniture. They generally include a large number of photographs and price estimates that can provide almost as much information as a textbook.

By carefully studying these catalogs, you can gain an understanding of differences in the styles and origins of a wide variety of objects and draw some conclusions about good, better, and best examples. Be aware, however, that individual auction house employees who supply the data published in these catalogs can make mistakes and offer misattributions, or miss by a wide margin the price an object eventually brings when it is actually sold.

A number of American, European, and Canadian auction houses offer their sales catalogs by subscription, but old catalogs are available at antiques shows, antiques malls, and even at flea markets from time to time. One of the best sources for older auction catalogs is the Catalog Kid, Andy Rose. He exhibits at various antiques venues throughout the Northeast and can be reached at P.O. Box 2194, Ocean, New Jersey 07712; 1-800-258-2056; www.catalogkid.com.

Periodicals

Meaningful research can also be done in antiques trade publications such as *Maine Antiques Digest* and *The Antiques and Arts Weekly* (there is a list of

periodicals in the resource guide at the end of Part III). These magazines and newspapers provide up-to-the-minute information on trends in the antiques marketplace, as well as where and when antiques shows are being held. On many occasions, they publish pictures and prices from recent antiques events, and they publish articles on a variety of antiques, which can provide scholarly information that is hard to obtain anywhere else.

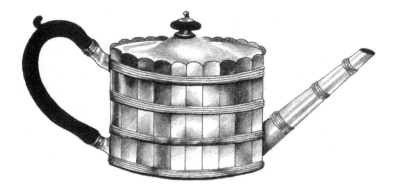

Practice
Appraisals

Now that you have the basics under your belt, it is time to get down to the nitty-gritty, as they say, and price some antiques. In this section, we evaluate items arranged in five categories: furniture, silver, glass, pottery and porcelain, and miscellaneous—specifically, clocks and textiles. Our purpose is to demonstrate how the evaluation process actually works and to delineate the information that needs to be gathered before each item can be valued.

We begin by providing the facts that you need to know about the object. These data can be gathered by a careful examination of the piece. Next, we list references that provide useful information on the object, and lastly, we walk you through an evaluation, asking, How do I know it is old? and exploring history, date of origin, country of origin, rarity, and whether it is a good, better, or best example.

We chose pieces that are either found in American homes or have been offered for sale in the recent past. Are there any fakes included? Well, that is something you will have to find out for yourself. In addition, we thought it might be more fun and instructive to let you test yourselves; therefore, we will not give prices with the evaluations. To learn our opinions and compare

them to yours, turn to the appendix in the back of the book, where you will discover both the fair market value and the insurance replacement value. The glossary in the back of the book contains many terms that may be new to you. They are italicized in the text when first mentioned in an item description.

LOT 1

Furniture

ITEM 1: GATELEG TABLE

Just the Facts

FORM

Gateleg table with four stationary legs connected by stretchers and two swing-out or "gate" legs designed to support the D-shaped drop leaves on either side of the central stationary panel.

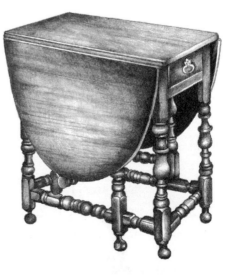

MATERIAL

White oak with brass pull on single drawer.

DIMENSIONS

29 inches tall, 19 inches wide, and 49 inches long.

METHOD OF CONSTRUCTION

Handcrafted using pegs instead of nails; the wood shows no circular saw marks and was probably cut with a bow saw. The turnings on the legs were created by a foot-powered lathe. Three handmade dovetails were used to join the drawer front to the sides.

IDENTIFYING TRADEMARKS AND SIGNATURES

None.

CONDITION

The piece has not been refinished, and the top, drawer front, and feet show an expected amount of wear. There is splitting to the one board top, and the interface between the two boards in one of the D-form drop leaves has separated slightly.

PROVENANCE

Ex-collection of an English gentleman.

The Evaluation Process

REFERENCES

Edwards, Ralph. *The Shorter Dictionary of English Furniture: From the Middle Ages to the Late Georgian Period,* Country Life, London, 1964.

Kirk, John T. *American Furniture and the British Tradition to 1830,* Alfred A. Knopf, New York, 1982.

Knell, David. *English Country Furniture 1500–1900,* Antique Collector's
 Club, Woodbridge, Suffolk, England, 1988.

Miller, Judith & Martin. *The Antiques Directory Furniture,* G. K. Hall,
 Boston, Massachusetts, 1985.

Wills, Geoffrey. *English Furniture, 1550–1760,* Doubleday, New York,
 1971.

How Do I Know It Is Old?

The signs of age on this piece are unmistakable, and the wear is absolutely
correct. This type of table was customarily used for informal dining and
was normally placed against a wall when not in use. When needed, the
table was moved into the room, causing extensive wear to the ball-shaped
feet, which are now considerably worn down. The drawer front around the
pull (which is mid-18th century and original) has extensive wear, as do the
drawer runners. The tabletop also exhibits extensive wear consistent with
250 years of use.

 Another good sign of age is that there is only one wide board in the
central panel of the tabletop, and all the other boards are wider than they
would have been if this piece were a reproduction made in the late 19th or
early 20th century. In addition, there is proper shrinkage in the wood; as a
result, the pegs used to hold the joints together have backed out or been
forced out slightly above the surface and can be felt with the fingers. A
careful measurement of the diameter of the various elements of the turn-
ings on the legs reveals that each leg is a bit different, which is evidence
that the legs were not created on a modern machine-powered lathe.

History

Gateleg tables came into fashion in the mid-1600s and continued to be
made well into the 18th century. They had a revival of popularity in the late

19th and early 20th centuries, and most examples found are from this later period.

DATE OF ORIGIN

This particular table is early George III (ruled 1760–1820). This age is determined by the character and sophistication of the turnings and the style of the original pull on the drawer.

PLACE OR COUNTRY OF ORIGIN

England. We know this piece is English because the wood is white oak and because the construction of English tables is usually tighter and more compact than American-made examples. A North American gateleg table might be red oak but not white oak. Pieces made on this side of the Atlantic are more likely to be walnut, maple, or cherry. English gateleg tables from the 17th century are either white oak or white oak and elm, whereas English gateleg tables from the 18th century are typically mahogany. Since this one is 18th century and made of white oak rather than mahogany, it is considered to be a provincial piece made in the country outside London.

RARITY

Good-quality 18th-century gateleg tables are becoming increasingly hard to find. In the United States, American examples are more highly desired and are rarer than English examples. This table was designed to accommodate six diners; larger ones that could seat eight are more uncommon and much more valuable.

PUTTING IT ALL TOGETHER

The pluses on this piece are its good unrefinished condition and the beautifully turned legs and stretchers. The minuses are its relatively late date, the fact that it is English rather than American, and its small size. This is a better piece because of its smoothness of form and its well-crafted turnings.

ITEM 2: CORNER CUPBOARD

Just the Facts

FORM

Flat-front corner cupboard with *chamfered* sides built in two parts. The top section consists of a molded *cornice* above two doors with mullioned glass panes that form an arch. In the lower portion, there are two recessed panel drawers over two cabinet doors. The front of both sections is flanked by fluted *pilasters,* and the cupboard stands on T-shaped feet.

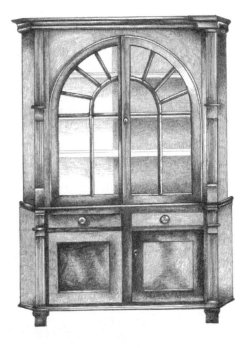

MATERIAL

American walnut with burl or "flame" walnut panels in the lower cabinet door fronts. Secondary wood (found on the interior and on the back) is white pine.

DIMENSIONS

6 feet 8 inches tall, 56 inches wide, and 26 inches deep.

METHOD OF CONSTRUCTION

Handmade with dovetail and pegged *mortise and tenon* construction. There are no circular saw marks.

IDENTIFYING TRADEMARKS AND SIGNATURES

None.

CONDITION

This cupboard was refinished in the early 20th century and the interior has been repainted. There is minor splitting of the walnut above the arched doors, and the hinges have been replaced. The feet, which were probably originally in the bracket style, have also been replaced. All other parts are original.

PROVENANCE

A New Jersey estate.

The Evaluation Process

REFERENCES

Kovel, Ralph and Terry. *American Country Furniture 1780–1875*, Crown Publishers, New York, 1987.

Montgomery, Charles F. *American Furniture, the Federal Period,* Viking Press, New York, 1981.

Tracy, Berry B. *Federal Furniture & Decorative Arts at Boscobel,* Harry N. Abrams, New York, 1981.

How Do I Know It Is Old?

There are several areas that need to be examined closely when inspecting a two-piece corner cupboard. First, look at the back. It should be made of rough, unfinished lumber; the boards that make up the top portion should match the boards on the bottom. In this case, the boards on the back are pine; they are unfinished, wide, and matching. Second, make sure the top and the bottom match. This is obvious in the case of this corner cupboard because the fluted pilasters on the front form a continuous design element running through both sections. Also, the pegs have backed out in an appropriate manner, and there is shrinkage in the pine backing boards and in some of the walnut boards on the front, causing the minor splitting mentioned earlier. The glass in the arched door front is rippled and has small bubbles in it, indicating that it is original and of the period.

History

Corner cupboards are said to be a Dutch invention and came to England in the early 18th century. Most of the American examples found on the market today are mid-18th to mid-19th century. Corner cupboards are believed to have been most popular when rooms were paneled. When a cupboard was placed in the corner of one of these rooms with decorative wooden walls, it appeared to be an elegant continuation of the paneling and to blend into the architecture of the room. After wallpaper became popular, corner cupboards became less fashionable.

DATE OF ORIGIN

Late 18th century, circa 1790, and is considered to be a transitional piece between the Chippendale and American Federal styles. The arched doors and the molded cornice are related to Chippendale design, while the rectangular form and fluted pilasters are American Federal. The 1790 date of origin is consistent with the transitional nature of this piece.

PLACE OR COUNTRY OF ORIGIN

United States, probably Pennsylvania or New Jersey. Corner cupboards such as this one are almost always North American, and this one has the architectural feel of corner cupboards made in eastern Pennsylvania, but the fluted pilasters and *canted* corners are related to some known New Jersey examples.

RARITY

Corner cupboards such as this one are not particularly rare, but they are in demand for use in high-country or Americana-inspired interiors.

PUTTING IT ALL TOGETHER

The pluses on this piece are its very elegant form and its reasonably good condition. Although replaced feet are a common occurrence, the ones on this example warrant a significant reduction in value because there are too many examples on the market that still have their original supports. The refinishing and repainting job was done long ago, and the piece has had time to redevelop some *patina*. Still, this is a minus. This cupboard is a good example because better pieces would have shaped shelves and more elegant, original feet. Best examples would have these two elements plus a shell-shaped top in the interior, a more elaborate cornice, and perhaps

some harmoniously carved decoration above the arched doors and on the cabinet doors.

ITEM 3: PIER TABLE

Just the Facts

FORM

Marble-topped pier table with S-form scrolled supports. It has a mirrored back that rests on a shaped base supported on paw feet. In certain parts of the country, this would be called a petticoat mirror, because women were said to check the length of their skirt in the mirror as they passed by this table to make sure their slip was not showing. Actually, the mirror was there to reflect light and thus brighten the room.

MATERIAL

Veneered and solid mahogany and marble.

DIMENSIONS

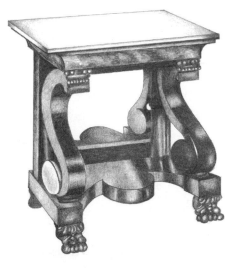

37 inches tall, 36 inches wide, and 20 inches deep.

METHOD OF CONSTRUCTION

This piece is handmade with some machine work. There are circular saw marks on the back behind the

mirror, but the paw feet are hand-carved. The table is put together using mortise and tenon construction and with screws.

IDENTIFYING TRADEMARKS AND SIGNATURES

None.

CONDITION

The mahogany veneering is in good condition with no chips or losses and the paw feet have only minor damage. The mirror is original and the piece has not been refinished.

PROVENANCE

Purchased at a Delaware antiques show. None of its former owners is known.

The Evaluation Process

REFERENCES

Cooper, Wendy. *Classical Taste in America 1800–1840*, Abbeville Press, New York, 1993.

Tracy, Berry B., and Gerdts, William H. *Classical America 1815–1845*, Exhibition Catalogue, Newark Art Museum, Newark, New Jersey, 1963.

How Do I Know It Is Old?

This furniture form has not been reproduced widely, so there will be very little doubt of authenticity when this or a piece in a similar style is encountered. However, there are several quick checks that can and should be made just to make sure that all is well. It is a good idea to check the thickness of the veneer. Early-19th-century veneer is fairly thick and substantial, whereas modern veneers are much thinner. Next, look under the marble top to see if there are slats to support the weight of the marble and not a finished solid wooden top. Furniture makers did not (as a general rule) put marble on a finished wood top because the stone would ruin the surface in a very short time. Instead, pieces that were fitted with marble tops when they were made will have tops that are open and crossed with slats to support the weight of the stone. Finally, the presence of screws is a cause for alarm in most antique furniture, but they were used in high-stress areas to attach such things as tabletops. Modern screws have regular threads, flat heads, and pointy ends. The screws found in this piece have flat heads and regular threads, but they have blunt rather than pointy ends, which means they are post-1815 but premodern, as they should be.

History

This is a pier table, which means that it was meant to be placed against a wall between two windows. Pier tables were usually made in pairs and were placed underneath pier mirrors to give balance to a room. The S-shaped scroll supports, the paw feet, and the conforming *cove frieze* below the marble top put this in the American Classical period (1790–1835). This style was once called American Empire. However, that nomenclature is out of fashion at the moment (Joe still uses it occasionally and Helaine chides him unmercifully).

DATE OF ORIGIN

This piece is circa 1830. The paw feet found on this piece were first in fashion circa 1810, but the simply shaped cylindrical back legs, the S scroll supports, and the overall simplicity of design strongly suggest that this pier table dates from the 1830s.

PLACE OR COUNTRY OF ORIGIN

There is no doubt that this piece is American because of its overall configuration. It was possibly made in the mid-Atlantic states (Pennsylvania, New York, Maryland, Delaware, New Jersey) but was almost certainly made outside the major design centers of New York City, Baltimore, and Philadelphia.

RARITY

These tables are not rare, but they are sought after in certain regions of the country for use in antebellum homes.

PUTTING IT ALL TOGETHER

Among American pier tables made in the first 35 years of the 19th century, this one is fairly plain-Jane. The pluses are its superb, unrefinished condition, the fact that it still has its original mirror and marble top, the charming paw feet, and the graceful S scroll supports. The big minus is its lack of any kind of decorative pizzazz, which places this example in the good category.

ITEM 4: SOFA

Just the Facts

FORM

Camelback *sofa* (or sofa with an undulating back) with outscrolled arms, slightly bowed *apron,* single loose cushion, and eight square tapered legs. The four legs in the back are plain; the four in the front are fluted.

MATERIAL

Mahogany primary wood with maple and white pine frame and satin upholstery (not original).

DIMENSIONS

41 inches tall at the top of the crest, 6 feet 6 inches long, and 17 inches from floor to apron.

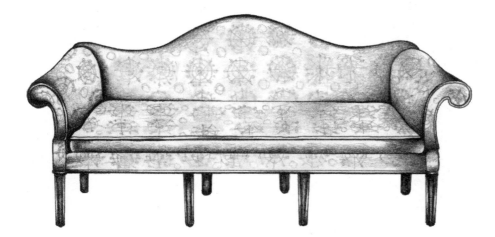

METHOD OF CONSTRUCTION

The sofa is handmade using mortise and tenon construction, and the legs are secured using blocks. It is difficult to determine the details of the frame construction because of the upholstery, but all the nails are handmade except for the ones used to attach some reinforcement bracing that was added later.

IDENTIFYING TRADEMARKS AND SIGNATURES

None.

CONDITION

In unrefinished original condition with the exception of the upholstery, which has been replaced on several occasions. All visible wooden parts are original, and the legs were never fitted for stretchers and never had casters. The frame has been patched and reinforced, but the crest rail, arms, and front seat frame are original.

PROVENANCE

This sofa was originally owned by a prominent Lowell, Massachusetts, family who donated it to a nursing home. When the facility went out of business, the sofa was sold at auction.

The Evaluation Process

REFERENCES

Fairbanks, Jonathan L., and Bates, Elizabeth Bidwell. *American Furniture 1620 to Present,* Richard Marek Publishing, New York, 1981.

Hummel, Charles F. *A Winterthur Guide to American Chippendale Furniture,* Crown Publishers, New York, 1976.

Sack, Albert. *The New Fine Points of Furniture: Early American, Good, Better, Best, Superior, Masterpiece,* Crown Publishers, New York, 1993.

HOW DO I KNOW IT IS OLD?

The only way to know about the age and condition of an upholstered piece of furniture is to examine it without its cloth or leather covering. The frame should show abundant undisguised tool marks and it should be obvious that the frame is completely handmade. All the joins should be mortise and tenon, and there should be no evidence of the use of round dowels, which are found only on modern pieces. The nails should be blacksmith made and should be square with either *roseheads,* T heads, or half T heads. Be aware that modern, machine-made round nails and screws with pointy ends may appear in areas that have been repaired. In addition, the frame may show signs of having been reupholstered on numerous occasions, and there should be a significant number of tack holes where the fabric or leather was attached. It would be most unusual to find a sofa with its original covering. However, the upholstery tack holes should be evenly distributed. An abundance of these holes in an easily accessible area and a far fewer number in a less-easy-to-examine spot may indicate an attempt at fakery or a replaced part. Check the parts of the legs that were not intended to be seen. These should not be smoothly finished and tool marks

should be felt when fingers are run over the surface. A certain amount of bracing and repairing of the superstructure and legs is a comforting sign of age. Finally, check the bottom of the feet to make sure they have appropriate signs of extensive use.

HISTORY

There is some disagreement about exact dates, but seats for two or more people with upholstered backs and arms did not appear in Europe until the 17th century. They were first called sofas in France in the 1680s, and the term was used in England by the turn of the 1700s. In France, a sofa was often called a canapé (okay, no jokes about hors d'oeuvres) and was first made in the Louis XIV style.

DATE OF ORIGIN

Circa 1780, and in the American Chippendale style (1750–1780). Camelback sofas were made as early as the Queen Anne period, but the straight fluted legs on this one mark it as Chippendale.

PLACE OR COUNTRY OF ORIGIN

United States, probably Massachusetts. The gently rolling curve to the arms and the molded, fluted legs relate this piece to New England and Massachusetts. The maple and white pine in the frame construction are also good indications of an origin in New England.

RARITY

Authentic period American Chippendale sofas are very rare.

PUTTING IT ALL TOGETHER

The positive factors for this sofa include its excellent unrefinished condition, its graceful back and subtle serpentine arms (i.e., the arms are lower in the front and a bit higher in the back and they take a smooth, undulating curve up and out), and the bowed front apron. Negative factors include the lack of stretchers between the legs and the ordinary fluting on the legs. This is a better example.

ITEM 5: SET OF SIX BOW-BACK WINDSOR CHAIRS

Just the Facts

FORM

An assembled set of six *bow-back Windsor* side chairs with *bamboo-turned legs* and spindles. The back of each chair is composed of nine spindles.

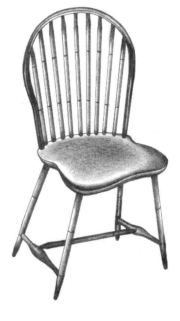

MATERIAL

Yellow poplar seat. The remaining parts are made from maple, oak, and hickory. The surfaces are covered with dark green paint.

DIMENSIONS

The chairs vary in size slightly, but generally they are 37½ inches tall, and the seats are 17¼ inches wide by 16 inches deep.

METHOD OF CONSTRUCTION

The various components were made by turning the legs, spindles, and stretchers on a foot-powered lathe. They were put together by drilling holes in the plank seat and inserting the spindles, bow back, and legs. No glue or fasteners of any kind were used, and the chair is held together by the shrinkage of the wood in the plank seat.

IDENTIFYING TRADEMARKS AND SIGNATURES

None.

CONDITION

The chairs are in excellent condition, but they were repainted in the mid-19th century. We know this because there are at least two layers of paint detectable upon close examination, and the green that is on top is not the early Windsor green, which was made using verdigris (i.e., the rust found on copper). It is a very distinctive shade, and the green on these chairs is darker.

PROVENANCE

The set was assembled by an Ohio collector over a number of years and is now part of his estate.

The Evaluation Process

References

Evans, Nancy Goyne. *Windsor Chairs,* Hudson Hill Press, New York, 1996.

Smith, Nancy A., editor. *Old Furniture, Understanding the Craftsman's Art,* Little, Brown, New York, 1975.

How Do I Know It Is Old?

Windsor chairs are still being made today using much the same methods employed 250 years ago, and this can make it very difficult for a novice to distinguish new from old. As in all antique furniture, the first thing to inspect for is wear, and these chairs display the kind of honest wear that suggests they have been in existence for 175 to 200 years. For the most part, bow-back Windsor chairs such as these were not intended to be fine furniture. In fact, they were often meant to be used outdoors as porch and garden furniture. The legs often came in contact with very hard surfaces and should show considerable wear. The legs on these chairs have been worn down significantly over the years. The center stretchers show considerable wear as well, because they have been kicked and scuffed by countless feet over the years, and the edges of the seats have been worn down. A close inspection around the holes where the front legs were attached to the seat reveals some score lines made by a scribe or scratch awl to guide the maker in placing the leg. These score lines are a good but not infallible sign of age. There is evidence that these chairs have been repainted, but the paint that is on them is somewhat brittle, which indicates that it has been on the chairs for 100 years or more.

HISTORY

In ancient times, the Egyptians, Greeks, and Romans all made simple pieces of furniture by using stick construction, meaning that holes were bored in a base and sticklike pieces of wood were inserted into these apertures to serve as legs, thus forming a stool, bench, or table. Windsor furniture per se started being made in England during the first quarter of the 18th century and could be found in America by the early second quarter of that century.

DATE OF ORIGIN

First quarter of the 19th century, circa 1810. This is indicated by the bamboo-style turnings on the legs and spindles, which were influenced by the bamboo-style turnings found on some Sheraton fancy chairs of this period.

PLACE OR COUNTRY OF ORIGIN

United States. England is ruled out as the place of origin because of the combination of woods used in these chairs. English Windsors are often made from ash and elm and occasionally yew. The yellow poplar seat makes it certain that this is an American Windsor.

RARITY

Bow-back Windsor chairs of this date are not rare, but six similar American examples are desired by collectors of American country furniture.

PUTTING IT ALL TOGETHER

An original set of six matching bow-back Windsor chairs made by the same maker at the same time would be quite valuable, but this set was

assembled, meaning that the chairs are similar but were not always together as a set and do not match exactly. This is less desirable than if the six chairs had started out life together. Still, having six extremely similar early-19th-century Windsor chairs is desirable, and the condition of these is very good. If they had had their original paint, this would have been a big plus, but the old paint that is on them is much more desirable than if they had been stripped of paint altogether or had been recently repainted. Other minuses to consider are that these are side chairs, which are generally less valuable than armchairs, and they are bow-backs, which is one of the more available types of Windsor chairs. There is an old myth that the value of a Windsor chair can be determined by the number of spindles composing the back, but while higher numbers of spindles can be a plus, this is only a minor contributing factor to the value and not the only component of the value equation. The nine spindles on these chairs are a good number, and this factor, along with the turnings and the nicely splayed legs, make these better examples.

ITEM 6: TALL CHEST

Just the Facts

FORM

Tall chest, sometimes called a *highboy*. It is in two sections with a flat molded cornice above five graduated drawers in the top section. The bottom consists of one long drawer over three short drawers and a scalloped apron. There are four *pad-footed cabriole legs.*

MATERIAL

Maple primary wood with white pine secondary wood, brass pulls.

DIMENSIONS

6 feet 2 inches tall, 38½ inches wide, and 20 inches deep.

METHOD OF CONSTRUCTION

Pegged mortise and tenon *joinery* with dovetailed drawers. There are bow saw marks on the lumber, and the pine backboards on both sections are matching.

IDENTIFYING TRADEMARKS AND SIGNATURES

"Clarence Stillwell" written in pencil on the back. It is not the signature of the maker, who is anonymous, but may be the name of a former owner.

CONDITION

This piece has been refinished within the last 75 years. There are some repairs to the drawer fronts and a small triangular section has been replaced in the top corner of two drawers: one in the top section, the other in the bottom section. There is some splitting to the maple carcass in the lower section, and one of the cabriole legs has been broken and repaired where the knee joins the apron. The hardware is original.

PROVENANCE

The name written in pencil on the back of this piece is probably the name of a former owner. In all likelihood, it was placed there as part of an inventory or as a mark to identify ownership during a move. Penciled or chalked signatures found on the backs of furniture and in drawers are almost always those of former owners. Although they provide an intriguing clue for scholarship, they generally do not enhance value.

The Evaluation Process

REFERENCES

Downs, Joseph. *American Furniture, Queen Anne and Chippendale Periods in the Henry and Francis DuPont Wintherthur Museum*, Bonanza Books, New York, 1952.

Nutting, Wallace. *Furniture Treasury*, MacMillan, New York, 1928.

Sack, Albert. *The New Fine Points of Furniture: Early American, Good, Better, Best, Superior, Masterpiece*, Crown Publishers, New York, 1993.

HOW DO I KNOW IT IS OLD?

The initial survey of the condition of this piece suggests that it is 18th century. The repairs to the drawer fronts, the splitting of the wood, and the repair to the cabriole legs are all consistent with the kinds of repairs that must be done over the years to a piece of this age. Next, the structure of the drawers is examined to make sure they are correct for the mid-18th century. All the drawers are pulled out a few inches from the case so that the dovetail construction of the drawers can be seen together. It reveals that they were made in the same way and all drawers are original. The dovetails

themselves are all hand-cut and vary slightly in size, and there is a scribe line still visible that was used by the craftsman to guide him in the making of the dovetails. The pine boards on the back are quite dark, which signifies that they have been exposed to oxygen for a very long time. On the inside of the case, the wood is still a fairly light color, which indicates that it has had less oxygen exposure, and this is as it should be (any inexplicable light and dark patches inside the case are cause for suspicion of either extensive repair or outright fakery). The overall wear on this piece is consistent with 250 years of use, but the piece has not been moved much and the pad feet are in excellent condition.

History

The late 17th and early 18th centuries saw the development of several types of chests constructed in two sections. Chest on frame denotes a chest that sat on a stand. Sometimes the stand had one long drawer, or a little later, three smaller drawers. As time progressed, the frame became a chest itself, and these pieces are known as chests on chests. Highboy is a colloquial or dealer term used in America to denote a tall case piece made in two sections with both units having multiple drawers and the lower piece supported on legs.

Date of Origin

First half of the 18th century, 1740–1750, in the Queen Anne style. This is denoted by the pad feet and cabriole leg, the shape of the apron, and the general profile.

PLACE OR COUNTRY OF ORIGIN

New England. This is suggested by the type of wood it is made from and the style. A maple example with white pine secondary wood is American, and would not have been made in Great Britain.

RARITY

Queen Anne period furniture has become rather difficult to find, but among highboys of this period, this is one of the more commonly found forms.

PUTTING IT ALL TOGETHER

The big plus on this tall chest or highboy is that it is American and of the Queen Anne period. It is in reasonably good condition with its original hardware and none of the legs have been replaced (replaced legs on these pieces are a fairly common problem). Most individuals who are interested in this type of furniture would not be greatly troubled by the repairs, but the refinishing is a matter of some concern. This example has good rectangular proportions and is relatively tall and narrow. It is supposed to look light and graceful on its cabriole legs, but, unfortunately, the legs appear to be a little short to accomplish this laudable goal and the chest appears to bear down and be heavy. The apron is also not as graceful as it might be, and the piece might have benefited from a divided top drawer—or at least one that appears to be divided. Still, this is a better example of a Queen Anne high chest.

ITEM 7: WORKTABLE

Just the Facts

FORM

Two-drawer worktable with *canted* corners. The top lifts up to reveal a leather-covered writing surface and fitted compartments. This is supported by a *foliate-carved* pedestal and four legs that terminate in paw feet.

MATERIAL

Mahogany and mahogany veneers on tulipwood, brass hardware.

DIMENSIONS

28¾ inches tall, 23½ inches wide, and 15 inches deep.

METHOD OF CONSTRUCTION

Hand-matched veneers, hand-cut dovetail joints, and hand-carved foliate decoration on pedestal base, legs, and feet. The base is attached to the top with screws appropriate to the time, and there are no circular saw marks evident on the lumber.

IDENTIFYING TRADEMARKS AND SIGNATURES

None.

CONDITION

Excellent unrefinished, unrepaired condition. The hardware and leather writing surface are original, and there are no losses to the veneer.

PROVENANCE

Deaccessioned by a small house museum in upstate New York with a family history that it had been made in New York City and originally belonged to a family residing in Manhattan.

The Evaluation Process

REFERENCE

Montgomery, Charles F. *American Furniture, The Federal Period,* Viking Press, New York, 1981.

HOW DO I KNOW IT IS OLD?

This is not the sort of piece that has been widely reproduced, but still a very close inspection is in order. Reassuring signs include thick veneers and handmade dovetails with scribe lines. The mahogany used to make the veneer found on this worktable is also consistent with an early-19th-century date of origin. The grain and figuring seen on the wood are associated with mahogany grown in Honduras, which is appropriate for pieces made in the first quarter of the 19th century. An examination of the carving on the legs, feet, and pedestal reveals the tool marks that would be expected from hand carving. Plus, the carving shows the kind of density

and attention to detail that would be found only on an earlier piece of furniture. In addition, there is the expected wear on drawer runners.

History

During the American Federal period, furniture makers made a wide variety of worktables that were used for a number of purposes. There were worktables primarily intended for sewing and mending, worktables for writing, and worktables designed to be used for both activities. Sometimes worktables might also include a chessboard, a mirror, or even a fire screen. From about 1790 to 1815, worktables usually had four legs, but about 1815, pedestal bases began to appear. Worktables came with oval tops, rectangular tops, and tops with canted corners. Those that had a cloth bag hanging underneath for the storage of mending or fancy needlework were also called pouch tables.

Date of Origin

Circa 1815. As was said, pedestal worktables began being made around this date, and this example is not much later than that.

Place or Country of Origin

New York. This is borne out by the provenance and by the form, and its maker was influenced by the workshop of Duncan Phyfe. The reeded band around the base, the foliate carving of the legs, the paw feet, the choice of hardware, and the type of wood all suggest a New York origin. There is a possibility this table could have been made in New York City.

Rarity

Worktables of this quality have become difficult to find.

PUTTING IT ALL TOGETHER

The condition of this American Federal worktable is really very good. The figured mahogany veneers provide a beautiful visual play across the surfaces like fireworks reflecting on water. The foliate carving on the legs is very detailed and rich, but it might be faulted in some minds for lacking in subtlety and finesse. The other minus on this piece is a problem that pedestal-base worktables often have: the top box is visually too heavy for its underpinnings. This is not as incongruous as some, and it is a better example.

ITEM 8: SET OF FOUR VICTORIAN SIDE CHAIRS

Just the Facts

FORM

Victorian side chairs in the Rococo Revival style with cabriole legs, elaborately pierced cartouche-shaped backs that contain a crest in the center with two roses. Shaped upholstered seats.

MATERIAL

Laminated rosewood, brass casters, and upholstery fabric.

DIMENSIONS

Each chair back is 41 inches tall, and the seats are 20 inches deep by 18 inches wide.

METHOD OF CONSTRUCTION

The layers of wood visible on the edges of the backs of these chairs indicate that they were made from laminated rosewood. Laminated wood has reportedly been around since Egyptian times. It was used in the 18th century for pieces with pierced or fretted decoration. The process involves gluing together successive layers of wood, each layer having a wood grain that runs at right angles to the adjacent layer above and below. This produces a kind of upscale plywood that is very strong, could be bent using steam and pressure, and would not shatter when pierced front to back to make three-dimensional carvings. The use of laminated wood reached its pinnacle in the mid-19th century when famed New York City cabinetmaker John Henry Belter perfected the process using rosewood. Other makers making Victorian furniture from laminated rosewood included George Henkels of Philadelphia and J. and J. Meeks of New York City and New Orleans. The carvings on these chairs may appear to have been done by hand, but on close examination it is revealed by their regularity and lack of hand-tool marks that they were done by machine.

IDENTIFYING TRADEMARKS AND SIGNATURES

None, but the pattern of the chair is Stanton Hall, which is attributable to J. and J. Meeks.

CONDITION

Unrefinished with beautiful *patina;* all parts except upholstery are original including the mid-19th-century casters. There are no repairs.

PROVENANCE

Bought at an antiques show with no previous history of ownership.

The Evaluation Process

REFERENCES

Dubrow, Eileen and Richard. *American Furniture of the 19th Century,* Schiffer Publishing, Exton, Pennsylvania, 1983.

Swedberg, Robert W. and Harriet. *Collector's Encyclopedia of American Furniture,* Volume I, Collector Books, Paducah, Kentucky, 1991.

HOW DO I KNOW IT IS OLD?

Meeks's Stanton Hall pattern has not been reproduced, so there is a great deal of confidence that these chairs are as they should be. A peek under the upholstery reveals numerous tack holes where the seats have been reupholstered over the years, and there is wear where there should be wear.

HISTORY

These four chairs were made by J. and J. Meeks, which had a long history of making furniture in both New York City and New Orleans. The family apparently started its business in New York City at 59 Broad Street in 1797

and established a warehouse in New Orleans in 1821. In the early days, the Meekses were a strong competitor of Duncan Phyfe's workshop, and later in the 19th century, they competed vigorously with John Henry Belter, the acknowledged star of mid-Victorian furniture making. Over the years, various partnerships between brothers and sons in the Meeks family were formed, and it gets rather complicated, but the initials in J. and J. Meeks stand for Joseph and John. One of the most intriguing aspects of their business is that they are said to have established the first chain of furniture stores in the United States. They basically had furniture outlets from Boston to New Orleans, and in these facilities they retailed the items the family made. They stopped making furniture in 1868.

DATE OF ORIGIN

Circa 1850. These pieces are Victorian Rococo Revival, which was in vogue from 1840 to 1865. This style is sometimes called Louis XV influence or Louis XV Revival. It is characterized by avoidance of straight lines in its designs as well as the use of heavily carved representations of fruit, flowers, leaves, nuts, rocks, and shells. Pieces of Victorian Rococo Revival often have cabriole legs, and tables commonly have marble tops.

PLACE OR COUNTRY OF ORIGIN

United States, New York City.

RARITY

Chairs such as these are very difficult to find and most collectors would consider them to be uncommon if not rare in the strictest meaning of the term.

PUTTING IT ALL TOGETHER

In all likelihood, these four chairs were once part of a larger parlor set that consisted of a love seat–sized sofa, two armchairs, and probably six side chairs of which these are the remaining four. A complete parlor set in Stanton Hall would be extremely valuable, but collectors are still quite happy to find four side chairs. Examples of Victorian furniture that are attributable to the great makers such as John Henry Belter, Prudence Millard, Daniel Pabst, Charles A. Boudoine, Alexander Roux, and J. and J. Meeks, among others, are highly regarded and can be quite valuable. Among Victorian Rococo Revival side chairs, these four examples are in the best category.

ITEMS: 9 TILT-TOP PIECRUST TABLE

Just the Facts

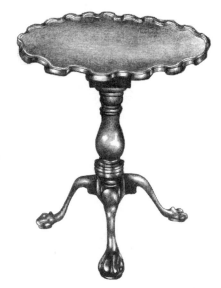

FORM

Tripod tea table with *piecrust*-shaped top. Underneath the top, there is a birdcage and a *baluster* standard with three cabriole legs that end with *ball and claw feet*.

MATERIAL

Mahogany, brass hinge and catch.

DIMENSIONS

28 inches tall, with a tabletop that is 32 inches in diameter

METHOD OF CONSTRUCTION

The piecrust edge on the mahogany top is hand-carved and the top is slightly dished, meaning it is lower in the center than at the edge. The central shaft or stem that forms the center portion of the base is one piece of wood that was turned using a foot lathe. The tabletop is attached to the center post of the base using a birdcage, which is made from two squares of wood separated from each other by short, turned pillars located at each of the four corners. A hole is drilled through the center of the birdcage to allow the cylindrical top of the shaft to fit through this arrangement. The top of this block is hinged to the tabletop to allow it to be tilted vertically to save space when the table is not in use. When the tabletop is horizontal, a latch fastens it to the birdcage to keep the top from tilting unexpectedly. The birdcage also allows the tabletop to be removed entirely or to be rotated. The ball and claw feet are also hand-carved, and the cabriole legs fit into the center pedestal in large slots called slot or wedge dovetails. These are held in place at the bottom with an iron plate secured with screws.

IDENTIFYING TRADEMARKS AND SIGNATURES

None.

CONDITION

This piece has been repaired and the birdcage is of a later date than the rest of the table and there are extra screw holes in the underside of the tabletop.

The table has been carefully refinished by professionals within the past 50 years, but there are several nicks on the talon portion of two of the ball and claw feet. Otherwise, this table is in good condition.

PROVENANCE

Purchased at a Chicago auction as part of an estate.

The Evaluation Process

REFERENCE

Wills, Geoffrey. *English Furniture 1760–1900,* Doubleday, New York, 1971.

HOW DO I KNOW IT IS OLD?

One of the first things to do when presented with a round tabletop on a piece of furniture that purports to be from the 18th century is to measure the diameter in the direction in which the grain of wood is running, then measure again choosing a diameter that runs across the grain at 90 degrees to the first measurement. The two numbers obtained in this process should be slightly different, showing that the tabletop has shrunk along the grain over the years. A word of warning here: 18th-century mahogany will have shrunk less than walnut, cherry, or maple. Next, examine the mahogany. It should be very heavy and dense. The mahogany in reproductions is somewhat less heavy. Excluding the birdcage, the table should be made from just five pieces of wood. The tabletop should be made from one piece; two pieces are a sure sign of a problem unless it is an American example made from walnut, and these sometimes have two-

piece tops. The base should be made from the remaining four pieces of wood: three to make the legs and one to create the central shaft. The wood grain exhibited on the shaft should run in an unbroken line from top to bottom. If a deviation exists, there is a problem. Examining for proper wear is the next step. The bottom of tabletops received a lot of wear from being constantly changed from vertical to horizontal. There should be dents and depressions where the birdcage meets the tabletop, and since the piece under examination has had its birdcage and latch replaced, there should be (and there is) evidence of the different position of the original birdcage and latch and the wear associated with that previous location. In the case of a replacement, there should be the vague outline of the original and the extra screw holes where it was attached. In a repair situation such as this, an examination of the fasteners—in this case, screws—might reveal that some are new and some are old. The screws that now fasten the top of the birdcage to the bottom of the table are all machine made and from the late 19th century. They have pointy ends, regular threads, and flat heads. On the base, however, the screws are different. These screws are handmade and have domed heads, irregular threads, and blunt ends. As a final test, fingers run across the tabletop should feel the slight ripples that were left when the wood was hand-planed. After deciding that the table is 18th century, make sure that it is *all* 18th century. The best way to ascertain this is to make sure that all the wood is the same color and that each leg (legs are the leading candidate for replacement) is carved in the same manner and exhibits similar wear patterns.

HISTORY

Tables such as this one can trace their origins to the small tilt-top candle stands that originated in the 16th century. Tables with a central stem and three legs (generally called tripod tables) were first made in the late 17th

century from walnut. But their real popularity did not occur until tea drinking became an important social ritual and dense tropical mahogany was widely available and had become the wood of choice.

Date of Origin

This table is from the third quarter of the 18th century, circa 1770, and should be called a George III tilt-top (or tip-top) piecrust tea table.

Place or Country of Origin

England. This tripod table is judged to be English partially because of the way the ball and claw feet sit on a flat shoe to make the table more stable. Piecrust tables such as this one are more likely to be English than American.

Rarity

English piecrust-edged tripod tables still appear with some regularity in major markets and are desirable to collectors but are not considered rare unless they have very finely carved decoration on the stem and legs, which this one does not.

Putting It All Together

The color of the mahogany on this attractive tripod table is warm and inviting, and the piecrust edge is very elegant and well-executed as are the ball and claw feet. Except for the birdcage and the finish, the piece is of the period. The replaced birdcage is certainly a deduction, but the refinishing was done professionally and the patina was left intact. The value of this particular table is very adversely affected by the plain baluster stem and the unembellished cabriole legs. It is a better example.

ITEM 10: ARMCHAIR

Just the Facts

FORM

Armchair with shaped upholstered back, also called a lolling or Martha Washington chair. It has reeded arms and flared tassel-shaped reeded arm supports. The front legs are tapered and reeded.

MATERIAL

Mahogany primary with maple and birch secondary wood, brass casters.

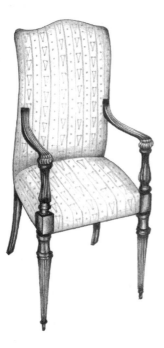

DIMENSIONS

This chair is 42½ inches tall, 26 inches wide, and 21½ inches deep.

METHOD OF CONSTRUCTION

Mortise and tenon joints were used throughout this piece. All the reeding on the arms, arm supports, and legs is hand-carved.

IDENTIFYING TRADEMARKS AND SIGNATURES

None.

CONDITION

This chair is in its original condition with no replacements except for the upholstery, and it has not been refinished. There are some nicks and scratches, but they are minor and do not detract from the overall aesthetic appeal.

PROVENANCE

Found in a house in Connecticut and thought to have been bought by the present owner's father early in the 20th century.

The Evaluation Process

REFERENCES

Fairbanks, Jonathan L., and Bates, Elizabeth Bidwell. *American Furniture. 1620 to Present,* Richard Marek Publishers, New York, 1981.
Montgomery, Charles F. *American Furniture, The Federal Period 1788–1825,* Viking Press, New York, 1981.

HOW DO I KNOW IT IS OLD?

The form and proportions of this chair are characteristic of late-18th- or early-19th-century construction. The tall, shaped back with its subtle oxbow profile is typical and appropriate for this period. Under the upholstery, the frame is handmade from maple and birch, and there are two minor repairs where the back has been strengthened. In addition, there are numerous tack holes, showing that the chair has been reupholstered several

times in its lifetime. There are also the expected but subtle tool marks in the carving, and the wear on the arms and legs is correct for this piece to be close to 200 years old. The casters are original and early 19th century.

HISTORY

Chairs such as this one originated in the early 18th century, but they were most popular in America from the last quarter of the 18th through the first quarter of the 19th century. Today, these chairs are known by a variety of names including Martha Washington, lolling, and if they have padded arms, Gainsborough. They might also be called by the French name *fauteuil*. Lolling chair, however, is the proper name used in the 18th and 19th centuries. To us this name suggests a slumped and sloppy sitting position, but to our ancestors it designated a graceful, elegant, relaxed posture that would be appropriate for having one's portrait painted. Interestingly, there is some suggestion in the literature that wheels on the legs were placed there so that the chair could be pushed across the room while someone was sitting in it.

DATE OF ORIGIN

First quarter of the 19th century, circa 1810. This is determined by the style of the chair and the examination, which conclusively revealed it to be of the period which is American Federal.

PLACE OR COUNTRY OF ORIGIN

United States. From the late 18th and early 19th centuries, this type of chair is almost always American, made in New England. Most are from Massachusetts.

RARITY

These chairs are not uncommon.

PUTTING IT ALL TOGETHER

The condition and elegant lines of this chair are much in its favor, but single armchairs are not as desirable as pairs. It is a very midrange chair and would be more valuable if it had been signed by its maker or had more elaborately carved ornamentation. This is a better example.

Glass

ITEM 1: BURMESE FAIRY LAMP *EPERGNE*

Just the Facts

FORM

Glass fairy lamp in a gilded metal stand. A fairy lamp is a small glass or translucent porcelain lamp designed to hold a candle. They were generally used as night-lights. Sometimes they are called romance lights and are said to have been used in a parlor during courtship to provide a soft, romantic glow. This fairy lamp *epergne* has a central vase flanked by two small fairy lamps. The bottom portions of the lamps are clear glass surmounted with open-topped, elongated, dome-shaped shades in bicolored yellow and pink glass. The vase has a ruffled top and a clear glass *berry prunt* attached to the pointed base. The two shades and the vase are all enameled with a leaf-and-flower design.

MATERIAL

Burmese glass, clear colorless pressed glass, and gilt metal.

DIMENSIONS

7½ inches tall.

METHOD OF MANUFACTURE

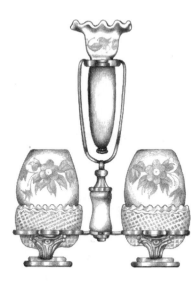

The colored-glass portions of this piece have a satin finish and are handblown. We know they are handblown because the central vase has a clear glass berry prunt on its pointed end that was put there to hide the pontil scar left by the blowing process. The pontil scar on the two dome-shaped shades was removed when the tops were opened up to allow candle smoke and heat to escape. The clear glass bases are pressed glass, and we know this because a mold seam is evident on the side. The base metal frame has been mechanically pressed out and gilded.

IDENTIFYING TRADEMARKS AND SIGNATURES

The clear glass base of the lamps is marked Clarke for Clarke's Pyramid and Fairy Lamp Co. Ltd., England.

CONDITION

The glass is in perfect condition, with no chips, cracks, or rubbed enamel. The frame may have been regilded because its condition is too pristine.

PROVENANCE

Private collection.

The Evaluation Process

REFERENCES

Pullin, Anne Geffken. *Glass Signatures, Trademarks and Trade Names from the Seventeenth to the Twentieth Century,* Wallace Homestead, Radnor, Pennsylvania, 1986.

Revi, Albert Christian. *Nineteenth Century Art Glass, Its Genesis and Development,* Galahad Books, New York, 1967.

HOW DO I KNOW IT IS OLD?

Fairy lamps marked Clarke or with the full trademark that includes a representation of a pyramid and a sphinx are generally genuine; in this case, an examination of the glass reveals this fairy lamp epergne to be 19th century beyond question. The colored glass is heat shaded—as it should be—and goes from pale yellow to soft salmon pink, with no noticeable line of demarcation between the two colors. There is proper wear seen on both the clear glass bases and the glass-domed shades where they have meshed together on countless occasions. The metal feet also show short random scratches indicative of genuine wear, and the enamel decoration exhibits the kind of coloration and attention to detail that is expected from 19th-century enameling.

HISTORY

The colored glass in this fairy lamp epergne is a type of 19th-century art glass known as Burmese. The story goes that it got this name when Queen Victoria was presented with several pieces of this type of glass. She is said to have exclaimed, "It looks like a Burmese sunrise." This story, however, may be apocryphal. In any event, this type of glass was invented by Frederick S. Shirley, who was the manager of the Mt. Washington Glass Company located in New Bedford, Massachusetts. It was made by adding small amounts of uranium and gold to a batch of opal (white) glass. The uranium turned the glass yellow, and the gold made it heat-sensitive, so when part of it was exposed to heat, that part turned pink. Burmese was patented on December 15, 1885, in the United States, and in England on June 16, 1886. Shortly thereafter, Thomas Webb and Sons of Stourbridge, England, purchased a license to make Burmese, which he called Queen's Burmese Ware. Burmese was extensively reproduced and faked during the 20th century, but most of these fakes are very unconvincing due to color variations from the original. The Fenton Glass Company of Williamstown, West Virginia, made large quantities of Burmese in the late 20th century, but their wares are marked and are collectible in their own right.

DATE OF ORIGIN

Circa 1890. This piece could be as early as 1886, when Webb acquired the license to make Burmese, or as late as 1900, when this kind of glass and fairy lamps in general went out of fashion.

PLACE OR COUNTRY OF ORIGIN

Stourbridge, England. This is determined largely by the English fairy lamp bases signed Clarke, and by the enameled decoration found on the vase and

the two Burmese shades. This leaf-and-flower pattern is found on pieces that are signed Thos. Webb & Sons, Queen's Burmese Ware, Patented.

RARITY

Burmese glass is extensively available in the better art glass market. Most pieces of Burmese are undecorated, and as a general rule, these are the least desirable examples of this type of glass. Enameled pieces of Burmese, such as this fairy lamp epergne, are much more sought after, but the kind of the decoration is very important. The most common designs are floral; the most desired images are flying ducks, Egyptian themes, and fish. Burmese is most often encountered as small vases, bowls, and creamers. This double fairy lamp epergne is a hard-to-find piece.

PUTTING IT ALL TOGETHER

The three big pluses on this double fairy lamp epergne are its form, the fact that it is signed by Clarke, and its condition. Decoration is also in its favor, but only marginally, because this particular decoration is of the most common sort. Since best examples are usually determined by the content of their decoration, this is a better example.

ITEM 2: ART GLASS VASE

Just the Facts

FORM

Goblet-form vase with a yellow background decorated with *iridescent* silver incorporating pulled threading and applied blobs of glass on the shoulder that have been pulled into a thread extending toward the base.

MATERIAL

Iridized glass.

DIMENSIONS

10 inches tall.

METHOD OF MANUFACTURE

Handblown as evidenced by a polished pontil and no seam lines. The vase started out as a yellow vessel that had threads of glass wrapped around the outside and then pulled with a tool to make them undulate around the circumference. After this was done, the vase was reheated and the threads were incorporated into the yellow base, making a smooth outer surface. The blobs of red glass on the shoulder were applied, then threaded with a contrasting color. A trail of glass was pulled down to the base. The piece was then sprayed with a chemical to make the surface iridescent.

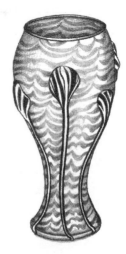

IDENTIFYING TRADEMARKS AND SIGNATURES

None.

CONDITION

Excellent, with no chips or cracks. There is expected wear (scratches) to the base.

PROVENANCE

Bought at auction with previous owners unknown.

The Evaluation Process

REFERENCE

Neuwirth, Dr. Waltraud. *Loetz Austria 1900,* Seven Hills, 1986.

HOW DO I KNOW IT IS OLD?

The short, random scratches on the base of this vase announce that it is old beyond any doubt. The form, color, polished pontil, and type of decoration establish it as having been made by Loetz (or Loetz Witre). The fact that this vase is unsigned is a good indication of age and authenticity, since the vast majority of all Loetz signatures are fake. Genuine pieces were signed only if they were going to a museum or were being exported to the United States or Britain. Sometimes the name was spelled Lotz.

HISTORY

What came to be the world-famous glass factory known to collectors as Loetz was founded in 1836 by Johann Eisenstein. But by 1840, the company had been acquired by Johann Loetz. Loetz died in 1848, but the business continued under his wife, Suzanne. At this time, the company was often called Loetz Witwe—*witwe* meaning "widow." Starting about 1890, Loetz made art glass in the Art Nouveau style. In the 20th century, the company experienced a great deal of financial difficulty caused by world-wide depression and war. They struggled through the 1920s and 1930s, finally closing in 1946 or 1947 (there is some dispute about the exact date). Years ago, it was thought that Loetz took its inspiration for iridized art glass from Louis Comfort Tiffany, but in recent years, more and more specialists in the field are contending that it was the other way around.

DATE OF ORIGIN

Circa 1900. This type of glass was originated by Max Ritter Von Spaun, whose father had married Suzanne Loetz's only daughter, Karoline. He called it Phenomenon glass, and it consisted of a variety of designs decorated with randomly pulled glass threads and an iridized surface. This type of ware was first exhibited in Paris in 1899.

PLACE OR COUNTRY OF ORIGIN

Klostermuhle, Bohemia. At the time this vase was made, Bohemia was part of the Austro-Hungarian Empire. Genuine pieces are sometimes found that are marked Loetz Austria. Now Bohemia is part of the Czech Republic.

RARITY

The size, color, and applied decoration make this a fairly rare and desirable piece. Some extremely stylish metal-mounted examples and pieces with a more elaborate and exuberant *Art Nouveau* style are a bit rarer and more valuable.

PUTTING IT ALL TOGETHER

Collectors, appraisers, and connoisseurs need to be very careful about making an incorrect attribution of a piece of glass to the Loetz factory. Misattributions of pieces to Loetz are rampant; sometimes it seems that almost any piece of unsigned art glass that appears to be Continental European in origin is given this label. This particular piece is right out of the textbooks, providing the basis for a firm attribution that collectors will accept without quibble. Fifteen years ago, Loetz glass was not very expensive because there were no reliable books on the subject that could help with identification. As confidence in the identity of the factory's products began to increase, so did the prices. Today, the value of the best Loetz prices can rival those realized by Tiffany. This Phenomenon vase is on the higher end of the better classification.

ITEM 3: RUBY GLASS PUNCH BOWL ON STAND

Just the Facts

FORM

Globular-form punch bowl on stand with lid surmounted by mushroom-shaped finial. The top of the punch bowl has a scalloped rim and the lid is notched to allow for the insertion of a ladle. The base is in the form of a shallow bowl with a notched rim and bottom cut with a star.

MATERIAL

Homogeneous red-colored glass (i.e., the glass is red throughout and is not a thin layer of red glass *flashed* on top of a much thicker layer of clear, colorless glass).

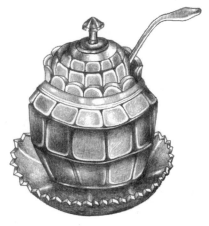

DIMENSIONS

The punch bowl is 12 inches tall from the base to the top of the finial. The stand is 10 inches in diameter.

METHOD OF MANUFACTURE

All parts of the punch bowl and stand were handblown. This is evidenced by the lack of mold marks and in the star-cut bottoms placed there to cover the pontils. All surfaces are panel cut, with the scalloped edge of the top of the bowl and the notched edge of the stand also being done by hand. The knob was applied to the lid using a wafer or thin disk of glass.

IDENTIFYING TRADEMARKS AND SIGNATURES

None.

CONDITION

Excellent, with just a few small chips in the notched groove where the ladle rested and was banged against the side.

PROVENANCE

The collection of the late Viscount L———.

The Evaluation Process

REFERENCES

Daniel, Dorothy. *Cut and Engraved Glass, 1771–1905,* William Morrow, New York, 1950.

Hajdamach, Charles R. *British Glass, 1800–1914,* Antique Collector's Club, Woodbridge, Suffolk, England, 1991.

HOW DO I KNOW IT IS OLD?

The decision about age centers around a careful examination of wear and the techniques used in the manufacturing process. All three pieces in this set exhibit the proper wear. The lip of the lid and flange around the top of the punch bowl's base show proper wear where they have come together countless times over the years, and both the base and the inside of the stand have wear where the punch bowl has rubbed against the base and the

bottom of the base has been moved across a table or some other hard surfaces. The small chips around the notch where the ladle rests is a good sign, as is the fact that the knob or finial has been attached to the lid using a wafer or thin disk of glass. There is no evidence of shortcutting in the decorating process in order to save on labor costs, which is a good sign of age. In addition, the cut panels are not a uniform width but vary slightly, which is an indication that they were done by hand.

History

Sometimes the simple cut panels found on this punch bowl and stand are not recognized immediately as being cut glass. The wide panels are very smooth to the touch. Only the crisp seams between each section and the slightly undulating surface reveal that the surface was mechanically cut away. Many people think of cut glass as being the elaborate pieces made after about 1875 that consist of deeply incised lines forming intricate patterns that catch light and reflect it like a faceted jewel. However, before 1875 or so, the designs found on cut glass tended to be somewhat simpler, and the simple flute or panel cut was one of the most popular and most commonly used motifs. In the 18th, 19th, and early 20th centuries, glass cutting was almost always done on *blanks* that were clear and colorless. Occasionally, a piece will turn up that was cut on a blank that has had one or more thin layers of colored glass flashed on top, and usually these colors are red, blue, green, white, or a combination placed one on top of the other. When the thin, colored layer (or layers) is cut through, it reveals the clear layer underneath to form an attractive contrast. This is called color-cut-to-clear. Rarer still are pieces that were cut on a solid color blank. They are usually found in shades of ruby, cranberry, cobalt blue, or green, and they are highly prized. Color-cut-to-clear pieces are now being made quite extensively and are flooding the market, but reproductions of cut glass on a solid-color blank are seldom encountered.

Date of Origin

It is difficult to date this piece precisely other than to say it is mid-19th century. This style of flute cutting on a clear or colored glass body was made as early as the 1840s and as late as the early 1870s. We feel that a circa 1860 date is probably about right.

Place or Country of Origin

It is difficult to ascribe this piece to a precise country or place of origin. A few covered punch bowls were made in America, but we do not believe this one was. There is a possibility that it is English, but we feel that it should be described as being Continental European to be safe.

Rarity

No one would call this punch bowl a great rarity, but examples in this kind of pristine condition and in this color are not seen in the marketplace very often.

Putting It All Together

This piece has a lot going for it, including its age, its color, its condition, and its somewhat rare and elegant form. Many collectors like red, and this piece would make a real statement if it were displayed in a dining room decorated with early- to mid-19th-century or even early Victorian furniture. It is also a plus that the punch bowl still has its original stand, because this component of the set was most commonly broken. The value of this set would be much improved if it still had its original punch cups, but they are almost never found with the bowls. This set was expensive when it was new and would have been found only in an upscale home where entertain-

ing guests was common. The best examples of this type of cut glass are often further embellished with *engraved* decoration. The plainness of the flute cutting makes this set a better example.

ITEM 4: MINIATURE ENAMELED
ACID-CUT BACK VASE

Just the Facts

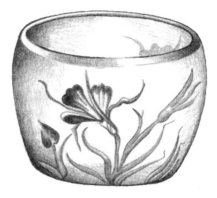

FORM

Ovoid-form miniature vase.

MATERIAL

Light blue glass with green enameled leaves and purple enameled flowers.

DIMENSIONS

1½ inches tall.

METHOD OF MANUFACTURE

This tiny vase was handblown. The evidence is seen on its base, which has been completely ground down to a flat surface both to eliminate the pontil and to make it rest properly on a flat surface. The top has been fire-polished to make it perfectly smooth and rounded. The leaves and flowers that form the decoration are raised above the surface, and this was done by cutting

away the background with acid. The design was either drawn or transferred to the surface of the glass with a wax-based ink, then covered with a wax to protect that area from the hydrofluoric acid. When this miniature vase was dipped in the acid, the background not covered with the protective wax was eaten away, leaving the decoration slightly raised above the new surface. The piece was finished by enameling the leaves and stems green and the flower head purple.

IDENTIFYING TRADEMARKS AND SIGNATURES

Daum Nancy, France.

CONDITION

There are no chips, cracks, or damage to the enameled decoration.

PROVENANCE

Property of a New York estate.

The Evaluation Process

REFERENCES

Arwas, Victor. *Art Nouveau to Art Deco, The Art of Glass,* Andreas Papadakis, Windsor, Berks, England, 1996.
Grover, Ray and Lee. *Carved and Decorated European Art Glass,* Charles E. Tuttle, Rutland, Vermont, 1970.

How Do I Know It Is Old?

Pieces of glass can be found that are fraudulently signed Daum Nancy, but it would be very unusual to fake a signature on such a small and comparatively unimportant piece. The wear on the bottom strongly suggests the date of this piece, and the exquisite and precise workmanship also support that this piece is old.

History

In 1870, Jean Daum had to flee the advancing Prussian army as it marched into the provinces of Alsace and Lorraine. He settled in Nancy, the historic capital of Lorraine, and lent money to a glassmaker, who went out of business in 1875, leaving Daum with the factory. Daum struggled to keep the glass factory going until his sons, Auguste and Antonin (sometimes referred to as the Brothers Daum), took over. One brother took care of production and the other concentrated on the business aspects; together, they made a real success of the enterprise that exists to this day. They were greatly influenced by the art glass they saw at the Paris Exposition of 1889 and began making a variety of very high-quality Art Nouveau–style glass that rivaled the artistic achievements of Nancy's other great glassmaker, Émile Gallé. Daum Nancy is justly famous for its *cameo*, acid-cut back, and enameled glassware.

Date of Origin

Circa 1900. Since this piece is marked France, it was made after 1891, when the McKinley Tariff went into effect, requiring that all items exported to the United States had to be marked with the country of origin, and before 1910, when the Art Nouveau style was no longer in fashion.

PLACE OR COUNTRY OF ORIGIN

Nancy, France, and so marked.

RARITY

Daum pieces of this quality are available on the current marketplace. Miniature pieces such as this one are a bit uncommon but are also available. Daum's more ambitious, highly artistic pieces can be very rare and valuable.

PUTTING IT ALL TOGETHER

The major plus for this vase is its size. Collectors are extremely fond of miniatures, and this vase is a charming example. The decoration found on this diminutive vase with its organic form and sensuously curved leaves and stems is Art Nouveau in design, which is also appealing to collectors. The perfect condition is a plus. On the minus side, the decoration is minimal and unexceptional. The workmanship is average (Daum's average is most companies' best), and this piece is classified as good.

ITEM 5: PERFUME BOTTLE

Just the Facts

FORM

Perfume bottle, which once contained Roget et Gallet's Paquerettes perfume. It has a cascade stopper decorated with daisies surmounting an undecorated bottle.

MATERIAL

Clear, colorless, pressed glass base with frosted colorless glass stopper.

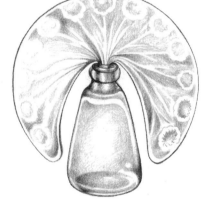

DIMENSIONS

3 inches tall.

METHOD OF MANUFACTURE

This piece was made by blowing glass into a mold (called blown-in-mold glass). The usual mold seams are not evident here because the maker took great care to polish them out. The stopper has been acid-dipped to create the frosted appearance.

IDENTIFYING TRADEMARKS AND SIGNATURES

R. Lalique France.

CONDITION

No chips or cracks, but there is a persistent brown stain in the bottom of the bottle from perfume residue that may or may not be removable. The stopper comes out of the bottle freely.

PROVENANCE

Property of a Chicago estate.

The Evaluation Process

REFERENCES

Launert, Edmund. *Scent and Scent Bottles,* Barrie & Jenkins, London, England, 1974.

Sloan, Jean, *Perfume & Scent Bottle Collecting,* Wallace-Homestead, Randor, Pennsylvania, 1986.

HOW DO I KNOW IT IS OLD?

This piece is very well documented as being a perfume bottle designed by René Lalique and produced during the first quarter of the 20th century. It exhibits proper wear; the solidified perfume residue in the bottom of the flask is also a sign of age. The fact that the mold seams were polished out is a good sign of age and authenticity because the makers of reproduction perfume bottles seldom take the time or go to the expense to take this extra step that was so important to René Lalique.

HISTORY

René Lalique (1860–1945) started his professional life as a jeweler. It is said that by the turn of the 20th century he was one of the most—if not the most—highly regarded jewelers in the world. Lalique was also a talented sculptor working in bronze, ivory, silver, and gold. In 1902, Lalique opened a small glass-making facility at Clairefontaine and began experimenting with pieces made using the *cire perdue* or lost wax method of casting glass. He would later rent another factory and purchase one that was run by his son, Marc. Initially, Lalique made small plaques of glass to use in his jewelry, but in 1907, M. F. Coty, the owner of Coty Perfume, asked him to design some scent bottle labels for him. This venture was so successful that Lalique eventually designed and made perfume bottles for Worth, D'Orsay, Rigaud, Roget et Gallet, Coty, and others. He gave up jewelry making altogether in 1911 and concentrated on designing and making glass objects. In addition to the commercial perfume bottles, he created decorative bottles, boxes and trays for the dressing table, tableware, lighting, and decorative objects from lead crystal glass. Most of Lalique's production was clear, colorless glass, but pieces can also be found in opalescent glass, and rarely, in colors such as red, amber, green, and black. Pieces made before René Lalique's death in 1945 are signed R. Lalique; pieces made afterward are signed Lalique. Usually, the name of the country of origin, France, appears with the Lalique name.

DATE OF ORIGIN

Circa 1920.

PLACE OR COUNTRY OF ORIGIN

France.

R A R I T Y

The *Art Deco*–style cascade stopper is very attractive to collectors. Although this bottle is hard to find, it is not one of the rarest examples.

P U T T I N G　I T　A L L　T O G E T H E R

For a number of years, perfume bottles have been of great interest to a large number of collectors. The bottles that held the perfume when it was initially retailed are called commercial bottles, and for some time these have been the focus of perfume bottle collecting. Currently, the emphasis has shifted just a bit and enthusiasts are becoming more and more interested in the bottles into which the perfume was transferred after it was brought home. These are often very decorative containers designed to be displayed either on a dressing table or carried in milady's purse. Lalique made both types of bottles. Examples of his work from the early 20th century are sometimes regarded as art and prices can be quite high. The one being evaluated here is a commercial bottle in the much desired Art Deco style, with a slight condition problem that holds its price down just a bit. As we have said, it is not among Lalique's rarest and finest, but it is a better example.

ITEM 6: SILVER OVERLAY PITCHER

Just the Facts

F O R M

Tankard pitcher.

MATERIAL

Cranberry glass (a lighter shade of red than ruby) with a sterling silver overlay.

DIMENSIONS

11½ inches tall and 5½ inches in diameter at the base.

METHOD OF MANUFACTURE

The glass pitcher is handblown and the pontil has been removed by grinding down the bottom to create a smooth base that allows the pitcher to sit flat on a surface. At the time it was made, this type of ware had various names, including silver deposit, silver overlay, silver inlay, silver-electroplated glass, and solid deposit. Today, only two of these terms are in general use among collectors—silver deposit and silver overlay—and they refer to glass made by two very different methods. What collectors now call silver deposit was made by painting on a design with a mixture of ingredients including borax, powdered silver flux, and white arsenic. The decoration was fired in a kiln, then the entire piece was placed in an electroplating bath. When the electric current was turned on in this bath, silver ions attached themselves to the painted areas, not to the unembellished areas. That is, silver was actually deposited on selected areas of the glass to make a design. Silver overlay, in contrast, was made by applying a pierced cutout pattern of sterling silver to the outside of the glass. The decoration on silver deposit is generally rather thin and easily damaged, whereas silver

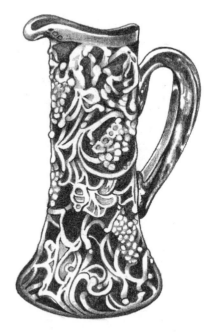

overlay is much thicker and somewhat more durable. The pitcher under evaluation is silver overlay.

IDENTIFYING TRADEMARKS AND SIGNATURES

The phrase *sterling silver* is on the metalwork.

CONDITION

The glass is in perfect condition with no chips, cracks, or clouding. The silver is also in perfect condition with no breaks and no losses of small pieces.

PROVENANCE

Descended in a Georgia family since the turn of the 20th century.

The Evaluation Process

REFERENCE

Shuman III, John A. *The Collector's Encyclopedia of American Art Glass,* Collector Books, Paducah, Kentucky, 1988.

HOW DO I KNOW IT IS OLD?

Modern glass with metal overlays can be found, but the metal is usually pewter, or in some cases bronze, brass, or silver plate. This type of high-quality glass with a cutout sterling silver overlay would be much too difficult and much too expensive to make for it to be an attractive target for

fakers. On an empirical level, the wear on the base indicates age and the small scratches on the silverwork indicate years of polishing.

History

Some sources say that the technique of applying silver to glass started in the 1880s, whereas others report a slightly later date in the 1890s. Silver overlay was rarely made after the end of the first quarter of the 20th century and is most often found on items meant to hold some sort of liquid such as pitchers and bottles.

Date of Origin

Circa 1900. The family reports that this piece first came into their possession at this time. Since this date agrees with the known history of such pieces, it can be accepted with some confidence.

Place or Country of Origin

This kind of ware is generally an American product, but there are exceptions. Beyond the style and type of glass, the one solid piece of evidence that this piece was made in the United States is the word *sterling* that appears on the silver. Marking pieces sterling is an American practice. We have seen this word used on some Mexican and Asian silver, but these objects are usually marked either with the country of origin or are clearly not American because of their design. Some early Scottish pieces use the word sterling or *stirling* as part of their mark, but these words appear on earlier pieces that do not incorporate glass parts.

RARITY

This type of pitcher has become relatively hard to find, and examples with a cranberry or ruby glass body are highly desired by collectors. Silver overlay can be found on a variety of objects, and the color of the base glass has a large bearing on the value. The most common examples and the least valuable are the silver overlay pieces found with clear, colorless, or amber glass bases. More desirable and much more valuable are the pieces with green, cobalt blue, ruby, and cranberry bases. Ruby and cranberry examples are among the most desired. The pattern also plays an important role in the valuation. Many contain a large area reserved for a monogram, which can hurt the value. The vintage pattern is commonly seen, and any design that is unusually stylish and features landscapes, people, or animals would command a premium. In general, the more ornate the silver overlay pattern, the better and rarer it is.

PUTTING IT ALL TOGETHER

Collectors much prefer silver overlay to silver deposit because the silver deposit pieces are never as well made, and the silver on these pieces is very fragile and easily damaged. Silver deposit items command only a small fraction of the value of silver overlay pieces, so it is very important for those doing evaluations to know the difference. The pluses for this pitcher are the color of its base glass, the fact that it is silver overlay and not silver deposit, and its pristine condition. If there is a minus, it is the standard vintage pattern, but it is very heavy and well executed on this piece. This is a best example.

ITEM 7: PAPERWEIGHT

Just the Facts

FORM

Paperweight containing three-dimensional fruit and leaves on a filigree or *latticino* background.

MATERIAL

Glass.

DIMENSIONS

2½ inches in diameter.

METHOD OF MANUFACTURE

This is a lampwork paperweight, meaning the leaves, fruit, and filigree background were made by an artisan who took rods of colored glass and formed the various elements by manipulating them over a heating device with an open flame called a lamp (the lamps used by modern lampworkers look like Bunsen burners familiar to chemistry students everywhere). The white basket-like background was made by intertwining white thread-like glass rods. The fruit and leaves, which rest on top of this arrangement, were made separately and assembled to make a pleasing still life. The various elements were very lightly attached to one another, then covered with a dome of clear, colorless glass. This is difficult to do and requires great skill, because sometimes when the molten glass is added to encase the decoration and

complete the paperweight, the heat of the clear glass can cause the lamp-work pieces to become distorted.

IDENTIFYING TRADEMARKS AND SIGNATURES

None.

CONDITION

Excellent, with no chips or bruising to the dome caused by the paper-weight being dropped.

PROVENANCE

Purchased at an antiques mall with no previous history of ownership available.

The Evaluation Process

REFERENCE

Jargstorf, Sibylle, *Paperweights,* Schiffer Publishing, Atglen, Pennsylvania, 1991.

HOW DO I KNOW IT IS OLD?

There is little doubt that this is an old paperweight because the base is clouded with an extensive network of random scratches caused by decades of being slid across paper, wood, and other desktop materials. The colors in this weight are also distinctively mid-19th century and have subtle shad-

ings and hues not found in similar but newer paperweights. In addition, research reveals that this paperweight is attributable to a particular factory at a particular time.

HISTORY

Items similar to paperweights have been made for centuries, but the name *paperweight* was not applied to these familiar glass spheres until about 1845. The classic period or golden age of paperweights is from 1845 to 1865, and this designation primarily applies to the production of three factories in France: Baccarat, St. Louis, and Clichy. However, the paperweight industry in France at this period was based on glassmaking techniques perfected in Venice over many centuries and centered around the Venetian use of long rods of colored glass called canes. As we said earlier, these were used to make the lampwork petal, leaves, pieces of fruit, and other pictorial elements that went into the making of some paperweights, but these canes could also be put together to form a kind of mosaic that is said to resemble a grouping of flower heads. This is called *millefiore* (literally "thousand flowers"), and when these rods are cut into thin slices, they can be used as the major design element or for a background decoration in paperweights and other types of glass. Other than the three French factories, there were concerns around the world making paperweights in the mid-19th century. In the United States, for example, both Boston and Sandwich and the New England Glass Company made weights that are now very collectible. It should be mentioned that the art of paperweight making is still very much alive today, and current collectors are extremely interested in modern pieces because the best of them are considered to be art. Baccarat, for example, continues to make fine paperweights, as do several companies in England and Scotland, but the main focus seems to be on the products of artists such as Paul Stankard, the Ysart family (particularly Paul Ysart), Rick Ayotte,

Charles Kazium, and many others. Keep in mind that some modern Stankard weights sell for more than $10,000!

DATE OF ORIGIN

Circa 1850. This is a classic period French paperweight, and this circa date is appropriate for an example of this sort.

PLACE OR COUNTRY OF ORIGIN

France, the Cristalleries de St. Louis factory (founded in 1767 as the Verrerie Royale de St. Louis). Several glass companies made paperweights similar to this one, but the profile or shape of this example is typically St. Louis and the pattern is also a documented one of theirs.

RARITY

French paperweights of the classic period that were made by one of the big three makers are always desirable. This paperweight, however, is a very standard design and of a type that is commonly seen.

PUTTING IT ALL TOGETHER

The pluses for this paperweight are that it is in very good condition, it is a classic period French weight, the factory that made it is identifiable, and it is very attractive. The minus is that it is not an exceptional example but one that is commonly found. It gets a good classification.

ITEM 8: VASE

Just the Facts

FORM

Square-bodied base with square neck.

MATERIAL

Glass.

DIMENSIONS

7½ inches tall.

METHOD OF MANUFACTURE

Handblown with vertical *mezza filagrana* stripes of amethyst and turquoise on one half and turquoise and white on the other half. Mezza filagrana means "half filigree" and consists of threads of glass running diagonally and parallel to each other.

IDENTIFYING TRADEMARKS AND SIGNATURES

Venini Murano Italia is acid stamped on the base.

CONDITION

Perfect, with no chips or cracks.

PROVENANCE

Private collection of individual who reported buying this piece in Italy in 1956.

The Evaluation Process

REFERENCE

Piña, Leslie, *Fifties Glass*, Schiffer Publishing, Atglen, Pennsylvania, 1993.

HOW DO I KNOW IT IS OLD?

There is very light wear on this piece and it is very difficult to see. It exists only on a few spots on the base, but this is acceptable on a a piece of glass that was made in the 1950s and was primarily designed to be seen, not used. The glass is called *Vetro Tessuto*, meaning "cloth" or "fabric" glass, and • although it was probably designed earlier, it is a product associated with Venini in the 1950s.

HISTORY

The signature on this piece tells us that it was made by Venini and Company, which was established on Murano in 1921 by Paolo Venini and Giacomo Cappellin. Before this venture began, Venini was a lawyer and Cappellin was a dealer in antique glass. The original name of the company was Vetri Soffiati Muranesi Venini Cappellin & Company. Cappellin left in 1925 to form his own glassmaking company, but Venini continued and employed some of the most important glass designers of the 20th century.

Carlo Scarpa became art director at Venini in 1932 and he designed the vase being evaluated. Scarpa left Venini in 1947, but many of his designs were made well into the late 1950s. Paolo Venini died in 1959, and the glass company passed out of the Venini family's possession in 1986.

Date of Origin

Circa 1955. The company reissued some glassware created by its early designers at the time of its 75th anniversary in 1996, but there is no record that this vase or Vetro Tessuto was among the items reproduced. In addition, there is no reason to doubt the provenance in this instance.

Place of Origin

As the signature states, Murano, Italy, which is an island near Venice.

Rarity

Over the years since it was founded, Venini has produced some spectacular examples of modern glass that can command respectable prices on the current market. Vetro Tessuto is a very respected type of Venini glass, but it is not the rarest or the most valuable. It is, however, rather hard to find.

Putting it all Together

This is a highly desirable piece of Venini glass, and its tricolored mezza filigrana decoration is very beautiful. There are no deductions, but it is a better rather than a best example.

ITEM 9: CORDIAL GLASS

Just the Facts

FORM

Cordial glass with a bucket-shaped bowl. The stem has a double opaque *air twist* stem with a central gauze.

MATERIAL

Clear, colorless glass and opaque glass.

DIMENSIONS

6¾ inches tall.

METHOD OF MANUFACTURE

To say that this process is complicated would be an understatement of vast proportions, but we will try to explain as best as we can. There are a variety of methods used to make an opaque twist stem. One of them is to place several rods of glass into a mold that is grooved down the center of the interior, then the rods are covered with molten glass and removed using two punty rods (one on either end of the glass), twisting and pulling until the desired twist develops. Another method is to make a pattern of circular holes or slits in a rod of glass, filling these openings with molten glass, then drawing and twisting until the twist is formed. This particular cordial glass also has a gauze in the center, which refers to a twist made from very fine opaque threads of glass that are twisted to make a rope-like feature down

the middle of the stem. This early cordial glass was made in three sections: the bowl, the stem, and the foot. Some wineglasses of this same period have only two parts, with the stem being pulled out of the same molten glass from which the bowl is formed and the foot attached separately.

IDENTIFYING TRADEMARKS AND SIGNATURES

None.

CONDITION

No chips, cracks, or clouding.

PROVENANCE

Discovered in a garage sale in Baltimore, Maryland. The owner knew only that it had belonged to his grandmother.

The Evaluation Process

REFERENCES

Newman, Harold, *An Illustrated Dictionary of Glass,* Thames & Hudson, London, England, 1977.
Wills, Geoffrey, *Antique Glass for Pleasure and Investment,* Drake Publishers, New York, 1972.

How Do I Know It Is Old?

The construction of this piece is a big clue to its age. Modern glasses with twist stems may look very much like this one at first glance, but they are usually not made in three parts. As a general rule, they are just one piece or at most two, and if the glass is more than one piece, it is very hard to see where the parts are joined together. On genuine antique examples, the join or joins between the various parts are usually fairly obvious. The slightly domed foot is another reassuring sign, as is the quality and the intricacy of the double twist and the gauze. It is hard to describe the next important sign of age on this object because it is a detail that takes a trained eye to discern: the color of the glass. Modern glass is usually very clear and sparkling and is truly colorless, but 18th- and early-19th-century glass can have a subtle cast to it that is often grayish or bluish. Those who have seen numerous pieces of 150-year-old-plus glass can spot this faint quality immediately, but it takes familiarity gained by going to museums, antiques shops, and antiques shows. Of course, the last sign of age is the wear on the base, which is extensive and as it should be.

History

The majority of all surviving pre-19th-century glass are drinking vessels. They can usually be dated by the type of bowl they have, the characteristics of the stem, and how the foot is shaped. Opaque twist stems, such as the one on the cordial glass being evaluated here, originated about 1747 (that is the earliest dated specimen) and were in vogue until about 1775. Glasses with twist stems are generally considered to be either English or Continental European in origin (a colored thread incorporated in the twist would be an indication of a possible non-English origin). It is imperative to understand that there are far more modern twist-stem glasses than

antique ones, so an example should be presumed to be modern until it is proven beyond any doubt to be 18th century.

DATE OF ORIGIN

Circa 1760. The opaque nature of the twist in this glass narrows the years in which it might have been made into the 1755 to 1775 range.

PLACE OR COUNTRY OF ORIGIN

England. This cordial glass is very typical of pieces made in England. A Continental European origin is unlikely.

RARITY

Twist-stem glass from the 18th century is rare and highly prized by collectors. Cordial glasses are a desirable shape within the wineglass category, and this one would only be rarer if it were enameled or engraved (and rarer still if that decoration could be attributed to a known artist or maker).

PUTTING IT ALL TOGETHER

The pluses on this glass are the form and the intricacy of the opaque twist and gauze, as well as its excellent condition. The minuses are the lack of any kind of decoration and the inability to attribute this glass to a particular maker with some certainty. It gets a better classification.

ITEM 10: PAIR OF CORNUCOPIA VASES

Just the Facts

FORM

Cornucopia vases.

MATERIAL

Red cut to clear glass with gilded bronze mounts and a white marble base.

DIMENSIONS

6½ inches tall.

METHOD OF MANUFACTURE

The glass portion of this pair of vases started out with clear, colorless glass being blown into horn shaped vessels. Then a thin layer of red glass was flashed, plated, or overlaid on top of the clear, colorless glass, meaning that

the vases were literally dipped into molten red glass. This produced a very thin layer of red over a thick body of clear, colorless glass. Next, circular segments were cut through the red to reveal the clear layer below. The round "windows" that were formed are called *punts* or *punties*. When this was finished, each vase

was placed into a mount or socket made from cast gilt bronze attached to a rectangular white marble base.

IDENTIFYING TRADEMARKS AND SIGNATURES

None.

CONDITION

The vases are in perfect condition except most of the gilding has been worn off the bronze mounts.

PROVENANCE

Purchased at an estate auction at a Mississippi antebellum home. At the time of sale, they were claimed to be original to the house, which was built in the 1840s.

The Evaluation Process

REFERENCE

Newman, Harold. *An Illustrated Dictionary of Glass*, Thames & Hudson, London, 1977.

HOW DO I KNOW IT IS OLD?

Reproductions are not a problem with these pieces, but an inspection is still in order. In this case, the extensive wear of the gilding on the bronze mounts is a good sign, but make sure the wear is natural and occurred as a

result of cleaning. Fake wear to gilding tends to be a little bit blotchy and is often left on places where it should have worn off because the faker thought patches in these places would be aesthetically pleasing. The mounts in this case have a very dark surface with just a bit of gilding remaining in places that would have been hard to reach with fingers or with cleaning materials. The marble base shows discoloration from decades of being handled and absorbing dirt and oil. The final positive sign of age is that the glass itself is obviously hand-cut and the fingers can pick up a certain amount of sharpness on the edges of the punties.

HISTORY

Cornucopia vases were very popular in the mid-19th century when neoclassicism was popular. They were commonly used as decorations for tables, sideboards, and occasionally mantels. The bronze mounts are often in the shape of a ram's head or sometimes formed like a gloved hand with the vase inserted at the wrist. They are associated with the Baccarat factory in France, but they were made in many other locations in Continental Europe and in England.

DATE OF ORIGIN

Circa 1860. They are almost always from the 1850s to the 1870s.

PLACE OR COUNTRY OF ORIGIN

Continental Europe. A more precise location is impossible, but the leading candidate would be Bohemia.

Rarity

These are by no means rare, and similar pieces are available. However, the cutting found on this pair is somewhat unusual, since most pairs of cornucopia vases are single-layer glass and simply flute cut, enameled, or left completely unadorned. The red-cut-to-clear decoration makes these vases an above average example.

Putting It All Together

The first plus for these vases is that they are a pair. This is very important because surviving singles are not nearly as desired. In addition, the color is very popular with collectors, and the neoclassical form is particularly appealing to buyers looking for good design for decorative purposes. If there is a minus, it would be that the marble base is a little plain. Often the marble slabs are mounted on elaborate bronze or gilt bronze bases, which can add significantly to the visual appeal. Therefore, these vases get a better classification.

LOT 3

Pottery and Porcelain

ITEM 1: PORCELAIN FIGURE GROUP

Just the Facts

FORM

Figure group (Joe hates the word *figurine* and feels it should only be applied to mass-produced, inexpensive items of no merit whatsoever) consisting of three *putti* musicians cavorting on a Rococo-style round base with architectural elements (i.e., a fallen column and a capital) and leafage.

MATERIAL

Chinese-style *hard paste porcelain*. To determine this, find an unglazed spot on the base that cannot be seen and attempt to make a small scratch with a steel-bladed knife. Hard paste porcelain will not scratch and will remove some of the steel from the knife blade, leaving a gray mark that can be wiped off.

DIMENSIONS

11½ inches tall.

METHOD OF MANUFACTURE

The various components of this figure group were molded separately, then put together and fired in a kiln at a very high temperature to fuse them. The piece was hand-painted and fired again at a lower temperature to make the glaze permanent. Last, the gold accents were painted on and the piece was fired a third time at a still lower temperature.

IDENTIFYING TRADEMARKS AND SIGNATURES

A pair of crossed swords painted under the glaze in blue with a star below the handles that resembles an asterisk. This is the mark used by the Meissen porcelain factory during the Marcolini period (1774–1813).

CONDITION

The piece is in good condition except for some minor losses of the *putti*'s fingers. Three are partially missing.

PROVENANCE

Purchased in Germany shortly after the end of World War II by the wife of a colonel in the United States Army.

The Evaluation Process

REFERENCES

Berling, Dr. K., editor. *Meissen China, An Illustrated History,* Dover Publications, New York, 1972.

Rontgen, Robert E. *Marks on German, Bohemian, and Austrian Porcelain, 1710 to the Present,* Schiffer Publishing, Exton, Pennsylvania, 1981.

Ware, George W. *German and Austrian Porcelain,* Bonanza Books, New York, 1963.

HOW DO I KNOW IT IS OLD?

One of the first things we do when we are trying to determine how old a figure group might be is to look at the eyes. If the eye color is blue, we can be almost sure the piece is 19th century or later; but if the color is brown, an 18th-century date of manufacture is possible. The eye color on the three *putti* is brown. At 11½ inches tall, the size of this figure group is in its favor because many of the late-19th- and early-20th-century examples tend to be somewhat smaller. The color of the glaze on this piece is also very warm and is not the colder colors associated with modern pieces. Unfortunately, making this judgment requires experience and is not something the novice evaluator should attempt until he or she has seen significant numbers of 18th-century porcelain figures. Examining the bottom of this figure group is reassuring because there is a very noticeable amount of wear. There are some who would say that the mark is the most meaningful feature on the bottom, but we want to point out that the crossed swords mark is one of the most frequently reproduced in the world and that Meissen itself has used it for more than 250 years. This crossed swords mark with the star below and between the hilts is not normally found on reproductions or on

later Meissen productions, but a very similar mark was used by a Russian company known to collectors as Gardener. This Russian concern was founded by an Englishman in 1758 and reportedly still exists. The fact that Gardener used a mark very similar to the one on this figure group is a cause for worry, but research reveals that this is a Meissen form that originated in the 18th century.

HISTORY

In a nutshell, the Royal Porcelain Manufactory at Meissen began when an alchemist named Johann Friedrich Bottger, working with Ehrefried Walther von Tschirnhaus, discovered the secret for making Chinese-style hard paste porcelain. The first experimental piece was fired in 1708, but full-scale production did not start until 1710. Shortly thereafter, the Meissen secret (called the arcanum) was stolen, and hard paste porcelain technology spread all across Continental Europe in relatively short order.

DATE OF ORIGIN

Third quarter of the 18th century. The mark on this piece is genuine and was in use from 1774 to 1813. It is called the Marcolini period by collectors, referring to Count Camillo Marcolini, who became director and manager of the Meissen factory in 1774. The modeling on this figure group appears to be in the style of Michael Vincent Acier, who was employed at Meissen from 1764 to 1779, making a date in the early third quarter of the 18th century plausible.

PLACE OR COUNTRY OF ORIGIN

Royal Porcelain Factory Meissen, Saxony, Germany.

RARITY

Eighteenth-century Meissen figures do not show up every day, but they are available in international auctions and in upscale shops. This particular model with its three figures and good size is desirable if not a great rarity.

PUTTING IT ALL TOGETHER

The big plus with this figure group is its 18th-century origin and the fact that it was made at Meissen. The missing fingers are not a serious problem because they are expected losses. It would have been very difficult for this group to have survived for more than 200 years without at least one of these tiny, fragile appendages being lost. The value of this piece is kept down because it is a standard production item and not an earlier work of art by the most desired Meissen modeler, Johann Joachim Kandler. The classification is only good.

ITEM 2: PORCELAIN BASIN

Just the Facts

FORM

A basin with an outward-turning or everted rim with an interior painted with panels or reserves of figures in an interior setting alternating with panels of birds and butterflies. The exterior is decorated with widely inter-spaced flowers.

MATERIAL

Hard paste porcelain enamel and gilding.

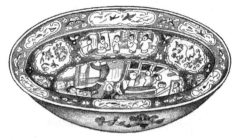

DIMENSIONS

16 inches in diameter.

METHOD OF MANUFACTURE

The basin is hand-thrown on a potter's wheel, and the decoration is hand-applied, as is the gilding.

IDENTIFYING TRADEMARKS AND SIGNATURES

None.

CONDITION

Excellent, except for some abrasion on one portion of the bowl's outer rim and some wear to the gilding on the edge. Otherwise, no chips or cracks.

PROVENANCE

Descended in a family originally from Boston, Massachusetts, engaged in the China trade.

The Evaluation Process

REFERENCES

Andacht, Sandra, *Oriental Antiques and Art: An Identification and Value Guide,* Wallace Homestead, Greensboro, North Carolina, 1987.

Cox, Warren E. *The Book of Pottery and Porcelain,* Crown Publishers, New York, 1970.

Medley, Margaret. *The Chinese Potter, A Practical History of Chinese Ceramics,* Charles Scribner's Sons, New York, 1976.

Wain, Peter, and Wood, Jo, editors. *Miller's Chinese and Japanese Antiques Buyer's Guide,* Miller's (a division of Octopus Publishing Group), Tenterden, Kent, England, 1999.

HOW DO I KNOW IT IS OLD?

This kind of Chinese ware is known as Rose Medallion. It is a pattern that has been made for more than 175 years and its production continues to this day. Most of the later Rose Medallion ware will be on flawless, very white porcelain, which is a quick giveaway that the piece is new. The porcelain used to make the piece being evaluated here is very dense and gray and even looks a bit crude to eyes used to porcelain being perfectly smooth and meticulously finished. Most late-19th- and 20th-century Rose Medallion will be marked either China (circa 1891 to 1920) or Made in China (circa 1921 and later). Sometimes these telltale marks have been ground away. However, this process always leaves evidence behind; an otherwise inexplicable abraded area on the bottom is a good indication. A careful examination reveals that this basin has never been marked. Finally, the real clue that this bowl is old is found in the nature of the gilding. Older Rose Medallion pieces were accented with rather large amounts of gilding that

should appear warm and burnished, which is the case on this basin. Newer pieces either have less gold or the gold is too lavish and much too bright and brassy.

HISTORY

This basin falls into several groups. First, it is Chinese Export, meaning that it was made in China for the sole purpose of being exported to the West because these products did not appeal to Chinese tastes. Second, it is *famille rose* or rose family, meaning that the enamel colors include a pinkish hue, which to the Chinese was a "foreign" color. It was not used on Chinese wares until the early 18th century (circa 1720) when an opaque rose-colored enamel made from gold and tin oxide was introduced into their color palette by European merchants and craftsmen. One source says that it took the Chinese approximately 10 years of experimenting to perfect the coloration, but they mastered it about 1730, and *famille rose* wares are now a favorite in the West. Third, this basin is in the Rose Medallion pattern group, which features panels of decoration around a center reserve or medallion that is usually round. The panels surrounding this central decorative element alternate. One panel will feature a scene with people in it and the next will contain such elements as flowers, birds, and butterflies. The central medallion is often decorated in floral motifs, but on the basin being evaluated, the medallion is filled with an elaborate interior with human figures.

DATE OF ORIGIN

Mid-19th century. This is determined by the fine detail of the painting and the amount and nature of the gilding, as discussed earlier.

PLACE OR COUNTRY OF ORIGIN

Canton, China. *Canton* was one of the great centers for the making of Chinese Export china. This piece is in the style of that location.

RARITY

Rose Medallion was shipped to Europe and the United States by the literal boatload. It and other wares were used as ballast to keep the ships upright, and today, there are vast quantities available. Most of what is found is dinnerware, and this large basin is uncommon but not exceedingly rare.

PUTTING IT ALL TOGETHER

There is a large group of collectors interested in Chinese Export china in the Rose Medallion pattern. Due to the huge amounts of late-19th- and 20th-century examples found on the current antiques market, collectors are always happy to find examples from the mid-19th century, and they are especially delighted if those pieces are in forms other than the shapes associated with dinnerware. Plates, small bowls, and platters are widely available, whereas other objects such as this large basin are not. The abraded edge and the rubbed gold will diminish the value. This is a better piece.

ITEM 3: PAIR OF EWERS

Just the Facts

FORM

The body of the ewer has a rectangular section in a teardrop form with arching handles. The handles are "ear form." The decoration has panels of pomegranates and cherry blossoms against a background of octopus vine and flowers.

MATERIAL

Hard paste porcelain, enamel, and gilding.

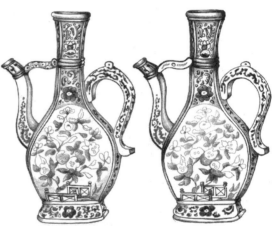

DIMENSIONS

15 inches tall.

METHOD OF MANUFACTURE

The bodies are molded; the spouts and the handles have been applied. All the decoration is by hand, done with the "gosu" blue under the glaze and the iron-red-and-gold overglaze.

IDENTIFYING TRADEMARKS AND SIGNATURES

None.

CONDITION

Perfect, with no chips, cracks, or damage to overglaze decoration.

PROVENANCE

Property of a San Francisco, California, estate.

The Evaluation Process

REFERENCES

Gorham, Hazel H. *Japanese and Oriental Ceramics,* Charles E. Tuttle,
 Rutland, Vermont, and Tokyo, Japan, 1990.
Schiffer, Nancy N. *Imari Satsuma and Other Japanese Export Ceramics,*
 Schiffer Publishing, Atglen, Pennsylvania, 1997.

HOW DO I KNOW IT IS OLD?

The first clue to the age of these ewers is that the colors other than blue are painted over the glaze. The red in particular can be felt with the fingers, which is a good sign that the piece is not modern. On most pieces from the late 19th century onward, all the colors are placed under the glaze and cannot be felt as raised areas. The gold color is rich, burnished, and not particularly shiny. It is completely unlike modern gold, which tends to be very bright. The color of the blue also suggests a pre-1869 date because it is "gosu" blue rather than a blue obtained from cobalt oxide. Gosu is a pigment obtained from Asian river pebbles rich in cobalt. It was mixed with thick green tea and used as a colorant on ceramics. Gosu blue has a slightly grayish tone and is rather mellow compared to pigment made from cobalt

oxide, which is more intense and somewhat harsher in tone. Gosu also tends to be less evenly applied and has a tendency to exhibit very subtle light and dark areas. On these particular ewers, an examination of the leaf tendrils on the base, neck, and handle reveals that most of the design is a very deep blue, but here and there are short sections that are almost gray. If you know what to look for, this is a sure sign of an older example. Cobalt oxide was first used at the Arita kilns in 1869, and a uniform deep dark blue pigment is a sign of a late-19th- or 20th-century origin. In addition, the form of these ewers is very complicated and is not one that a modern copier would try to duplicate. Last—and we know we have beaten this one to death—the proper wear can be seen on the bottom and in the areas where the ewers have been repeatedly handled.

HISTORY

Imari is the name given to porcelain wares that were exported to the West from the Japanese port with that name, which is located on the island of Kyushu. These porcelain pieces were actually made in and around the town of Arita and they are based on Chinese porcelains of the Ming Dynasty. The first Imari porcelain bound directly for Europe left this port in 1660 and was carried by ships of the Dutch East India Company. These first wares were blue and white, which collectors call *sometsuke*. These were followed by *sansai* Imari or Old Japan Imari, which refers to wares decorated with blue under the glaze and red and gold over the glaze. This addition of the red was an important step and part of the main thoroughfare in Arita was called Red-Picture-Street. Up until 1770, there were only 11 households on this street allowed to apply the enamel decoration (red at first, later green, yellow, and purple), but in that year 5 more households were added, raising the number to 16. A destructive 1828 fire in the valley where Arita is located caused a general decline in the quality of Imari wares.

DATE OF ORIGIN

Last half of the 18th century (Edo Period). It is difficult to date these ewers any closer than this, but the shape of the vessels, the style, and the quality of the decoration suggest a pre-1800 date.

PLACE OR COUNTRY OF ORIGIN

Arita, Japan. The content and style of the decoration plus the ear-shaped handle all proclaim these ewers to be Japanese and Imari.

RARITY

A pair of 18th-century Imari ewers in perfect condition with this kind of very high-quality decoration is extremely hard to find.

PUTTING IT ALL TOGETHER

This pair of ewers is really superb, but while the decoration is excellent, it is not quite as good as that done 100 years earlier. Also, many Western collectors find the decoration of early *Nishikide* or *brocade Imari* to be more appealing. Among sansai Imari, however, these are best examples.

ITEM 4: POTTERY JUG

Just the Facts

FORM

Pitcher or jug with bulbous body, short, pointed lip, and strap handle. One side is decorated with a representation of a ship, *The Aurora of Philadelphia.* The name Henry Stephens is lettered under the spout. The other side has a representation of George Washington surrounded by a ribbon with the names of 15 states.

MATERIAL

Creamware pottery, lead glaze, and enamel. Creamware is a cream-colored earthenware that was made by any number of English potteries during the 18th, 19th, and 20th centuries. It varies in color from almost white to the somewhat yellowish white of cream. Potters made it to compete with white porcelain, and as the 18th century wore on, it became very lightweight. Creamware was perfected by Wedgwood, who called it *Queen's Ware,* and that company is still making this product to this day.

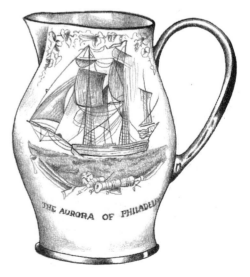

DIMENSIONS

11½ inches tall.

METHOD OF MANUFACTURE

This creamware pitcher has been decorated using a transfer, which is a process that is much older than many people suppose. There is some disagreement as to who invented the transferring of prints to ceramic bodies, but many ascribe it to John Sadler, who applied for a patent on the process in 1756. It is said that Sadler was a printmaker in Liverpool who threw out some prints that did not meet his standards and the ink on these prints was not yet dry. The legend then states that Sadler noticed some children playing with them by pressing the prints against shards of pottery (one of Liverpool's major industries) and that a faint impression of the print's design was left behind. Sadler eventually perfected the printing of pictures or designs on tissue paper that could be transferred to the surface of a piece of pottery or porcelain. He took Guy Green in as a partner and together they opened a Printed Ware Manufactory in which they applied prints to other people's pottery. Wedgwood was a big customer of theirs until 1763 when they purchased the right to perform the process themselves. The ship and the garland that surrounds it are all transfer printed in black, as is the title, *The Aurora of Philadelphia.* The water, American flag, ship's body, handle, and spout have been enhanced by the addition of hand-coloring.

IDENTIFYING TRADEMARKS AND SIGNATURES

None.

CONDITION

The lip on this jug has been extensively repaired and has been remade to some extent. The handle is cracked and repaired, and the coloring on the base, handle, and spout is extensively worn.

PROVENANCE

Property of a Boston estate.

The Evaluation Process

REFERENCES

Godden, Geoffrey A. *British Pottery: An Illustrated Guide*, Clarkson N. Potter, New York, 1974.

Ray, Marcia. *An Encyclopedia of Pottery and Porcelain for the American Collector*, Crown Publishers, New York, 1974.

HOW DO I KNOW IT IS OLD?

The age of this jug is written in the cracked handle and in the repaired spout. There have been reproductions of jugs such as this one, but they are unconvincing. The body is generally too white and is not at all like the cream color of the originals.

HISTORY

There are records of earthenware being made in the port of Liverpool since the end of the 13th century. Toward the end of the 18th century, Liverpool was a center for the production of creamware. It was also a port for ships from the new country known as the United States of America, and the Liverpool potters shamelessly pandered to this trade. They produced jugs and other objects with black transfer printed decoration on creamware bodies proclaiming the glory of the new nation that had so recently defeated Britain in a savage war. These English potters depicted such

scenes as an American sailor with his foot on the head of a vanquished British lion and images of Lafayette with Benjamin Franklin. Often, the American sailors who came into the port of Liverpool wanted jugs that depicted their vessel; these are now known to collectors as shipping jugs. All of these items were out of fashion by about 1825.

DATE OF ORIGIN

Circa 1797. Lloyd's Register of Ships records that Henry Stephens, whose name is under the spout on this jug, was master of *The Aurora of Philadelphia* from 1796 to 1798, when the ship was decommissioned. It is logical that this jug was made between these two dates or just a bit later at most.

PLACE OR COUNTRY OF ORIGIN

Liverpool, England. Jugs of this type are traditionally associated with this location, but the exact maker will never be known.

RARITY

This jug is very rare. The fact that the name of the ship and its master are listed on the piece is a factor much in its favor.

PUTTING IT ALL TOGETHER

Liverpool creamware shipping jugs have become very desirable and come up for sale much less frequently than they once did. This jug is a rare historic record that appeals to a broad range of collectors. The condition is the big detraction, and because of it, this is a good piece instead of a best.

ITEM 5: COVERED BOWL AND STAND

Just the Facts

FORM

This type of bowl and stand or underliner is called an écuelle, or, in this case, an écuelle couverte et plateau (i.e., covered écuelle and stand). Écuelle is French for "porringer" and is sometimes defined as a two-handled cup traditionally used for serving hot drinks made with wine. Porringer, however, is a derivative of the word porridge, which suggests this vessel was originally designed to contain boiled cereal that was usually eaten with milk. It is thought that from the beginning of the 18th century onward, porringers were largely decorative rather than useful items. This shape originated in the 17th century. This écuelle has a deep blue *ground* (called beau blue) with floral reserves and gilt enrichment.

MATERIAL

Hard paste porcelain, enamel colors, and gilding.

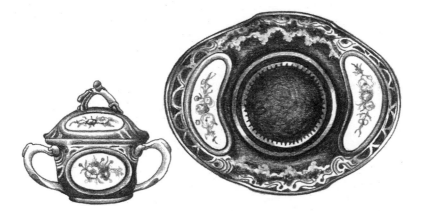

DIMENSIONS

Height of covered cup, 3⅛ inches; length of stand, 7¾ inches.

METHOD OF MANUFACTURE

All handmade. Handles were crafted separately and attached. Enameling and gilding was all done by hand.

IDENTIFYING TRADEMARKS AND SIGNATURES

On the base, the pieces are marked with the monogram for King Louis XV, who became the actual owner of the Geures factory in 1759. It consists of two interlaced L's facing each other and surmounted by a crown. The crown was used only on pieces that were made of hard paste porcelain. Inside the L's, there is the letter *y*, but this letter can appear beside the mark as well. This is the familiar mark of the Sevres factory and the *y* is their date letter for 1776. There is also a painter's mark, *cp*, in black enamel for Antoine-Joseph Chappuis, who was known for his depictions of flowers and birds. There is another mark resembling the pound sign (#), which was used by Michel-Barnabé Chauvaux, who was the gilder. All of these marks are consistent with one another and appear to be correct.

CONDITION

The condition is excellent except for some wear to the gilding on the handles and in the center of the stand.

PROVENANCE

Private collection.

The Evaluation Process

REFERENCES

Cox, Warren E. *The Book of Pottery and Porcelain,* Crown Publishers, New York, 1970.

Theus, Will H. *How to Detect and Collect Antique Porcelain and Pottery,* Alfred A. Knopf, New York, 1974.

HOW DO I KNOW IT IS OLD?

It is said that up to 90 percent of all pieces that are marked with the Sevres insignia are fakes. Every piece that is encountered must be viewed with extreme suspicion and nothing must be taken at face value. Pieces with ground colors (i.e., solid-color backgrounds) must be viewed with particular caution because they were the target of many fakers. The first positive sign about this écuelle and stand is that it is a very well-documented Sevres shape. It is absolutely right in every detail, from the distinctively shaped oval stand to the Rococo handles on the bowl and *knop* on the lid. Another reassuring detail is that the porcelain is very white with a slight bluish tone, and it glistens, as Sevres hard paste porcelain should. When this écuelle was made, Sevres had only been making hard paste, which they called *pâte dure,* for a few years; the crown over the mark was placed there to distinguish between the new hard paste products and the more traditional soft paste products. Prior to 1772, all Sevres pieces were soft paste, and this artificial porcelain was in use until the beginning of the 19th century. The point here is that all pre-1772 Sevres should be soft paste; a hard paste example with a pre-1772 date letter on it is a fake. Sevres started putting date letters on its productions in 1753, when an A was placed inside or beside the interlocked L's mentioned previously. This continued through

Z, which was used in 1777, then the sequence was started over with AA for 1778. This practice ended in 1795 with pieces dated RR (another system was used briefly at the beginning of the 19th century, but we will not go into it here because it is not important to our discussion). We have discussed the dating system at some length because it is a detail that fakers often foul up. Many reproductions use the date letter A, so any piece with this designation should be examined with the attitude that it is probably a fake. Any piece with this letter should be soft paste, which means that the exposed porcelain on the rim can be scratched with a steel knife. Any hard paste example with an A will be a fake. Any piece with the conjoined L's that has a letter C for a date is also suspicious because many fakes were made by a man named Caile who worked in the early 20th century. BB inside the L's can also be a problem because it was used by Bareau and Bareau, who made fakes in the 20th century as well. The *y* on the écuelle being evaluated is not suspicious; the mark itself is very strongly drawn (as it should be) and is the right shade of blue. The wear on these pieces is very reassuring, as is the superb quality of the coloration and painting. This écuelle and stand are genuine 18th-century Sevres.

HISTORY

The French were a little slow to get into the porcelain game after Meissen discovered how to make Chinese-style hard paste porcelain in 1708. Under the patronage of Louis XV, a factory was set up in 1738 in a riding academy at Vincennes, which is near Fountainebleau. The work was largely experimental until 1745, when soft paste porcelain was made from sand, sea salt, saltpeter, soda, alum, and alabaster that was fired, crushed, and mixed with white clay. This endeavor was never financially successful, but in 1753 it was decided that the factory would be moved from Vincennes to Sevres, which was near the home of Madame de Pompadour, who was one of the enterprise's most vocal supporters. They

moved into the new facilities in 1756, but soft paste was still the product being made. Sevres refused to buy the secret for making hard paste because there were no known deposits of high-quality kaolin in France at the time and because the competition from the Germans, Austrians, Japanese, and Chinese was just too great. In 1768, the kaolin deposits at Yrieix near Limoges were discovered, but production of hard paste did not begin until 1772. Soft paste continued to be made until the early 1800s, but production was briefly resumed in the late 19th century. Some of the most luxurious porcelains ever made were manufactured in the early years at Vincennes and Sevres because the factory's biggest clients were French royalty, who were very demanding customers indeed. Sevres was owned by the French crown until the French Revolution, then it passed to the control of the new state. The company exists to this day.

DATE OF ORIGIN

1776.

PLACE OR COUNTRY OF ORIGIN

Sevres, France.

RARITY

This item would not turn up at most auctions or antiques shops nor would it turn up in the vast majority of upscale homes. However, it is not a great Sevres rarity. The best examples of Sevres would have a more unusual or desirable ground color such as yellow or pink, and the painting would have to be something other than flowers.

PUTTING IT ALL TOGETHER

The name Sevres is magical to collectors, conjuring up images of royalty and what some feel is the finest Western porcelain on the planet. Some of the most desired examples have a royal provenance, such as Marie Antoinette's milk pail or a gift that was given by the royal family to a distinguished personage. Pieces with elaborate decorations and enamel jeweling against exotic ground colors are highly desired and are far above this écuelle, which is very beautiful, but is basically a utilitarian object with a standard decoration. The small amount of damage to the gilding in the center of the stand where the base of the bowl came in contact with would also distress collectors to a small degree. This is a better piece.

ITEM 6: POTTERY JUG AND CIRCULAR TRAY

Just the Facts

FORM

Bottle-shaped jug with original stopper and tray decorated in the Islamic style with designs meant to simulate *cloisonné*.

MATERIAL

Pottery or earthenware also called faience. Faience is generally considered to be a French word derived from the town of Fayence or from the name of the Italian town of Faenza. Both locations made tin-glazed earthenware in the 15th century that is known to collectors as majolica. Classically, pieces

of faience have a thick, white, tin-based glaze decorated with colorful embellishments. Over the years, however, the term has been expanded to embrace all kinds of colorful earthenware with thick glazes from France, Italy, Germany, and Portugal.

DIMENSIONS

The jug is 17 inches tall and the tray has a diameter of 15¼ inches.

METHOD OF MANUFACTURE

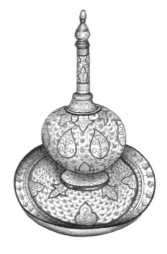

The three pieces (bottle, tray, and lid) were molded and the decoration was impressed into the moist clay before the first firing. The enamel colors were then applied within the impressed lines to create the illusion of cloisonné. The piece was fired a second time. The background is blue with darker blue accents, and the reserves in the center of the jug's body have a yellow ground with green leaves and blossoms that shade from pink to white.

IDENTIFYING TRADEMARKS AND SIGNATURES

The bottom of the tray and jug are impressed with the word Longwy and printed marks in green that also contain the word *LONGWY.* These are marks of the Société des Faienceries de Longwy et Senelle.

CONDITION

Excellent, with no chips or cracks or abrading to the decoration.

PROVENANCE

Private collection.

The Evaluation Process

REFERENCES

Cox, Warren E. *The Book of Pottery and Porcelain,* Crown Publishers, New York, 1970.

Kovel, Ralph and Terry. *Kovels' New Dictionary of Marks, Pottery and Porcelain: 1850 to Present,* Crown Publishers, New York, 1986.

Ray, Marcia. *An Encyclopedia of Pottery and Porcelain for the American Collector,* Crown Publishers, New York, 1974.

HOW DO I KNOW IT IS OLD?

At the time this book is being written, the marks on this piece are considered to be trustworthy as there are no reproductions of this type of ware. The impressed Longwy mark was first used about 1878 and the particular stamped mark originated about 1875.

HISTORY

The Longwy factory is located in the French area of Lorraine, and they have been making faience since 1798. They are reportedly still in business. They are most famous for their fine *Art Deco* wares of the 1920s and 1930s and for their enameled faience in the style of cloisonné, which is generally from the last half of the 19th century and later.

DATE OF ORIGIN

Last quarter of the 19th century, circa 1885. This circa date is calculated from the marks and from the tastes of the time period for brightly colored designs based on Asian and Islamic themes.

PLACE OR COUNTRY OF ORIGIN

France.

RARITY

Small pieces of this type of Longwy pottery are encountered with some frequency, but more impressive examples such as this one are seldom seen. This set is relatively uncommon.

PUTTING IT ALL TOGETHER

Longwy is not exactly a household name even among most collectors, and those who know it often associate it with Art Deco–style pottery, which this is not. Longwy, however, is a respected name, and there is a small but dedicated collector following for their upscale 19th-century art pottery of which this bottle-shaped jug and tray are an attractive example. The big pluses for this set are that it is beautiful, intricate, exotic-looking, and respectably old. In addition, the blue and yellow that predominate on these pieces are good colors to attract interior designers looking for unusual accent pieces. The minus is the relative obscurity of the maker and the fact that this kind of product has not made a big impression on the American market. This is a better example.

ITEM 7: FOUR CANDLESTICKS

Just the Facts

FORM

Candlesticks in the form of curling horns on a circular base with single candle cups attached in a twist of the horn near the end.

MATERIAL

Tinted hard paste porcelain with gilt enrichment.

DIMENSIONS

Each candlestick is 9¼ inches tall.

METHOD OF MANUFACTURE

Molded, hand-assembled, and hand-gilded.

IDENTIFYING TRADEMARKS AND SIGNATURES

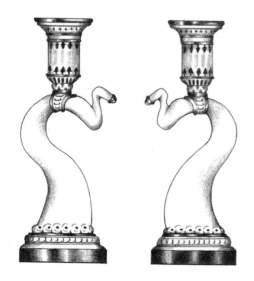

These four candlesticks have a variety of marks from the Worcester Royal Porcelain Company, commonly called Royal Worcester. The first is a crown above a circle; inside the circle are four intertwined W's around a crescent that contains the number 51. Surrounding the circle is

the name Royal Worcester England and between the R in Royal and the crown at the top of the circle there are three dots. Along with this are several impressed and incised marks identifying, among other things, when the design was first registered with the English patent office.

CONDITION

Excellent with no flaws.

PROVENANCE

Deaccessioned from the museum of an American land-grant university. In the 1930s, they were the gift of a locally prominent family who brought them home after a European tour they had taken just before the turn of the 20th century.

The Evaluation Process

REFERENCES

Godden, Geoffrey A. *British Porcelain: An Illustrated Guide,* Clarkson N. Potter, New York, 1975.
Godden, Geoffrey A. *Encyclopedia of British Pottery and Porcelain Marks,* Barrie & Jenkins, London, England, 1991.

HOW DO I KNOW IT IS OLD?

The Royal Worcester mark is a good indication of age, since it contains a dating system that delineates the exact date of manufacture of these pieces. The Worcester Royal Porcelain Company started dating its products in

1867. They used the letter a below the mark in 1867, then a different letter was used until a series of dots was introduced in 1892. In that year, one dot was placed between the word Royal and the crown that appears in the mark. The four candlesticks have three dots in this location, which means they were manufactured in 1894. In this case, there should be no fear of a reproduction.

HISTORY

The Worcester Royal Porcelain Company can trace its origins to the Worcester porcelain factory founded by Dr. John Wall and William Davis in 1751. They made soft paste porcelain using soapstone and are considered to be one of the most important of the early English porcelain enterprises. Items made between 1751 and 1783 are said to be from the Doctor Wall period. This original factory was purchased by Thomas Flight in 1783 and the Flight period at Worcester began. It lasted until 1793, when Martin Barr joined the company; 1793 to 1807 are referred to as the Flight and Barr period. From 1807 to 1813, the company was known as Barr, Flight and Barr; from 1813 to 1840 as Flight, Barr and Barr; and in 1840, they joined with another porcelain-making company located in the town of Worcester and became Chamberlains & Company until 1852. A partnership between Kerr and Binns took over in 1852, and in 1862, R. W. Binns renamed the company Royal Worcester Porcelain Company, Ltd., which exists to this day.

DATE OF ORIGIN

1894.

PLACE OR COUNTRY OF ORIGIN

Worcester, England.

RARITY

Royal Worcester turned out large numbers of beige-tinted and gilded porcelain items that sometimes had enameled flowers added to the overall decoration. They are a large part of the Victorian and Edwardian Worcester porcelain encountered by modern collectors, and most pieces do not cause excitement. These horn candlesticks are a bit unusual and are very decorative. They are uncommon but far from rare.

PUTTING IT ALL TOGETHER

Royal Worcester has a big following among collectors. It is a company known for its high quality and artistic design. This quartet of candlesticks with their naturalistic form and sensuous curves are an example of this prestigious firm's Art Nouveau designs. The circumstance that there are four of these is also a plus. Candlesticks should always occur in pairs at the very least; single candlesticks are generally viewed with great disapprobation. Sets of four are excellent because it was the standard number during the times when candles and candlesticks were used to provide light rather than atmosphere. The major minus is the beige-tinted porcelain used to make these pieces. Collectors do not get excited over this monochromatic background. These are better examples.

ITEM 8: POTTERY PITCHER

Just the Facts

FORM

Pitcher with twisted handle in the form of a branch and raised decorations consisting of a branch, pinecone, and pine needles.

MATERIAL

Pottery, with a yellow cast and ceramic pigment.

DIMENSIONS

9½ inches tall.

METHOD OF MANUFACTURE

The body and the decoration are molded, but the piece was hand-finished and hand-colored.

IDENTIFYING TRADEMARKS AND SIGNATURES

The bottom is marked Roseville in raised, cursive script, which identifies this pitcher as a product of the Roseville Pottery Company of Zanesville, Ohio. The pitcher is also marked with an impressed 708-9, which is the style number and the approximate size.

CONDITION

Excellent, with no chips, cracks, or glaze crazing.

PROVENANCE

Bought from an antiques dealer in 2001 with no prior history available.

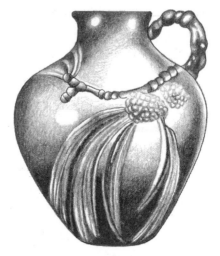

The Evaluation Process

REFERENCES

Huxford, Sharon and Bob. *The Collector's Encyclopedia of Roseville Pottery*, Collector Books, Paducah, Kentucky, 1976.

Kovel, Ralph and Terry. *The Kovels' Collector's Guide to American Art Pottery*, Crown Publishers, New York, 1974.

HOW DO I KNOW IT IS OLD?

In this case, age is a very valid concern because the market has been flooded with fake Roseville commercial art ware in the past few years. It is of extreme concern since this piece was bought in 2001 from an antiques dealer and has no history of past ownership. An examination, however, reveals clues that attest to it being an original. The best clue is the color of the pitcher, which is predominantly blue and is consistent with the blue seen on other genuine Roseville examples. The colors on Roseville reproductions have been described (accurately in our opinion) as "poisonous," and they are certainly markedly different from the originals. A careful comparison with any real Roseville piece with a blue background will

reveal if the color is correct and whether the piece in question is genuine. The signatures found on the reproductions are also a bit different from the old, and again, the only sure way to distinguish old from new is to compare with a known piece of old Roseville. The color and the signature on this particular pitcher check out as being original, and the wear on the base confirms this analysis.

HISTORY

The Roseville Pottery Company was incorporated in Roseville, Ohio, in 1892. Originally, they made stoneware jars, flowerpots, and other useful household items. The company was successful and in 1898 expanded to nearby Zanesville, Ohio. By 1910, all operations in Roseville had stopped and the company worked only in Zanesville. The making of art pottery began in 1900 with a line of brown-glazed *slip*-decorated pottery called Rozane. This was similar to other wares made both earlier and later by a number of different potteries in the United States and England in imitation of Rookwood's Standard glaze line, first developed in 1883. The pattern on the pitcher being evaluated is called Pinecone. It was reportedly designed about 1917 by Frank Ferrell, who was Roseville's art director from that year until the company closed in 1954. However, Pinecone did not go into production until 1931, becoming the most popular of all the Roseville lines. By the 1920s, Roseville had abandoned all of its handmade art pottery lines and switched to commercial art wares, which were basically molded pieces with a little hand-finishing. Pinecone is commercial art ware and it was available in four colors: brown, green, blue, and pink.

DATE OF ORIGIN

Mid-20th century circa 1940.

PLACE OR COUNTRY OF ORIGIN

Zanesville, Ohio.

RARITY

Among Pinecone wares, the brown examples are the most common and the least desired by collectors. The pink pieces are true rarities and are very hard to find. Other than the pink, the blue and the green Pinecone items are preferred by collectors, but they are by no means rare. The pitcher under evaluation is a very desirable Pinecone shape that is seldom found.

PUTTING IT ALL TOGETHER

Pinecone in general is very popular with collectors. Although not the rarest, the color of this piece is popular; the shape is uncommon and attractive, and the condition is perfect. It is a better example of Roseville's commercial art wares.

ITEM 9: POTTERY VASE

Just the Facts

FORM

Cylindrical vase with flared base narrowing to a circular mouth.

MATERIAL

Pottery with slip decoration.

DIMENSIONS

7½ inches tall.

METHOD OF MANUFACTURE

The vase was formed by molding and the decoration of a winter scene was hand-painted using colored liquid clay called slip.

IDENTIFYING TRADEMARKS AND SIGNATURES

An impressed RP with the two letters placed back-to-back with 14 flames above and the Roman numerals XIX below. It is also marked with the initials S.E.C. for Sara Elizabeth (Sallie) Coyne, who was a decorator at Rookwood from 1892 to 1931. There is a style number followed by the letter V, which signifies a vellum glaze.

CONDITION

Excellent, with no chips, cracks, or glaze crazing.

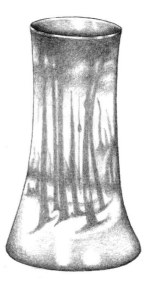

PROVENANCE

Descended in the family who bought it in Cincinnati, Ohio, in 1919.

The Evaluation Process

REFERENCE

Kovel, Ralph and Terry. *The Kovels' Collector's Guide to American Art Pottery,* Crown Publishers, New York, 1974.

HOW DO I KNOW IT IS OLD?

Rookwood pottery has been reproduced, but not this particular type of ware. It is also comforting to know that the decoration on this vase is consistent with other known examples painted by Sallie Coyne. The provenance and the wear on the base are convincing.

HISTORY

The Rookwood pottery was founded in Cincinnati, Ohio, in 1880 by Maria Longworth Nichols. Mrs. Nichols was a china painter. In 1876, she saw the Japanese and the Haviland (*Limoges,* France) pottery exhibit at the Philadelphia Centennial Exhibition and decided to start an American company to make fine wares with an emphasis on underglaze decoration.

After returning to Cincinnati, Mrs. Nichols began experimenting, and she and Miss M. Louise McLaughlin set up a studio at the Dallas Pottery, but the kiln there proved to be too hot for their purpose (it burned all the colors out except blue and black). Mrs. Nichols's father, Joseph Longworth, purchased an old school and converted it into a pottery. The first kiln was drawn late in 1880, and the new enterprise was named after the crows or "rooks" that lived in the woods surrounding Mrs. Nichols's father's home. In this manner, Rookwood was born, and it stayed in business until 1967. In 1904, Rockwood introduced a new kind of glaze at the St. Louis World's Fair. It was said that the surface of the glaze looked like old parchment, thus the name *vellum*. It is a matte glaze without any kind of luster. The decoration and the glaze are applied at the same time. Pieces are always marked with a V.

DATE OF ORIGIN

1919, as per the Roman numerals XIX.

PLACE OR COUNTRY OF ORIGIN

Cincinnati, Ohio.

RARITY

Vellum-glazed items with scenic designs are considered to be relatively rare.

PUTTING IT ALL TOGETHER

The best Rockwood pottery is always signed by the artist who decorated it. Some of the decorators are more highly prized than others (Kataro Shirayamadani, Robert Valentien, Jens Jensen, and William P. McDonald, to

name a few). Sallie Coyne's work is considered to be excellent, but it is not classed with the very best. This scenic painting with the long, straight, stark tree trunks against the snow is quite nice and rather rare. The colors are attractive and are primarily blue, pink, and purple. This vase is a very beautiful piece of Rookwood's vellum-glazed pottery, but it is not a spectacular specimen and should be considered a better example.

ITEM 10: PORCELAIN PLATE

Just the Facts

FORM

Round plate decorated with gilding and portrait of a woman holding a flowering branch.

MATERIAL

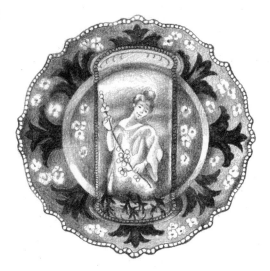

Hard paste porcelain, gold, and ceramic colors.

DIMENSIONS

9 inches in diameter.

METHOD OF MANUFACTURE

The plate is molded and the pictorial decoration was applied using a transfer print. The extensive gilding is hand-done.

IDENTIFYING TRADEMARKS AND SIGNATURES

The back of the plate has a mark composed of the initials R. S. inside a wreath with a five-pointed star at the top and the word Prussia below. The mark is red and green.

CONDITION

Excellent, with no chips or cracks and only very minor rubbing to the gold.

PROVENANCE

Purchased at an antiques show from a dealer specializing in R. S. Prussia items.

The Evaluation Process

REFERENCES

Gaston, Mary Frank. *The Collector's Encyclopedia of R. S. Prussia and Other R. S. and E. S. Porcelain,* Collector Books, Paducah, Kentucky, 1982.
Gaston, Mary Frank. *Collector's Encyclopedia of R. S. Prussia, Identification and Values,* Third Series, Collector Books, Paducah, Kentucky, 1994.

HOW DO I KNOW IT IS OLD?

There is no question that this plate is a genuine R. S. Prussia plate decorated with a portrait of a woman representing spring. These plates have not been reproduced. The problem with R. S. Prussia is twofold. The first is that fake marks have been placed on old items that were not made by the

factory in Suhl, Prussia (now Germany), owned by Reinhold Schlegelmilch. The second is that new pieces are being made, but for the most part, these bear only a vague resemblance to the old. Neither of these problems applies to this plate, which is a documentable example.

HISTORY

We do not think that the definitive history of R. S. Prussia has been written yet. There are still some gray areas, but it is thought that Reinhold Schlegelmilch began his porcelain factory in Suhl, Prussia, about 1868 (the factory was not formally registered until 1869) and specialized in making good-quality porcelain tableware for the middle class. By the late 19th century, the Schlegelmilch factory in Suhl had become large and important, and it is thought they began using the R. S. Prussia wreath mark, like the one found on the plate being evaluated, in the late 1800s and continued using it until about 1917. At this last date, the Suhl factory was closed and operations moved to Tillowitz, where production continued until 1945. This plate was part of a series of four plates, each one with a different portrait of a woman representing a different season of the year—fall, winter, spring, and summer.

DATE OF ORIGIN

Early 20th century, but it is only possible to say that it was made before 1917, and a circa 1905 date is probably safe and correct.

PLACE OR COUNTRY OF ORIGIN

Suhl, Prussia.

RARITY

The vast majority of all R. S. Prussia pieces are decorated with images of flowers. Any example with a portrait, a scene, or the image of an animal (particularly a lion or a tiger) is desirable and hard to find. The four seasons plates are considered to be a rarity; each is rated as being equally uncommon. This portrait can also be found on trays, bowls, and relish dishes, but all seem to have nearly the same value and rarity level.

PUTTING IT ALL TOGETHER

R. S. Prussia collectors are real sticklers for perfection. In many instances, a small chip will cause them to reject all but the rarest of the rare, and the very slight rubbing to the gold is a concern. It is the big minus on this piece. The plus is that it is a hard-to-find spring plate that is still very beautiful, and this is a marginal best piece.

Silver and Other Metals

ITEM 1: SILVER CUP WITH LID

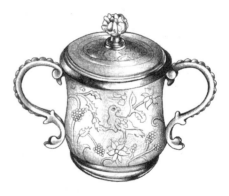

Just the Facts

FORM

Circular, two-handled covered cup called a por-
ringer (or sometimes a *caudle cup*) with two scrolled
handles that terminate with birds' heads. It is covered with a lid that has a
leaf-shaped finial. The cup is decorated with incised designs of birds,
insects, and flowers.

MATERIAL

Approximately 18 ounces of sterling silver (i.e., 92.5 percent pure silver).

DIMENSIONS

The height is 6¼ inches.

METHOD OF MANUFACTURE

All handmade, with the body raised by hand-hammering and the decoration hand-incised.

IDENTIFYING TRADEMARKS AND SIGNATURES

Under the lid near the lip of the cup there are four indentations called hallmarks. They are a crowned leopard's head signifying the piece was made in London, England; a lion passant (the figure of a lion seen in profile with its tail curled over its back), which means the metal content is of sterling quality; a Gothic letter C, which is the date letter for 1680–1681; and the initials LS with a crown over the top, which is the mark of an unknown maker. These marks also appear on the lid of the cup.

CONDITION

The cup is in very good condition, with some denting to the base and lid. The marks are partially worn from polishing but are readable. All parts appear to be original.

PROVENANCE

Purchased from an international auction house with no previous ownership records available.

The Evaluation Process

REFERENCES

Jackson, Sir Charles James. *English Goldsmiths and Their Marks*, Dover Publications, New York, 1991.

Waldron, Peter. *The Price Guide to Antique Silver*, Antique Collector's Club, Woodbridge, Suffolk, England, 1982.

HOW DO I KNOW IT IS OLD?

The marks on a piece such as this one are generally trustworthy unless there is a sign that they have been cut out and replaced. The shape and the style of decoration on this piece are compatible with the 1680s. Since this date is confirmed by the marks, there is every reason to be confident that this piece is of the period. For further confirmation that there has been no attempt to deceive, it is a good idea to scrutinize the engraved decoration to make sure that there are no areas of alteration or places where there is evidence that some sort of design element has been removed or added. If there are problems in this regard, the surface will usually have areas where the color of the surface is different from the rest of the body or the wear pattern in one or more sectors is not consistent with the wear on the rest of the body. Next, make sure there are no signs around the handles that they have been under excessive stress, such as being pushed into the body, leaving a telltale dent. This may indicate that the handles have either been repaired or replaced. It is prudent to check and make sure there are no holes in the body or lid that have been filled in with solder. It is always a good idea to hold a cup up to see whether the light shines through anywhere. This can be a sign of damage and repair that could negatively impact the value. Make sure that the rim of the lid and the base of the cup

have not been replaced. This is often betrayed by a split or separated seam or by an abundance of solder.

HISTORY

This porringer is from the reign of King Charles II, who ruled England from 1660 to 1685. From the late 1500s to 1675, there was much abuse by English silver and goldsmiths in the making of their wares. Small pieces especially were not taken to Goldsmith's Hall to be assayed before they were sold, and many items during this period were sold with only a maker's mark. Large numbers of these wares were not of sterling standard, and in 1675 the Wardens of the Company of Goldsmiths, London, issued an order that all maker's marks must be registered with them and all items made from silver and gold had to be assayed for the proper purity before they were sold. This edict worked, and after 1675, the marking on English sterling silver became more regular and the standard of purity more reliable. In 1677, a record of the names of makers and their mark or "touch" was preserved on vellum, but that has been lost. In most cases, we have no idea who made what piece of sterling silver until 1697, when the London Goldsmith Company began recording names and marks in a book that exists to this day.

DATE OF ORIGIN

1680–1681 as per the date letter found on the porringer.

PLACE OR COUNTRY OF ORIGIN

London, England, as per the marks found on the porringer.

RARITY

All pieces of 16th-century and earlier sterling silver hollowware should be considered to be quite rare. This piece is a superb example from the 1680s and it is in excellent condition for an object that is more than three centuries old. The only thing that would have improved the value and rarity of this covered cup is if the engraving had depicted a more uncommon subject. Examples with chinoiserie designs are much prized.

PUTTING IT ALL TOGETHER

This rare Charles II sterling silver covered cup or porringer is absolutely typical of the time in which it was made. The condition is what collectors hope to find in a piece of this age. The only minus is one of degree concerning the engraved decoration, which could be more exciting and uncommon. Despite its age, rarity, and condition, it is a better piece because heavier, more finely decorated examples can be found.

ITEM 2: STERLING SILVER PARTIAL FLATWARE SERVICE

Just the Facts

FORM

Extensive sterling silver flatware service in Versailles pattern. The service consists of 36 each dinner forks, luncheon forks, and teaspoons; 24 each salad forks, flat bouillon spoons, soup spoons, dinner knives, and luncheon

knives; 16 bouillon spoons; 10 demitasse spoons; 8 serving spoons; 7 cocktail forks; 2 each berry spoons and gravy ladles; and 1 cold meat fork. The partial set totals 274 pieces.

MATERIAL

341 ounces of sterling silver.

DIMENSIONS

Various

METHOD OF MANUFACTURE

Cast in molds.

IDENTIFYING TRADEMARKS AND SIGNATURES

The back of each piece is marked with a line of three raised symbols: a lion (similar to the English lion passant), an anchor (similar to the English mark for pieces made in Birmingham), and a fancy Gothic-style G (similar to an English date letter). Below is the word sterling. There is also the phrase *Pat. 1888* and an H inside of a diamond. These pieces are from the Gorham Manufacturing Company of Providence, Rhode Island.

CONDITION

All of the pieces in the set are in excellent condition, with no rubbing to either the marks or the elaborately raised decoration.

PROVENANCE

Property of an Atlanta, Georgia, estate.

The Evaluation Process

REFERENCES

Carpenter, Charles H. Jr. *Gorham Silver 1831–1981*, Dodd, Mead & Co., New York, 1982.

Hagen, Tere. *Sterling Flatware, An Identification and Value Guide*, Revised Second Edition, Tamm Publishing Company, Tempe, Arizona, 1994.

HOW DO I KNOW IT IS OLD?

In this case, there is absolutely no question that these pieces are as old as they are supposed to be. There are no known reproductions of Gorham's Versailles pattern flatware.

HISTORY

Jabez Gorham (1792–1869) started working in silver in 1815, and in 1831 Gorham and Webster was founded in Providence, Rhode Island. The firm became Gorham, Webster and Price in 1837, but in 1841, when Gorham's son joined the firm, it became Jabez Gorham and Son. After several other partnership and name changes, Gorham was incorporated as the Gorham Manufacturing Company in 1863. The company worked in coin silver, which is approximately 90 percent pure silver, until 1868, when Gorham adopted the English sterling standard. Tiffany and Company had switched to the English sterling standard in the 1850s, but after Gorham made the

switch, most other makers in the United States followed suit. Gorham was a pioneer in the introduction of machinery and manufacturing techniques to the making of silver. In the late 19th century, they also produced silver plate, bronze, gold, stone, and wooden items. For a brief time in the late 19th and early 20th centuries, they made silver items that were in the British *Britannia standard,* which is about 95.84 percent pure silver (sometimes, however, the silver content was as low as 95 percent). This silver with the higher purity was used in Gorham's famous *Art Nouveau*–inspired Martelé line. The reason Gorham used this Britannia metal was because it is softer than sterling silver, and, therefore, easier to form by hand-hammering into objects. Since Martelé was all handmade, the softness and increased malleability made the manufacturing process easier. Gorham made several sterling silver flatware patterns that had different designs on the handles depending on what the form of the utensil happened to be. Forks might have one design, spoons another. Versailles, along with Fountainebleau, Gilpen, Piper, and their most famous pattern, Mythologique, fall into this category. Versailles was designed by one of Gorham's most famous artists, F. Antoine Heller, who came to Gorham after leaving Tiffany. Gorham is still in business as the Gorham Corporation, a Division of Textron.

DATE OF ORIGIN

Late 19th or early 20th century.

PLACE OR COUNTRY OF ORIGIN

Providence, Rhode Island.

RARITY

Versailles was a mass-produced pattern, and while it is not commonly seen on the current market, pieces are readily available. Such a large set, however, is highly desirable.

PUTTING IT ALL TOGETHER

Most out-of-production sterling silver flatware has a surprisingly modest value. Versailles, however, is one of the exceptions. Collectors are very interested in it because it is extremely ornate and beautifully made. It is an interesting side note that in the late 19th and early 20th centuries when Versailles was made, Gorham produced its flatware in five different weights: Trade, Extra, Regular, Heavy, and Massive. Of the five, four were marked with the first letter in their designation to identify the weight. Only the Regular-weight items, which contained 12 troy ounces of silver per dozen pieces, were not specially marked. The H in a diamond found as part of the marks on this flatware signifies that it is Heavy, and there should be 14 ounces of silver per dozen pieces. This H weight is a plus. This set of Gorham sterling silver flatware is a better example.

ITEM 3: SOUP TUREEN

Just the Facts

FORM

Oval soup tureen with flower-and-foliage encrustation on feet, rim, and handles in an Art Nouveau–inspired Chrysanthemum pattern.

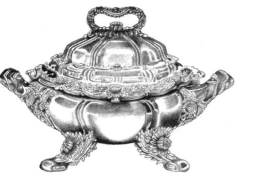

MATERIAL

135 troy ounces of sterling silver.

DIMENSIONS

17⅝ inches long.

METHOD OF MANUFACTURE

Some handwork but mainly cast.

IDENTIFYING TRADEMARKS AND SIGNATURES

On the base this piece is signed: TIFFANY & CO., 5712 MAKERS 5956, STERLING SILVER, 925-1000, M. Tiffany used this mark from 1875 to 1891. The 5712 is the pattern number and the 5956 is the order number. The M at the bottom refers to Edward C. Moore. Before 1868, Tiffany bought its silver from a company founded by John C. Moore in 1827, which worked exclusively for Tiffany. The firm had passed to Moore's son, Edward, in 1851; Tiffany bought it outright in 1868 and began making sil-

ver on its own. Edward C. Moore was on the Tiffany board of directors, and the initial of his last name appeared on Tiffany silver until his death in 1891. After that, the initial of the last name of the president of Tiffany's was used.

CONDITION

Excellent, with no monogram or crest.

PROVENANCE

Private collection.

The Evaluation Process

REFERENCES

Rainwater, Dorothy T., *Encyclopedia of American Silver Manufactures*, Schiffer Publishing, Atglen, Pennsylvania, 1986.

Schwartz, Jeri, *The Official Identification and Price Guide to Silver and Silver Plate*, House of Collectibles, New York, New York, 1989.

HOW DO I KNOW IT IS OLD?

There is no question that there are Tiffany fakes skulking about in the marketplace seeking to entrap unwary buyers, but this tureen is not one of them. Reproduction Tiffany lamps, glass, and small bronze items are an understandably worrisome problem for the novice, but a large, incredibly intricate sterling silver piece such as this one would be very difficult to fake convincingly. The pattern and order number on the base of this piece can

be checked with Tiffany to verify authenticity. The surface has a beautiful patina caused by decades of polishing.

HISTORY

When most collectors think of Tiffany items, they think of the pieces made at Tiffany Studios, but this tureen was not. Tiffany & Co. was founded in New York City in 1837 by Charles L. Tiffany, the father of the much more famous Louis Comfort Tiffany. Initially they stocked such luxury items as Chinese pottery and porcelain, fans, umbrellas, and small pieces of furniture. Any silver they sold, they bought from New York silversmith John Chandler Moore, who began making silver objects in 1827. Moore made silver for other companies to retail, but by the mid-19th century, his company made silver exclusively for Tiffany. In 1868, Tiffany and Co. was incorporated and they bought the Moore facility.

DATE OF ORIGIN

Circa 1885 to 1890. This is determined by the mark, which was in use from 1875 to 1891 and by the order number.

PLACE OR COUNTRY OF ORIGIN

New York City.

RARITY

Tureens in almost any form are uncommon, and this Tiffany sterling silver example is rarer than most. However, some Tiffany tureens with special enamel or mixed-metal enrichment are rarer and more valuable.

PUTTING IT ALL TOGETHER

This Tiffany tureen is spectacular, and there are no minuses. The chrysanthemum design is exquisitely detailed and is influenced by the naturalistic aspects of the Art Nouveau movement of which Louis Comfort Tiffany was a chief proponent in the United States. Interestingly, the body of the tureen is influenced by Rococo design, and the chrysanthemums have been married beautifully to this earlier style because both forms of expression embraced naturalistic depictions and the sensuously curved line. We would like to say that this is a best piece, but it really is an upper-end better example because more elaborate and stylish Tiffany tureens do exist.

ITEM 4: PAIR OF CANDLESTICKS

Just the Facts

FORM

Pair of candlesticks in the form of columns on square paneled bases. The bases are embellished with ribbon-tied swags, and the column shafts are wrapped in a spiral band of acorns and oak leaves. The columns are surmounted by Corinthian capitals with detachable *bobeches*.

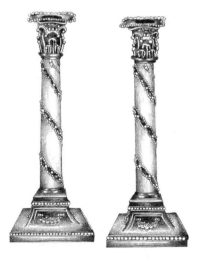

MATERIAL

Sheffield plate (sterling silver fused to copper).

DIMENSIONS

13¼ inches tall.

METHOD OF MANUFACTURE

The candlesticks are primarily made from copper that has had a thin sheet of sterling silver fused to its outer surface using heat. This is called Sheffield plate. The ornament on the base of the candlesticks was stamped into the metal to make a slightly raised decoration. The spiral band of acorns and oak leaves was cast separately and applied.

IDENTIFYING TRADEMARKS AND SIGNATURES

None.

CONDITION

Excellent, with only a slight bit of bleeding on the raised acorns and oak leaves.

PROVENANCE

Purchased from a Charleston, South Carolina, estate.

The Evaluation Process

REFERENCE

Helliwell, Stephen J. *Understanding Antique Silverplate,* Antique Collector's Club Ltd. Woodbridge, Suffolk, England, 1996.

Wyler, Seymour B. *The Book of Old Silver: English, American, Foreign,*
 Crown Publishers, New York, 1937.

HOW DO I KNOW IT IS OLD?

For the most part, the production of true Sheffield plate ceased around
1838, which was the year that silver electroplating was perfected, thereby
eliminating the need to fuse a thin sheet of sterling silver to a much thicker
piece of copper. Checking around the base of these candlesticks, there is
enough wear to indicate that they were made before 1838. The examina-
tion also reveals that there is a thin sheet of silver on top of a thick layer of
copper, as there should be. When it is true Sheffield plate, the metal used is
sterling quality and will have a bluish tinge. When the silver has been elec-
troplated over a copper base, as it has been from 1838 to this day, the silver
will be pure (.999) and will be somewhat whiter and brighter in color.

HISTORY

In 1742, Thomas Boulsover was repairing a knife in the garret of a building in
Sheffield, England. In the process, he fused silver to copper by heating it to
the point where the silver was just beginning to melt. The commercial impli-
cations were not lost on Boulsover, who began making small articles such as
buttons, buckles, and boxes that looked like they were solid sterling silver but
were mainly copper. Boulsover's apprentice, Josiah Hancock, understood the
industrial potential of Sheffield plate, and it was Hancock's diligent efforts
that turned the process into big business that went far beyond the making of
little trinkets. Sheffield was the manufacturing center, but this product was
also made in many other places. Sheffield plate was very popular with the rich
and the noble, who bought great quantities of items in this material. It was
not long before ethically challenged makers started marking their wares with
symbols that could be mistaken by the unwary for the marks found on solid

sterling silver. This raised the ire of the makers of solid silver and the marking of Sheffield plate was banned, but by 1784 it was permitted again. There are basically two periods of Sheffield plate. The first was between 1750 and 1780, and is characterized by elaborate embossed designs that tried to hide the failings of the plating process under ornamentation. Makers were learning how to make Sheffield plate, and as the 30-year period progressed, the manufacturers became more and more proficient. By the end of this first period, they were making items with delicately pierced rims that were almost as fine as their sterling silver counterparts. The second period from 1780 to about 1830 saw the full flowering of Sheffield plate. By this time, makers were covering rims with sterling silver wires to hide the glint of copper and were adding elaborate applied borders. In 1830, a new base was introduced for silver plating. It was called German silver and was an alloy of nickel, copper, and zinc that had a gray tone similar to silver. With the introduction of this new base metal, the problem of copper showing through was eliminated because the precious metal and the base metal were nearly the same color. For all practical purposes, true Sheffield plate ceased to be made after the perfection of the electroplating process by the Elkingtons of Birmingham, England, in 1838.

DATE OF ORIGIN

Late 18th century circa 1790. With the applied trim, these candlesticks should be second-period Sheffield; the neoclassical design suggests they were made between about 1780 and 1810. This pair of Sheffield-plate candlesticks is very similar to Corinthian column candlesticks made in sterling silver by John Carter and dated 1773. This probably indicates a date for the Sheffield-plate examples that is closer to 1780 than 1810.

PLACE OR COUNTRY OF ORIGIN

England, probably Sheffield.

RARITY

Candlesticks such as these are available on the market and are uncommon but not particularly rare.

PUTTING IT ALL TOGETHER

The big pluses on this pair of candlesticks are that they are in very good condition and they are in a neoclassical style that is appealing to many collectors. The minus is that there are only two, and serious collectors would prefer that there be four, as originally used. These are better pieces.

ITEM 5: BOWL

Just the Facts

FORM

Centerpiece bowl with flaring rim on a V-shaped tripod with openwork feet.

MATERIAL

110 ounces; 15 *pennyweights* of sterling silver.

DIMENSIONS

15 inches in diameter.

METHOD OF MANUFACTURE

Handmade.

IDENTIFYING TRADEMARKS AND SIGNATURES

Georg Jensen inside a circle of beads. At one time, Jensen is said to have used between 19 and 25 beads to surround his name. A circle of 23 beads was the indication that the piece was of sterling silver quality.

CONDITION

Excellent, with no dents, pits, or monograms.

PROVENANCE

Purchased by a tourist in Copenhagen in 1952 and is now part of her estate.

The Evaluation Process

REFERENCES

Hughes, Graham. *Modern Silver Throughout the World 1880–1967*, Crown Publishers, New York, 1967.

Krekel-Aalberse, Annelies. *Art Nouveau and Art Deco Silver*, Harry N. Abrams, New York, 1989.

Marion, John L., editor. *Sotheby's International Price Guide*, 1986–1987 Edition, The Vendôme Press, New York, 1986.

How Do I Know It Is Old?

Research reveals that this centerpiece bowl was designed by Henning Koppel (1918–1981) for Georg Jensen in 1950. It is a documented piece and there is no reason to doubt that it was purchased new in 1952.

History

Georg Jensen was trained as both a sculptor and a silversmith. He opened up his own workshop in Copenhagen, Denmark, in 1904, with the idea of producing modern designs rather than copying old silver. In collaboration with Johan Rhode, who is noteworthy in his own right, Jensen produced a line of hollowware and flatware that set a high standard for quality and design. The workshop was very successful. When Jensen died in 1935, the enterprise continued by hiring some of the best designers available. One of the most talented was Henning Koppel (1918–1981), who was the first new artist/craftsman to join the company after the end of World War II. Like Jensen, Koppel was trained as a sculptor, and he is known for his simple organic designs devoid of ornamentation. He was a strong proponent of Scandinavian Design, which many might associate with Danish Modern. Besides silver, Koppel designed items to be made from wood, fabric, glass, steel, plastic, and porcelain. Today, Georg Jensen is owned by Royal Copenhagen Porcelain and continues its reputation for award-winning design.

Date of Origin

Circa 1950.

Place or Country of Origin

Copenhagen, Denmark.

RARITY

This is a large, very hard piece to find. It is a highly sought after example of Georg Jensen/Henning Koppel silver.

PUTTING IT ALL TOGETHER

This bowl is all pluses. The design is a superb example of Koppel's Scandanavian Design, and it is large and in absolutely mint condition. It is a best example.

ITEM 6: PAIR OF COVERED BOTTLES

Just the Facts

FORM

Rectangular bottles with small circular lids painted on all sides with female figures in a garden setting with pavilions.

MATERIAL

Copper with colored enamel on the surface.

DIMENSIONS

11 inches tall.

METHOD OF MANUFACTURE

The bottles are hand-assembled from sheets of copper and the enamel is made from powdered colored glass. The decoration is done in a style similar to that seen on ceramics made in *Canton* in the early to mid-19th century.

IDENTIFYING TRADEMARKS AND SIGNATURES

None.

CONDITION

The bottles themselves are in fairly good condition, but the lip of one where it joins with the lid has been slightly bent. There is extensive damage to the enamel on the corners and on the edges at the tops of the bodies and below the tops. The painted panels, however, are in very good condition with no losses.

PROVENANCE

Purchased from an online auction.

The Evaluation Process

REFERENCE

Moorehouse, Judith. *Collecting Oriental Antiques*, Galahad Books, New York, 1976.

How Do I Know It Is Old?

This kind of ware is still being made in China in both Beijing (Peking) and Guangzhou (Canton), which should be a cause for caution among nonspecialists. Truthfully, the new *Canton* enamels, as these are called, should not be a serious problem because the colors are too harsh, the pink too dense and too pink, and the whole color scheme is lacking in softness and subtlety. The damage on these bottles would normally be a very good clue to their age, but this type of enamel is so easily damaged that even fairly modern examples can be extensively injured. On this pair of bottles, however, the wear appears to be the kind that would occur over many years of everyday use. There are a myriad of short random scratches on the bottom and the wear to the enamel along the edges is a good sign of continuous handling for a long period of time. Also, the decoration is extremely well done and has all the characteristics of mid-19th-century imagery done in Canton. The design is beautifully detailed without being busy and overcrowded. The faces of the ladies appear to be of idealized but real people.

History

The antecedents of this type of Canton enamel are found in Limoges, France, not in China or any other Asian country. In Limoges, artists have been enameling scenic and religious designs on metal since medieval times. The art form came to China from Europe about the same time that rose-pink enamel arrived, which formed the basis for the famille rose color palette. The decorations on the Canton enamel wares echo very closely the decorations found on Canton porcelain of the same time period, with most featuring interior scenes or landscapes. Since this art form was European, the shapes tend to be ones that would appeal to European tastes—for example, ewers, plaques, bowls, plates, vases, and tea caddies.

DATE OF ORIGIN

Mid-19th century. It is impossible to date these bottles with any more accuracy. This time frame is chosen because of the quality of the workmanship, the nature of the painting, and the amount of honest wear.

PLACE OR COUNTRY OF ORIGIN

Guangzhou (Canton), China.

RARITY

19th-century Canton enamel is difficult to find in reasonably good condition. Pieces that do turn up tend to be plates, bowls, and vases. A pair of bottles is uncommon and the enameling is above average.

PUTTING IT ALL TOGETHER

The big minus on these pieces is their condition. The bent lip and the chipped and rubbed enamel would greatly distress many collectors. On the plus side, the form is rare and the painting is exquisite, even if the subject matter is typical. These bottles are a better example.

ITEM 7: WEATHERVANE

Just the Facts

FORM

An Index swell-bodied horse weathervane with a shaped mane and *repoussé* tail. The term Index refers to the Index of American Design, which was a 1930s WPA (Works Progress Administration) project designed to provide work for unemployed artists who were to prepare a pictorial record of America's vanishing handicrafts. The artists created watercolor drawings of American folk art and other popular arts and crafts that were made in the United States from the first settlement to about 1900. The project was done state by state, with each object having a sheet of information detailing the item's date, source, location, and ownership. These watercolors are now in the National Gallery of Art in Washington, D.C. This horse weathervane is like one of those included in the Index, and is, therefore, called an Index horse.

MATERIAL

Zinc and copper. The forequarters are zinc; the hindquarters and the ears are copper. There are traces of yellow paint and gilding with some green patina.

DIMENSIONS

23 inches tall and 30 inches wide.

METHOD OF MANUFACTURE

The various body parts are cast or molded, the ears were applied separately, and the tail has a hammered or repoussé decoration.

IDENTIFYING TRADEMARKS AND SIGNATURES

None.

CONDITION

Very good, with restoration to one foot and to the tail.

PROVENANCE

Discovered in an old barn near Hartford, Connecticut, and sold at auction.

The Evaluation Process

REFERENCES

Bishop, Robert, and Coblentz, Pat. *A Gallery of American Weathervanes and Whirligigs,* E. P. Dutton, New York, 1981.

Hornung, Clarence P. *Treasury of American Design,* Harry N. Abrams, New York, 1950.

How Do I Know It Is Old?

Reproductions of weathervanes abound and anyone contemplating a purchase should be very careful because many are so good that experts have been fooled. The provenance on this piece bothers us a bit because the "found in a barn" line is often used with reproductions that are intended to fool the unwary. An exhaustive examination of this horse, however, reveals that everything is as it should be. The green verdigris patina occurs only on the copper hindquarters and ears, not on the zinc forequarters, and does not appear to have been induced artificially. It has both the right color and the right distribution over the surface to suggest that it was produced by nature. Chemically induced verdigris is often too evenly widespread over the body and has a fresh green color rather than the very weathered green shade that is seen here and there on this weathervane. A good test is to rub your hand gently over the patina; if it comes off on your hand, be suspicious. Also reassuring is the color of the gilding, which has the warm, rich glow of 19th-century enrichment. The repairs are somewhat reassuring as is the detail work (or lack thereof) on the mane and tail. The mane is really very simple and consists of an inscribed line that runs from the top of the horse's head near the ears to the top of the shoulder at the base of the neck. The plainness of the mane is a deduction in value, but it is an area that would almost certainly be embellished in a fake; therefore, the lack of detail in the form of lines suggesting hair is comforting to a small degree. The tail has been repaired for another subtraction in value, but it is decorated with hand-hammered lines that in all likelihood would have been molded in a reproduction.

History

The origins of the weathervane are clouded in mystery. Who made the first weathervane? No one knows. Where did they originate? No one knows. It

is certain, however, that they could be found in Colonial America by the mid-17th century. Every commercial weathervane manufacturer made an Index horse such as this one, but this example is attributed to J. Howard & Co., which was located in Bridgewater, Massachusetts. Not much is known about this company except their location and that they began working in the 1850s.

DATE OF ORIGIN

Circa 1860.

PLACE OR COUNTRY OF ORIGIN

Bridgewater, Massachusetts.

RARITY

Nineteenth-century weathervanes have become icons among collectors of Americana and are now hard to find. Some of the more commonly found designs feature images of roosters or horses.

PUTTING IT ALL TOGETHER

This is certainly a handsome example of a 19th-century Index horse weathervane. In its favor is its beautiful surface with the vestiges of gilding, yellow paint, and sprinkling of green verdigris. Not in its favor are the repairs to one foot and the tail and the lack of detail on the mane. This is a better example.

ITEM 8: LION STATUE

Just the Facts

FORM

Figure of a walking lion with down-curved tail and open mouth on a rectangular base or *plinth.*

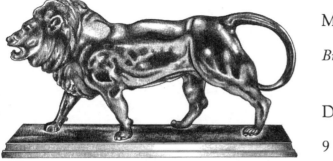

MATERIAL

Bronze.

DIMENSIONS

9 inches tall.

METHOD OF MANUFACTURE

Cast and hand-finished.

IDENTIFYING TRADEMARKS AND SIGNATURES

Inscribed Barye for Antoine-Louis Barye (French, 1796–1875) and F. Barbedienne for Ferdinand Barbedienne (French, 1810–1892).

CONDITION

Excellent with its original patina and an unmarred surface.

PROVENANCE

Property of a collector.

The Evaluation Process

REFERENCES

Benezit, Emmanuel. *Dictionnaire Critique et Documentaire des Peintres, Sculpteurs, Dessinateurs et Graveurs,* 10 volumes, Grund, Paris, France, 1976.
Janson, H. W. *19th-Century Sculpture,* Harry N. Abrams, New York, 1985.

HOW DO I KNOW IT IS OLD?

One of the first questions to ask is whether the statue is actually 100 percent bronze. Many fakes and reproductions were made from other, cheaper materials such as iron and bronze-plated white metal. If a magnet sticks to the piece, it is iron. If a tiny scratch on an inconspicuous spot on the underside reveals a white or silver glimmer, it is bronze-plated white metal. Perhaps the next thing to examine is the base. Notice that this walking lion is standing on its own rectangular bronze plinth and does not have a marble base. This is good, because the majority of 19th-century original bronzes were not attached to marble bases. Sometimes, owners did acquire a marble slab for display purposes, but the bronze just rested on it and was not physically attached. Reproductions of the 20th and 21st centuries, on the other hand, often have marble or marble-appearing bases attached to the piece of sculpture. Many fake Barye bronze sculptures are on bases that have a metal tag identifying the name of the particular piece of sculpture and the artist; the presence of one of these tags is almost a guarantee of a fake. Continuing to check the underside of the sculpture, make sure there

are no Phillips head screws attaching the metal base to the sculpture itself. If a Phillips head screw is found, the piece is a fake or has been badly repaired. The fact that this walking lion sculpture is signed by both Barye and by the person who did the actual casting of the metal, Ferdinand Barbedienne, is a good sign. It is even better that both signatures are clear, sharp, and well defined. Fakes often do not have the name of the foundry, and when they do, they are not generally very distinct. Artist signatures on fakes can also be somewhat fuzzy. Another reassuring sign is that the details on this sculpture are very sharp and the lion's major muscles stand out along the side with great clarity. The hair on the mane is also very richly executed and realistic. Reproductions are often cast from originals, so they can lose a lot in the translation because the details of the design become softer and less clear. Reproductions seldom have the kind of artistic precision or lifelike detail seen in this representation of a walking lion. It is always a good idea to know exactly what size the original bronze is supposed to be (that information can usually be found in the artist's catalogue raisonné). Reproductions are either smaller or were made in sizes that are altogether different from originals.

History

Antoine-Louis Barye was born in Paris on September 24, 1796, and became one of Europe's leading 19th-century sculptors. Barye was the son of a goldsmith who began his career as a metal engraver and die cutter. After a stint in the Napoleonic army, he continued his art studies while working for a goldsmith making small animals that were used in pieces of jewelry. Perhaps his most valuable experience came from his extensive visits to the Paris zoo and his participation in the dissection of a lion in 1828. His first works seen in public were depictions of animals that are notable for both their anatomical correctness and their ferocity. Besides animal studies, Barye also did historically and mythologically themed sculptures, but even these generally con-

tained a representation of a powerful, if not ferocious, animal. Barye is said to be one of the leaders of Les Animaliers, a group of artists who focused on animal themes and depicted them in a realistic yet romantic fashion. After a long and illustrious carrier, Barye died in Paris in 1875. The person responsible for casting this and the other bronzes sculpted by Barye was Ferdinand Barbedienne (1810–1892), who, along with Achille Collas, developed a way to reduce classical and Renaissance sculpture in size while preserving all the detail. This process was called appareil reducteur and it allowed Barbedienne and Collas to reproduce exactly the larger works of Michelangelo and Ghiberti in a size that would fit on a tabletop. In the mid- to late 19th century, Barbedienne was France's most accomplished bronze foundry.

DATE OF ORIGIN

Mid-19th century.

PLACE OR COUNTRY OF ORIGIN

Paris, France.

RARITY

For every original Barye bronze such as this one, there are probably 10,000 or more fakes. This is a well-known example of Barye's Animalier work and is considered to be a work of art, but it is not as desirable or as rare as some of his more elaborate and dramatic pieces.

PUTTING IT ALL TOGETHER

Any collector of Animalier bronzes would be delighted to have this elegant Barye depiction of a walking lion. The superb condition is also much in its

favor, but larger examples and pieces that deal with a dramatic display of fang and claw are more highly regarded. This is a better example.

ITEM 9: PAIR OF TWO-LIGHT CANDELABRA

Just the Facts

FORM

French Empire candelabra, each with a Nubian figure holding two elongated cornucopia surmounted with candle sockets. The figures are standing on columnar bases terminating in brass feet.

MATERIAL

Patinated *bronze* and gilding. The eyes are inlaid with small bits of ivory.

DIMENSIONS

19 inches tall.

METHOD OF MANUFACTURE

Cast with gilded kilt, cornucopias, candle sockets, band around the center of the column and base. All other areas have been patinated, which means they have been heated, then treated with acid to induce the dark coloration.

IDENTIFYING TRADEMARKS AND SIGNATURES

None.

CONDITION

Good, but the cornucopia and candle sockets are slightly bent and misaligned, and the gilding is worn overall.

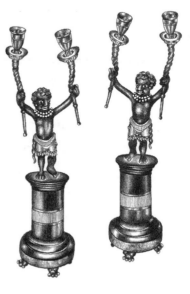

PROVENANCE

The estate of a collector who bought them in England in the 1960s.

The Evaluation Process

REFERENCES

Berman, Harold. *Bronzes: Sculptors and Founders, 1800–1930*, Abage/Publishers, Chicago, Illinois, 1974.

Savage, George. *Dictionary of 19th Century Antiques and Later Objets d'Art*, G. P. Putnam's Sons, New York, 1978.

HOW DO I KNOW IT IS OLD?

There are a number of clues that suggest this pair of candelabra is old. One of the most important is that the gilding is hand-applied mercury gilding, not the electroplated gilding that would have been used later. Mercury gilding, which is made by creating a mixture of mercury and pure

gold, has a very distinct, rich warm color that is unmistakable. In addition, the wear to the gilding, the wear to the paw feet, and the slightly off-kilter candle arms in the form of cornucopia all speak of genuine age. It is important to note the inlaid ivory eyes, which probably would not have been used in a reproduction. Paint would have been used instead. Taking one of the candelabra apart, it is evident that the various pieces have been together for quite some time; and the screws that hold these two candelabra together are handmade and have slightly irregular threads. It should be noted that the undersides have been beautifully finished so that the surfaces are smooth. Such care and craftsmanship is not taken with reproductions that are meant to have the look but not the quality.

HISTORY

The term *candelabra* is defined as a lighting device with two or more branches arising from a central pillar, and they are said to have originated in the 18th century. This pair of candelabra is in the French Empire style and dates from the first quarter of the 19th century. This style is based on neoclassical motifs that became popular around the time Napoleon I became emperor of France in 1804. French Empire drew its design inspirations mainly from Imperial Rome, but images from Greece and Egypt can also be found. After Napoleon's Egyptian Campaign of 1798, images of sphinxes and other Egyptian-inspired motifs became especially popular, and the kilt-clad Nubian figures that make up the central pillars of these candelabra are reminiscent of Nubian figures associated with ancient Egyptian art. To be sure, this image has been somewhat blended with early 19th-century concepts of what Africans look like, and the figures might also be thought of as being *blackamoors*.

DATE OF ORIGIN

Circa 1810.

PLACE OR COUNTRY OF ORIGIN

Continental Europe, probably France.

RARITY

Demand by interior designers and collectors has made candelabra such as these hard to find, but this pair should be considered to be uncommon rather than rare.

PUTTING IT ALL TOGETHER

The pluses for this pair of candelabra are the wonderful graphic depictions of the Nubian figures and the popularity of the French Empire with collectors. The minus is the condition. They are better examples.

LOT 5

Miscellaneous

ITEM 1: WALL CLOCK

Just the Facts

FORM

So-called figure-8 wall clock with a large circle above that contains the clock face and a smaller circle below that has a round window where the pendulum can be seen. The top circle is surrounded with the words *Coca-Cola The Ideal Brain Tonic,* and the bottom circle with *Delicious and Refreshing,* with *5 cents* at the 3 o'clock and 9 o'clock positions.

MATERIAL

Wood, *papier-mâché,* paper, and metal.

DIMENSIONS

The height is 30 inches and the widest width is 18 inches. The diameter of the bottom circle is 12 inches.

METHOD OF MANUFACTURE

The clockworks were manufactured by the Seth Thomas Company of Thomaston (formerly Plymouth Hollow), Connecticut. The advertising on the front was made from papier-mâché cast in a mold and the rest of the case is wood. The Baird Clock Company of Plattsburg, New York, made the case and the raised papier-mâché advertising that surrounds the dial and the pendulum, and assembled the clock using the Seth Thomas works.

IDENTIFYING TRADEMARKS AND SIGNATURES

The face of the clock is marked Baird Clock Company, Plattsburg, N.Y., and the case is marked with the trademark of the Coca-Cola Company.

CONDITION

The clock is in working condition. There is some wear to the raised papier-mâché lettering and some color loss.

PROVENANCE

Found in the basement of a former drugstore in Louisville, Kentucky, which was in business from the late 19th century through the 1950s.

The Evaluation Process

REFERENCE

Petretti, Alan. *Petretti's Coca-Cola Collectibles Price Guide*, 9th Edition, Nostalgia Publications, Hackensack, New Jersey, 1994.

HOW DO I KNOW IT IS OLD?

The wear and the aging on this clock are obvious. The size and materials are also correct and the clock meets all the specifications of known originals.

HISTORY

The Coca-Cola Company was founded in Atlanta, Georgia, in 1886, and they very quickly began an aggressive advertising campaign to tout the benefits of their drink. It was called "The Ideal Brain Tonic" and was said to relieve "mental and physical exhaustion" and to be a "specific for headache." The company issued a barrage of posters, calendars, cardboard cutouts, signs to be used in stores and on trolley cars, festoons, serving trays, thermometers, and a plethora of other advertising gimmicks. Initially, it was thought that clocks were too expensive to be distributed as advertising, but in the 1890s a way was found to make inexpensive wall clocks that could be emblazoned with Coca-Cola's message. Although the clocks cost a little more initially, they lasted a long time, and people looked at them with great regularity. In short, a clock was the perfect place to put a Coca-Cola advertisement. Edward P. Baird & Company of Plattsburg, New York, was able to make these clocks relatively inexpensively because they formed the front with the advertising message from papier-mâché pressed into a mold. The clockworks were inexpensive and the wooden

case was simple. The first of these clocks was probably made around 1891 (there is some debate on this issue) and came in either a simple round shape called a gallery clock or in the figure-8 style like the one being evaluated. These clocks had a number of different messages on their face; differences can be used to date a particular example.

DATE OF ORIGIN

1894 to 1896. This is determined by the style of the lower advertising circle. The earliest clocks tended to have messages on this ring that emphasized the medicinal qualities of Coca-Cola, but slightly later models dropped this in favor of "Delicious and Refreshing." The way the 5-cent price is represented also helps date the clock to this time frame.

PLACE OR COUNTRY OF ORIGIN

Plattsburg, New York.

RARITY

These are extremely hard to find and they are treasured by Coca-Cola collectors. They should be considered to be truly rare.

PUTTING IT ALL TOGETHER

There is one important aspect concerning this clock that has not been mentioned so far. It happens to have its original clock paper, which refers to a label found inside the clock that identifies the clock's maker and usually provides a variety of information including instructions for proper operation. The presence of clock papers is a plus in any clock and can add as much as 30 percent to the value. The clock paper on this example is located where most are—on

the inside back of the case behind the pendulum. There are a few Coca-Cola clocks that are more valuable than this one. Specifically, these are the early round gallery clock and the tin-faced Coca-Cola advertising clocks that Baird made after moving the company to Chicago very late in the last decade of the 19th century. Still, this clock should be considered to be in the upper 5 percent of all Coca-Cola advertising clocks made and should be rated a best.

ITEM 2: SHELF CLOCK

Just the Facts

FORM

Shelf clock with 8-day movement, time and strike, spring driven.

MATERIAL

Walnut case, glass front, gilding on glass, brass clockworks and pendulum. There is also glass in the center of the pendulum.

DIMENSIONS

23 inches tall and 15 inches wide.

METHOD OF MANUFACTURE

All parts are machine made with a little handwork in assembling and finishing. The decoration on the case that looks like hand-carving is really

machine done, and the gilding on the door was applied using a transfer process.

IDENTIFYING TRADEMARKS AND SIGNATURES

The clock paper glued to the inside back of the case identifies this as being a product of the E. N. Welch Manufacturing Company of Bristol, Connecticut.

CONDITION

In excellent working condition.

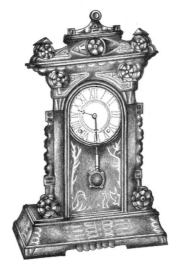

PROVENANCE

Private collection.

The Evaluation Process

REFERENCES

Smith, Alan. *Clocks and Watches,* Crescent Books, New York, 1989.
Swedberg, Robert and Harriet. *Encyclopedia of Antique American Clocks,*
 Krause Publications, Iola, Wisconsin, 2001.

HOW DO I KNOW IT IS OLD?

Since most reproduction shelf clocks are in oak, there is very little doubt that this is not a reproduction. Despite this, a careful examination is always in order. It reveals that the spring-driven brass clockworks are old. In addition,

the case has the correct amount of patina and enough minor scratches and dents to be an original.

HISTORY

Elisha Niles Welch (1809–1887) started out making iron bells and weights for clocks with his father. Welch made shelf clocks with Thomas Barnes Jr., but these had wooden works. In the 1840s, in partnership with others, Welch began making shelf clocks with brass 8-day movements. In the 1850s, Welch bought up several failing companies—including one that made clock cases and one that made clock parts—and put them together to establish the E. N. Welch Manufacturing Company. In 1868, along with Solomon Colby Spring and Benjamin Bennet Lewis, Welch organized Welch, Spring & Company, specializing in making high-quality clocks such as *regulators* and calendar clocks. This company made some clocks that are of great interest to collectors, but they went out of business in 1888. E. N. Welch Manufacturing, which made more ordinary clocks, followed suit after both their clock case and their clockworks factories burned in 1899. Shortly thereafter, they were acquired by the Session Clock Company.

DATE OF ORIGIN

Circa 1885. The walnut in the case suggests that this clock was made before 1895, when walnut was replaced by oak as the wood of choice (this was due to walnut having virtually disappeared from American forests at this time). It is also apparent that this clock was made after about 1880 because the case is in the Victorian Eastlake style that began being popular about this time.

Place or Country of Origin

Bristol, Connecticut.

Rarity

Shelf clocks such as this one are very common.

Putting It All Together

This is a very nice clock in an Eastlake-inspired case made from walnut. The door has an attractive gold decoration of birds among flowers and foliage in good condition. The pendulum has glass in the center and is called a Welch sandwich-glass pendulum, which is collectible in its own right—but beware, since these pendulums have been reproduced. The clock's good condition and working order are in its favor, but this clock is not hard to find and should be rated only as a good.

ITEM 3: QUILT

Just the Facts

Form

Occupational album quilt featuring 42 squares, many of which are appliquéd with designs representing specific occupations. Other squares are decorated with appliquéd designs of flowers and geometric designs.

MATERIAL

Various types of fabric including calico and a linen background.

DIMENSIONS

80 inches wide by 98½ inches long.

METHOD OF MANUFACTURE

All hand-sewn. This is important to collectors. The sewing machine has been in home use since the middle of the 19th century, and the use of one of these mechanical devices can have a serious negative impact on the value of a quilt. The use of a sewing machine is not hard to detect because the stitches will be very regular, whereas even the most precise stitches from a human hand will exhibit some irregularity. This quilt was also hand-pieced and hand-quilted and may be the work of more than one person.

IDENTIFYING TRADEMARKS AND SIGNATURES

Some of the squares in this quilt have stitched names. They are the names of people whose occupations are being depicted and not of the person who made the square, as is sometimes the case.

CONDITION

The quilt has slight discoloration in some areas, and the once white background has tones to an off-white shade. There is no serious staining and only a few breaks in some of the threads.

PROVENANCE

This quilt has descended in the same New York State family since the 1860s. All the names found on the quilt can be traced back to actual individuals who performed the depicted tasks (dressmaker, vintner, *Zouave* soldier, horse breeder, mason, blacksmith, fruit grower, among others) in the town where the family history says the quilt was made.

The Evaluation Process

REFERENCE

Safford, Carleton L., and Bishop, Robert. *America's Quilts and Coverlets*, Bonanza Books, New York, 1985.

How Do I Know It Is Old?

In this case, the provenance is so good that there is little doubt this piece was made in the early 1860s in New York State. The names of the individuals can be traced with no contradictions to this history. The fabrics in the quilt support this dating as they are all from the mid-19th century and colored with non-*aniline dyes.*

History

There are several different types of antique American quilts. We are probably most familiar with the ones constructed from patches of material that have been sewn together to make some sort of geometric design. More rarely seen are the quilts made from pieces of fabric that have been cut into designs and applied to a background fabric that is usually white cotton or linen. These are called appliqué quilts, and they are said to be almost exclusively an American craft (however, some of the best appliqué quilts were made in Hawaii before that island nation became part of the United States). Appliqué quilts were most popular from the last quarter of the 18th century through the third quarter of the 19th century. To begin making one of these quilts, a person would cut out shapes (flowers, hearts, birds, human or animal figures, and so forth), then turn the edges of each piece over and hem them. These shapes were then sewn to the background—hopefully in an artistic and graphically interesting manner. The particular quilt being evaluated is in the so-called album style, which means that the design was placed one element or one concept to a panel, then all the "pages" were stitched together to form an "album of pictures." The best album quilts are associated with Baltimore, Maryland. These quilts were showcases of the maker's skill, both with the needle and with the intricacies of artistic design. Album quilts were designed to be used for

display rather than as a bed covering to sleep under, and because these were cherished and did not see everyday use, many of them survived.

DATE OF ORIGIN

Early 1860s. This is derived from both the provenance and from examining the fabrics.

PLACE OR COUNTRY OF ORIGIN

Elmira, New York. Determined by the provenance.

RARITY

By definition, most 19th-century quilts are truly one of a kind, but the rarity of a given example is determined by how uncommon the form is, how well the work was designed and executed, and how unusual the design elements happen to be. This quilt is wonderfully rare because it is in the much appreciated album style and because the maker chose to depict occupations of friends and neighbors as a theme.

PUTTING IT ALL TOGETHER

The pluses on this quilt are its album-style design, thematic material, listing of actual individuals whose existence can be traced, and ironclad provenance. The minus is its condition, which is a relatively minor deduction. This is a best example.

ITEM 4: SAMPLER

Just the Facts

FORM

Pictorial sampler with a central poem. Flower-and-vine border with a brown squirrel flanked by two peacocks at the top, with roses, butterflies, and pairs of bluebirds surrounding the garlanded poem. At the bottom there is a landscape with a three-story house, trees, two pairs of men and women, and chickens in the yard.

MATERIAL

The background is gauze and the pictorial details are executed in colored silk floss.

DIMENSIONS

21 inches high by 21 inches wide.

METHOD OF MANUFACTURE

Hand-stitching.

IDENTIFYING TRADEMARKS AND SIGNATURES

Below the poem and within the surrounding garland, it is signed Anne Beamis, New Jersey, 1820.

CONDITION

There is some brown toning to the gauze background, but otherwise the colors of the silk floss are bright and vibrant and there are only a few broken threads.

PROVENANCE

Property of a private collector.

The Evaluation Process

REFERENCE

Bolton, Ethel Stanwood, and Coe, Eva Johnston. *American Samplers,*
 Dover Publications, New York, 1973.

How Do I Know It Is Old?

Early-19th-century samplers are so different from samplers made in the late 19th century and afterward that there is no question this item is old. We have seen people confused by framed modern photographs of samplers such as this one, but this is cleared by examining the piece out of the frame—and samplers should always be examined out of their frame. The detail, the intricacy of the workmanship, the manner in which the various elements of the design are depicted, and the color of the thread all say that this piece is genuine.

History

The earliest mention of a sampler—or an exampler as they were sometimes called—is found in the account book of Elizabeth of York, who noted that she had bought an "ell" (a measurement of about 45 inches in length, said to be the distance from the elbow to the tip of the middle finger) of linen to make a sampler. At that time, samplers were long and narrow and were often kept rolled up in a drawer. They were—as they would continue to be—samples of stitches that a young woman had mastered. When the seamstress needed a refresher on how a certain stitch was done, she could take the sampler from the drawer to serve as a guide. Later, samplers were used as a sort of final exam for young women who would stitch the alphabet, numbers, verses, and sometimes scenes to show the kind of work they had learned both at home at their mother's knee and in school, where sewing was an important subject (see *alphabet sampler* and *mending sampler* in the glossary). Sometimes these samplers served as a demonstration to a suitor that the young woman who stitched it would be a good helpmeet—someone who could make all the necessary clothing and warm bed coverings for her future family, do necessary repairs, and perhaps brighten the home with decorative needlework. In short, a sampler was both a diploma and something of a résumé.

DATE OF ORIGIN

1820.

PLACE OR COUNTRY OF ORIGIN

New Jersey. This sampler was possibly made at a girls' school or academy located near the New Jersey coast. There were many of these, and a number of samplers from these institutions are known to exist, but this is one of the finest.

RARITY

This sampler is exceptionally rare and was made with great skill. The design is elegantly organized and executed. The detail is also superb, and this example is in the top 5 percent of surviving samplers.

PUTTING IT ALL TOGETHER

Everything about this sampler is a plus except for the condition, which is only a minor problem. The brown toning around many of the design elements is a cause for concern and vigilance to make sure that any further deterioration is arrested. This is a best example.

ITEM 5: HOOKED RUG

Just the Facts

FORM

Flat, woven hooked rug with a scene of a sailboat and headlands. The image is in shades of black, yellow, dark blue, light blue, light green, and dark green within a black-and-gold border.

MATERIAL

Burlap backing hook, with fragments obtained from wool and cotton knit jersey garments and silk stockings.

DIMENSIONS

56 inches long by 38 inches wide.

IDENTIFYING TRADEMARKS AND SIGNATURES

None.

CONDITION

Excellent; colors are bright and there are no worn spots. The rug has been mounted on a frame by a professional.

PROVENANCE

Private collection.

The Evaluation Process

REFERENCES

Black, David, editor. *The Atlas of Rugs and Carpets: A Comprehensive Guide for the Buyer and Collector,* Tiger Books International, London, England, 1985.

Kopp, Joel and Kate. *American Hooked and Sewn Rugs: Folk Art Underfoot,* E. P. Dutton, New York, 1985.

HOW DO I KNOW IT IS OLD?

Hooked rugs are still being made and the question of age can be a problem. As a general rule, the colors on the underside of a hooked rug should be brighter than the colors on the top side because the underside was never exposed to light and was never walked on directly by feet. The pile on an old handmade hooked rug is not absolutely regular, but it usually is on a

manufactured or newer rug. In the case of this rug, an examination of the fibers reveals that it was constructed using fabric obtained from old clothing. This is a good sign, the color on the back is brighter than it is on the front, and the pile depth shows some slight irregularities.

HISTORY

This rug is attributed to Grenfell Industries of Labrador, Newfoundland, Canada. This attribution is made because of the flat weave and the double black-and-gold border, which is occasionally found on Grenfell hooked rugs. The theme of a sailing ship and headlands is also a typical Grenfell image. In 1890, Dr. Wilfred Grenfell (also known as Sir Wilfred Grenfell) arrived on a hospital ship in Newfoundland and found an indigenous population barely eking out a living by fishing and fur trading. These people were locked in by ice for 8 months of the year, and they no longer had the financial support of the British Government. As a physician, Grenfell was devoted to relieving the poverty and sickness of the locals. He attracted help for them from dedicated professionals as well as influential and wealthy humanitarians. While building hospitals, schools, and orphanages, he also encouraged the people to help themselves by utilizing their creative talents. Rug hooking was a popular pastime during the cold winter months, and in many parts of the northeastern United States and eastern Canada, this craft developed into a cottage industry. Grenfell organized the Labrador citizenry into a formal collective—or mission, as it was generally called—to exchange their hooked rugs (as well as weavings) for food, clothing, or cash. These were sold primarily in the United States and Canada through the International Grenfell Society Shops in Ottawa, New York, and Philadelphia and through churches. They were also sold to tourists traveling along the coast of Newfoundland. Since these rugs had to be easy to transport, they were normally made small enough to be rolled up and put in luggage. Typically, they featured bold,

graphically interesting images with northern themes such as dogsleds, polar bears, puffins, and snow scenes that spoke of the place where they originated. Even if the original Grenfell tag is missing—as it is on the rug being evaluated—these rugs are identifiable by the material from which they were made and the characteristics of the weave. The makers of Grenfell rugs normally used fragments of worn wool and cotton jersey—underwear or old silk stockings that were given to the mission as used clothing. If a garment was not wearable, it was customarily cut into strips and incorporated into a rug or mat. The dense, even pile of these rugs is extremely finely and smoothly hooked through the burlap backing, and the finished products often have the appearance of needlepoint. The first of these rugs was made about 1918 (some sources say 1910), and production was suspended in the late 1930s (some sources say mid-1930s). Grenfell is still in business today making rugs and textiles with northern themes, but the rugs are typically made from yarn rather than old garments. Current collectors are most interested in the examples made before the start of World War II.

DATE OF ORIGIN

Circa 1925. The style and the colors of the design suggest this date.

PLACE OR COUNTRY OF ORIGIN

Probably Labrador, Newfoundland, Canada.

RARITY

At more than 4½ feet long and 3 feet wide, it is unusually large for a Grenfell rug. The design is also precisely executed and extremely artistically conceived. All this makes for an extremely rare Grenfell hooked rug.

PUTTING IT ALL TOGETHER

This rug is all pluses except for the missing original label. This hurts a bit, but this rug would be considered to be a Grenfell masterpiece and a best example without doubt.

We feel these practice appraisals should provide a method for evaluating almost any antique found around the average American home. It is important to start by gathering little pieces of information and stringing these nuggets together like jewels on a necklace. Deciding what something is—what its form is and what it was originally used for—can be an important first step toward understanding its history, rarity, importance, and, ultimately, its value.

 We have shown you how to begin by learning what you can from simple observation and from information that is available from past owners (if any), then by doing the research. The book and periodical guide that follows should be a big help in pointing you toward the answers that may have seemed elusive in the past.

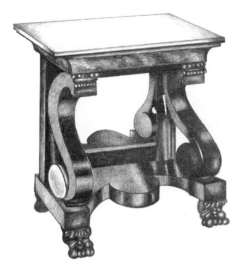

Resource Guide: Building a Library

W e are both bookaholics and feel very strongly that a library is to an appraiser or a connoisseur what bricks are to a mason and what an airplane is to a pilot. They are the raw material from which knowledge and connoisseurship are built and they are the vehicle that takes those interested in art and antiques to where they want to go.

A good personal library is essential to the appraiser/connoisseur, and building one can take years and years. When Helaine goes to an antiques show, one of the sellers she always visits is the bookseller. She is looking for the latest books that might fill a hole in her reference collection. She may buy nothing else in a show, but she almost always comes away with an armload of books.

Joe is sure his library is so large and so heavy that someday in the not-too-distant future it will go crashing through the floor of his second-story library. Joe likes to buy more than one book at a time and he likes to buy them as cheaply as possible. One of his favorite sources is L-W Book Sales of Marion, Indiana (1-800-777-6450 for catalog and book requests, and their mailing address is 5243 S. Adams St., Marion, IN 46953).

Joe likes them because they mail out a rather large catalog every month or so that has a very wide range of books on almost every subject imaginable. The great part is that if six or more books are purchased, there

is a very significant discount—generally in the neighborhood of 30 to 40 percent. Joe also appreciates the fact that the orders are usually filled very quickly and they arrive at the door—no fuss, no muss (but the mail carrier hates you).

Some books that are important to an antiques library are just plain hard to find. Joe had used his first copy of Geoffrey Godden's *Encyclopedia of British Pottery and Porcelain Marks* until the cover fell off and the pages pulled out from their binding. He desperately wanted—no, *needed*—another copy, but could not find one anywhere. Finally, a friend found a copy on Amazon.com and immediately purchased it as a present.

Another good place for hard-to-find books is on the web at Abebooks.com and Bookfinder.com. We have mentioned these sites before, and they are ones that Helaine uses with some regularity to purchase books that she cannot find elsewhere. Now, be prepared for the books to be expensive, but it has been our experience that almost every book pays for itself in very short order.

A listing of useful books follows, and in many cases they are indispensable in the everyday plying of our trade as appraisers. This is not to be construed as an end-all-be-all list because we are sure that many wonderful and useful books will be omitted either because we have not been introduced to them or because we do not have room to include them in this limited space. Also, keep in mind that there may be earlier and later editions of the books listed, all of which may have merit.

There are literally thousands of books available that might be useful in a given situation to provide a specific piece of information. Unfortunately, there is no way we can list all of these, but we can explore books that we use frequently and find most helpful in doing our research. We take some of these books with us to do appraisal clinics and consult them regularly when we are answering viewer and reader questions or writing columns for newspapers and magazines.

It is our goal to try and provide a listing of books that will make a good

basic antiques library. They are listed alphabetically by author and categorized. As a helpful guide, we give a brief description of what is in the book and why we find it useful.

Furniture

- Aronson, Joseph. *The Encyclopedia of Furniture,* Crown Publishers, New York, 1965. Arranged alphabetically, this book could be called a dictionary of furniture. The extensive amount of illustrations in the center portion of the book makes it easy to recognize styles and forms.
- Bishop, Robert. *Centuries and Styles of the American Chair 1640–1970,* E. P. Dutton, New York, 1972. Discussion of all the major styles of American seated furniture, their origins in Europe, and their regional and stylistic differences.
- Bishop, Robert. *How to Know American Antique Furniture,* E. P. Dutton, Inc., New York, 1973. This pocket guide is for those who are totally unfamiliar with any style of American furniture. It is a quick and easy reference that can be carried to antiques shows and auctions for on-the-spot information.
- Boger, Louise Ade. *Furniture Past and Present,* Doubleday, Garden City, New York, 1966. An illustrated furniture guide that discusses Italian, Dutch, Flemish, English, and American pieces, and covers woods and styles from ancient and Renaissance times through the 1950s.
- Dubrow, Eileen and Richard. *American Furniture of the 19th Century 1840–1880,* Schiffer Publishing, Exton, Pennsylvania, 1983. This book provides an invaluable examination of some of the more important styles of American Victorian furniture and its makers. It is particularly good with Gothic, Rococo, and

Renaissance Revival. Its focus is on higher-style Victorian furniture, and if it has a failing, it is that it completely ignores Eastlake, which was generally made after this book's 1880 cut-off date.

- Evans, Nancy Goyne. *American Windsor Chairs*, Hudson Hills Press, New York, 1996. This scholarly tome includes a discussion of the history of Windsor chairs and explores their production region by region. It is an invaluable resource.
- Fairbanks, Jonathan L., and Bates, Elizabeth Bidwell. *American Furniture 1620 to Present*, Richard Marek Publishers, New York, 1981. For a basic education on American furniture from the Pilgrims to contemporary times, this is a good place to start. This book gives details and discusses how pieces were made and the materials used in their construction.
- Forrest, Tim. *The Bullfinch Anatomy of Antique Furniture*, Little, Brown, Boston, Massachusetts, 1996. Survey book divided by furniture types with copious photos identifying period, details, and designs.
- Fredgant, Don. *American Furniture Manufacturers*, Schiffer Publishing, West Chester, Pennsylvania, 1988. This book focuses on furniture manufactured in America during the early years of the 20th century. It gives lists of furniture manufacturers alphabetically and by state, and is invaluable for looking up pieces found in many American homes that are not mentioned in other books on antiques. It gives a great deal of information about early-20th-century furniture styles and about the types of wood used.
- Hayward, Helena. *World Furniture*, Crescent Books, New York, 1955. Beginning in the ancient world and continuing through the Gothic and the Renaissance periods to the 20th century, this historical reference book has an impressive number of illus-

trations and presents an in-depth discussion of the types of furniture seen in museums and major collections.

- Kirk, John T. *The Impecunious Collector's Guide to American Antiques,* Alfred A. Knopf, New York, 1976. Helaine feels that this is probably the most important book on American furniture for the beginner to read and reread, study and restudy.

- Miller, Judith and Martin, general editors. *The Antiques Directory: Furniture,* Portland House, New York, 1988. This is a very useful get-your-feet-on-the-ground sort of book. It examines the various furniture styles of the United States, Great Britain, France, Italy, Germany and Austria, the Low Countries, Spain and Portugal, and Asia. It is helpful because it gives a very wide assortment of furniture forms from around the world and traces their development over time.

- Nutting, Wallace. *Furniture Treasury,* Macmillian, New York, 1928. With 5,000 photographs in two volumes, this is an important early work on the subject. The text is a bit dated now, but the plethora of illustrations can be illuminating.

- Piña, Leslie. *Fifties Furniture,* Schiffer Publishing, Atglen, Pennsylvania, 1996. An extremely useful resource on furniture designers from the mid-20th century and their products.

- Rouland, Steve and Roger. *Heywood Wakefield Modern Furniture,* Collector Books, Paducah, Kentucky, 1995. This book is a comprehensive exploration of Heywood Wakefield furniture, and is very valuable for the identification and evaluation of this very popular type of furniture.

- Sack, Albert. *The Fine Points of Furniture,* Crown Publishers, New York, 1950. This book is a classic and it is a good primer on the connoisseurship of American furniture. It is divided into the various forms of furniture, and then good, better, best analyses are given on various types of pieces within the general form.

- Sack, Albert. *The New Fine Points of Furniture: Early American, Good, Better, Best, Superior, Masterpiece,* Crown Publishers, New York, 1993. This book is a useful continuation of the one above. Like the original, it skillfully evaluates a variety of Early American furniture pieces. It also has wonderful color photographs, whereas the original listed above has only black-and-white.

Ceramics: Pottery and Porcelain

- Cole, Kathleen. *Head Vases, Identification and Values,* Collector Books, Paducah, Kentucky, 1989. This book is divided into categories such as "Ladies," "Young Ladies," "Teenagers," "Famous People," "Clowns," and "Men." This organization can make the identification process a bit difficult, but the book is still valuable for the study of this very popular type of ceramic collectible.
- Cox, Warren E. *The Book of Pottery and Porcelain,* Crown Publishers, New York, revised 1973. This two-volume set is one of the earlier works on the history of world ceramics, starting with and concentrating on China. While many beginners might consider it a bit too technical, it does provide a good background on the subject, and the index has a valuable marks section divided by country of origin. In addition, the illustrations are very helpful.
- Duke, Harvey. *The Official Price Guide to Pottery and Porcelain,* 8th edition, House of Collectibles, New York, 1995. This is a very useful guide to a wide variety of American dinnerware.
- Gaston, Mary Frank. *American Belleek,* Collector Books, Paducah, Kentucky, 1984. The only thorough volume on this subject containing all the factories and their marks. Well illustrated and easy to use.

- Gaston, Mary Frank. *The Collector Encyclopedia: R. S. and E. S. Prussia Porcelain,* Collector Books, Paducah, Kentucky, 1982. Now available in four volumes or series, this guide is valuable to identify unmarked pieces, mold shapes, and decorations on this popular and often-found type of ware. The books also show fake marks.

- Godden, Geoffrey A. *Encyclopedia of British Pottery and Porcelain Marks,* Barrie & Jenkins, Random House, London, England, revised 1991. Absolutely the most important book on the subject and a must-have for the researcher because of the frequency with which British pottery and porcelain is encountered. Thorough and detailed work by Britain's leading expert and researcher on the subject of British ceramics. Contains marks and factory information unavailable elsewhere.

- Greer, Georgeanna H. *American Stoneware: The Art and Craft of Utilitarian Potters,* Schiffer Publishing, Atglen, Pennsylvania, 1981. An introduction to what most refer to as country pottery. References for these products are not found in many general ceramics and marks books.

- Hecht, Robin. *Scandinavian Art Pottery,* Schiffer Publishing, Atglen, Pennsylvania, 2000. We have included this book because it covers an area of growing interest and increasing prices. These products might be easily overlooked and undervalued by beginning appraisers/connoisseurs who do not have this resource.

- Huxford, Sharon and Bob. *The Collector's Encyclopedia of McCoy Pottery,* Collector Books, Paducah, Kentucky, 1980. Prices are available for 1999–2000. This book helps separate the products of the various McCoy factories. The information and the photographs are good.

- Huxford, Sharon and Bob. *The Collector's Encyclopedia of Roseville Pottery,* Collector Books, Paducah, Kentucky, 1976

and 1980. This two-volume set is now available with 2001 prices. Both volumes are needed to get a full view of Roseville production. Since many of the earlier pieces of Roseville were unmarked, the photographs in these books can be an invaluable identification guide.

- Huxford, Sharon and Bob. *The Collector's Encyclopedia of Weller Pottery,* Collector Books, Paducah, Kentucky, 1979. Updated prices from 1999 are available. History, marks, the various lines of pottery, and a vast array of photographs make this a very useful reference.

- Kisner, Gary. *The Mettlach Book,* Glentiques, Coral Springs, Florida, 1994. If you want to know about Mettlach steins, plates, tureens, or other decorative pieces, this source provides all the pertinent information and the prices. We could not find an edition later than 1994, which may mean the prices are now out-of-date.

- Kovel, Ralph and Terry. *The Kovels' Collector's Guide to American Art Pottery,* Crown Publishers, New York, 1974. A good general introduction to American art pottery with lots of photographs and histories of makers. Easy to use, with many illustrations of marks and descriptions of product lines.

- Lehner, Lois. *Lehner's Encyclopedia of U.S. Marks on Porcelain and Clay,* Collector Books, Paducah, Kentucky, 1988. A comprehensive listing of American ceramics manufacturers with a brief history of many companies. This book contains information that is difficult to find anywhere else and an extensive listing of marks.

- Luckey, Carl F. *Luckey's Hummel Figurines and Plates,* 11th edition, Books Americana, Florence, Alabama, 1998. Each Hummel figure is listed by style number, then values are broken down by the type of mark that appears on a particular example. Extremely well done and very useful.

- McCaslin, Mary J. *Royal Bayreuth: A Collector's Guide,* Antique Publications, Marietta, Ohio, 1994. This is the only book on the subject. Good for identifying actual products that might be unmarked and separating them from similar items made in Japan, Austria, and Germany.

- Medley, Margaret. *The Chinese Potter: A Practical History of Chinese Ceramics,* Charles Schriber's Sons, New York, 1976. A good survey book that takes the reader from the basic technology of making ceramics through the various Chinese periods from the Neolithic cultures to the Qing Dynasty. There is a section on marks, a glossary, and a bibliography.

- Piña, Leslie. *'50's and '60's Glass, Ceramics, and Enamel Wares, Designed and Signed,* Schiffer Publishing, Atglen, Pennsylvania, 1996. This pioneering work explains and illustrates modern designer products that are often encountered in homes. These items are collectible, with great potential for future growth.

- Reed, Alan B. *Collector's Encyclopedia of Pickard China,* Collector Books, Paducah, Kentucky, 1995. To our knowledge, this is the only resource on the subject. It contains Pickard catalogs, artist signatures and biographies; has a large number of photographs and an extremely useful section on other china-decorating firms working in Chicago.

- Rontgen, Robert E. *Marks on German, Bohemian and Austrian Porcelain, 1710 to the Present,* Schiffer Publishing, Exton, Pennsylvania, 1981. The most complete listing of factories and marks for German, Bohemian, and Austrian porcelain. The marks are shown but not the factories' products. The book can be a bit challenging to use at first and can require tenacity to find the desired information. Still, it provides information not available elsewhere.

- Stitt, Irene. *Japanese Ceramics of the Last 100 Years,* Crown

Publishers, New York, 1974. A good survey of Japanese ceramics that is easy to read and understand. Contains many illustrations but few marks.

- Supnick, Mark and Ellen. *The Wonderful World of Cookie Jars,* L-W Book Sales, Gas City, Indiana, 1995. This book is now available with 2000–2001 updated prices. It features more than 3,500 cookie jars with photographs and is an excellent resource.

- Ware, George W. *German and Austrian Porcelain,* Bonanza Books, New York, 1963. Provides a clear introduction to Meissen porcelain with pictures of actual pieces and a concise selection of marks. Helps clarify the meaning of Dresden, and identifies many of the marks used. Also discusses other important factories such as Royal Vienna.

Glass

- Bredehoft, Neila. *The Collector's Encyclopedia of Heisey Glass 1925–1938,* Collector Books, Paducah, Kentucky, 1986. This book offers a very good discussion of the colored glass made by Heisey. There is also a lengthy section on Heisey's pressed-glass patterns with dates of production, colors in which they were made, and notations as to whether that particular pattern was reissued by Imperial Glass after they bought the Heisey molds.

- Cohen, Wilfred R. *Wave Crest: The Glass of C. F. Monroe,* Collector Books, Paducah, Kentucky, 1987. This is the definitive work on the glass of the C. F. Monroe Company of Meriden, Connecticut, and discusses Wave Crest, Nakara, and Kelva, as well as similar products made by other companies. The illustrations are a great help in identifying the large number of unmarked examples of C. F. Monroe glass.

- Daniel, Dorothy. *Cut and Engraved Glass 1771–1905,* William Morrow, New York, 1971. This is the classic work on American cut glass. It discusses the three periods of American cut glass and distinguishes among English, Irish, and American products. It includes a large number of patterns and illustrations.
- Edwards, Bill, and Carwile, Mike. *Standard Encyclopedia of Carnival Glass,* 7th Edition, Collector Books, Paducah, Kentucky, 2000. Pattern-by-pattern identification guide, with a price guide by pattern and form in the back. It covers carnival glass patterns made around the world.
- Florence, Gene. *Collector's Encyclopedia of Depression Glass,* Collector Books, Paducah, Kentucky, 1998. Use this book to identify Depression glass patterns, makers, and time of production. Prices are listed by pattern, shape, and color.
- Florence, Gene. *Elegant Glassware of the Depression Era,* Collector Books, Paducah, Kentucky, 1993. Listed by pattern name, this guide features the more upscale Depression-era products of such companies as Heisey, Cambridge, Duncan and Miller, and Tiffin. As in the *Collector's Encyclopedia of Depression Glass,* prices are listed by pattern, shape, and color.
- Florence, Gene. *Kitchen Glassware of the Depression Years,* Collector Books, Paducah, Kentucky, 1995. This book approaches the very broad subject in three ways: by color, form, and pattern. It is easy to use and the photographs are excellent.
- Gardner, Paul V. *The Glass of Frederick Carder,* Crown Publishers, New York, 1971. This is the best reference for pre-1936 Steuben glass, which is the era in which colored Steuben art glass was made. It has line drawings of all the shapes made during this period, enabling collectors to identify unsigned pieces of Steuben glass with confidence. If a piece of colored glass

does not appear among these line drawings, it was not made at the Steuben factory.

- Grover, Ray and Lee. *Carved and Decorated European Art Glass*, Charles E. Tuttle, Rutland, Vermont, 1970. This book lists the European companies that made cameo and other types of highly decorated art glass during the late 19th and early 20th centuries. It is particularly useful for the discussion of French, English, and Austrian cameo glass, and it is beautifully illustrated with photographs.

- Heacock, William. *Fenton Glass, The First Twenty-Five Years*, O-Val Advertising Corporation, Marietta, Ohio, 1978. Along with the other two books in the series, *Fenton Glass, The Second Twenty-Five Years* and *Fenton Glass, The Third Twenty-Five Years*, these books present photographs and catalog reprints of products made at Fenton until the late 1980s, along with a great deal of important historical information.

- Jarfstorf, Sibylle. *Paperweights*, Schiffer Publishing, West Chester, Pennsylvania, 1991. This book discusses paperweights from their origins in the 19th century to the modern studio makers. It is most useful when discussing the French paperweight makers of the mid-19th century and their products.

- Jenks, Bill, Luna, Jerry, and Reilly, Darryl. *Identifying Pattern Glass Reproductions*, Wallace-Homestead, Radnor, Pennsylvania, 1993. A pattern-by-pattern exploration of pattern glass and its reproductions. This book is a real asset to collectors and appraisers who must distinguish between new and old pattern glass, which can be a difficult task.

- Keer, Ann. *Fostoria: An Identification and Value Guide of Pressed, Blown and Hand Molded Shapes*, Collector Books, Paducah,

Kentucky, 1994. This resource provides a valuable listing of all the shapes that occur within a particular Fostoria pattern. It helps someone doing an evaluation decide which pieces are rare and which are common.

- Keller, Joe, and Ross, David. *Jadeite: An Identification and Price Guide,* Schiffer Publishing, Atglen, Pennsylvania, 1999. Everything a collector or an appraiser/connoisseur might want to know about this type of glassware that has recently zoomed into prominence.

- McCain, Mollie Helen. *The Collector's Encyclopedia of Pattern Glass,* Collector Books, Paducah, Kentucky, 1982. The line drawings found in this book help to identify specific pressed-glass patterns. Use this book for information, but find the prices of pressed-glass items elsewhere.

- McKearin, George S. and Helen. *American Glass,* Bonanza Books, New York, 1989. One of the great reference books on American glass. First published in 1941, it has 1,000 drawings and 2,000 photographs. George and Helen McKearin were a father-and-daughter team who did pioneering research on early American glass. Their classification of three-blown mold glass is now a standard in the field, as is their extensive listing of American pictorial and historical flasks. This is a must-have for history and basic knowledge. Unfortunately, it does not help identify the many reproductions in this field.

- Page, Bob, and Frederiksen, Dale. *Crystal Stemware Identification Guide from Replacements Ltd.,* Collector Books, Paducah, Kentucky, 1997. This book is a little tedious to use, but it is a good resource for an overview of stemware made by such companies as Cambridge, Fostoria, Heisey, Gorham, Duncan, Tiffin, and many others.

- Piña, Leslie. *Fifties Glass,* Schiffer Publishing, Atglen, Pennsylvania, 1993. An invaluable book for information on Italian and Scandinavian glass from the 1950s era (some pieces date from a little before, some a little after). Glass from other European countries and the United States is briefly explored as well. The discussion of artists, glass companies, and their marks contains information that is hard to find anywhere else and the photographs are excellent.

- Pullin, Anne Geffken. *Glass Signatures, Trademarks and Tradenames from the Seventeenth to the Twentieth Century,* Wallace-Homestead, Radnor, Pennsylvania, 1986. An alphabetical listing by company of signatures and trademarks used on glass for four centuries with an emphasis on the 19th and 20th centuries. This book is a tad hard to use and it is by no means complete, but it can be a very useful resource.

- Revi, Albert Christian. *American Art Nouveau Glass,* Thomas Nelson and Sons, Toronto, Canada, 1968. This is one of the books that Joe has worn out from use. It contains an extensive discussion of Tiffany glass as well as the products of the A. Douglas Nash Corporation, Quezal, Vineland Flint Glass Works (Durand), and Steuben. There is also a chapter entitled "Other Manufacturers of Art-Glass and Bent-Glass Lamps and Windows" that is very informative.

- Revi, Albert Christian. *Nineteenth Century Glass, Its Genesis and Development,* Galahad Books, New York, 1967. This is an indispensable standard reference in the field of art glass. It discusses everything from the different types of Peachblow to Burmese, Amberina, Crown Milano, Pomona, Cameo, and Coralene.

- Riggs, Sherry, and Pendergrass, Paula. *20th Century Glass Candle Holders: Roaring 20's Depression Era, and Modern Collectible*

Holders, Schiffer Publishers, Atglen, Pennsylvania, 1999. This book purports to cover American-made candleholders from A to Z, and it does a very good job. Without this reference, identifying the maker and pattern of a 20th-century glass candle holder would be a mind-numbing exercise.

- Truitt, Robert & Deborah. *Collectible Bohemian Glass 1880–1940,* B & D Glass, Kensington, Maryland, 1995. This books includes photographs of the work of a number of Bohemian glass makers that are not familiar to many American collectors. The products these manufacturers made is often found in the United States, but it is generally unmarked. The photographs help collectors match up types of glass to their makers. This is new research that identifies many previously misattributed items.

Silver and Other Metals

- Berman, Harold, *Bronzes: Sculptors and Founders, 1800–1930,* Abage/Publishers, Chicago, Illinois, 1974. This three-volume set deals with collectible bronze sculptures, the artists who made them, and the foundries that cast them. It is extensively illustrated with marks of both artists and founders.

- Bones, Frances M., and Fisher, Lee Roy. *The Standard Encyclopedia of American Silverplate Flatware and Hollowware,* Collector Books, Paducah, Kentucky, 1998. This book relies heavily on company catalogs and covers the products of such companies as 1847 Rogers Bros., Wm. Rogers, Holmes and Edwards, Alvin Manufacturing, and Community Silver. It is a good general reference.

- Coffin, Margaret. *The History and Folklore of American Country*

Tinware 1700–1900, Thomas Nelson & Sons, Camden, New Jersey, 1968. History of tinsmithing, tinmen, decorators, and peddlers of these important utilitarian wares through 200 years.

- Grist, Everett. *Collectible Aluminum: An Identification and Value Guide,* Collector Books, Paducah, Kentucky, 1994. Primarily a discussion of early- to mid-20th-century aluminum objects, the makers, and their marks. A wide range of items are pictured and priced.

- Hagan, Tere. *Sterling Flatware,* Tamm Publishing Company, Tempe, Arizona, 1994. We wish this book were bound better (ours started shedding pages after only a few uses), but this pictorial listing of sterling silver patterns by manufacturers is perfect for identification purposes.

- Helliwell, Stephen J. *Understanding Antique Silverplate,* Antique Collector's Club, Woodbridge, Suffolk, England, 1996. Extensive discussion of Old Sheffield plate and electroplated tablewares, with a focus on English examples and photos of makers' marks.

- Hood, Graham. *American Silver: A History of Style, 1650–1900,* E. P. Dutton, New York, 1974. Two-hundred-fifty-year historical survey of Baroque, Queen Anne, Rococo, Classical, and Empire pieces of silver with bibliographic, exhibition, and museum collection information.

- Jackson, Sir Charles James. *English Goldsmiths and Their Marks,* Dover Publications, New York, 1991. The subtitle on this book says it all: "a history of the goldsmiths and plate workers of England, Scotland, and Ireland with over thirteen thousand marks reproduced in facsimile from authentic examples of plate and tables of date-letters and other hallmarks used in the assay offices of the United Kingdom."

- Kovel, Ralph and Terry. *A Directory of American Silver, Pewter*

and Silver Plate, Crown Publishers, New York, 1961. This is perhaps the best general reference on American coin silver marks.

- Laughlin, Ledlie Irwin. *Pewter in America: Its Makers and Their Marks,* American Legacy Press, New York, 1981. An extensive survey of pewter making in America that examines both household and ecclesiastical examples. There is a great deal of historical information with an emphasis on the makers and their marks.

- Lindsay, J. Seymour. *Iron and Brass Implements of the English House,* Alec Tirati, London, England, 1970. Discussion of iron and brass items used in the hearth for cooking, heating, smoking, and lighting spanning the 17th through 20th centuries.

- Rainwater, Dorothy T. *Encyclopedia of American Silver Manufacturers,* Schiffer Publishing, Atglen, Pennsylvania, 1986. This book is a bit quirky because it addresses some non-American silver manufacturers such as Elkington, Georg Jensen, and Ellis-Barker. Still the alphabetical listing of silver makers and their marks includes entries that cannot be found elsewhere, and Joe has found it so useful that he has worn out three copies.

- Schiffer, Peter, Nancy, and Herbert. *The Brass Book,* Schiffer Publishing, Exton, Pennsylvania, 1978. American, English, and European brass from the 15th century through 1850. Broken down by numerous categories such as andirons, boxes, inkstands, candlesticks, and fire fenders, this book discusses objects by using copious illustrations. Historical background, makers, and manufacturing techniques are covered as well.

- Waldron, Peter. *The Price Guide to Antique Silver,* Antique Collectors' Club, Woodbridge, Suffolk, England, 1982. Do not mistake this as just another price guide, because it is far, far more. This book is about British silver that was made primarily between the middle of the 17th century and the end of the

19th century. It is wonderfully illustrated and contains a great deal of information about the development of silver shapes and decorations over time. It points out rarities that an American collector might miss, and includes details about where hallmarks should be found, common problems with condition, and the types of fakes that are encountered.

- Wyler, Seymour B. *The Book of Old Silver: English, American, Foreign,* Crown Publishers, New York, 1937. This has long been the standard reference on the subject and is still very useful. The section on English hallmarks is the best part of the book, but the American section is outdated. The "foreign" (i.e., Continental European) hallmarks section is hard to use but does produce results sometimes.

Miscellaneous

Advertising

- Dodge, Fred. *Antique Tins,* 3 volumes, Collector Books, Paducah, Kentucky, 1995. Pictorial survey of the tin containers that once held such commodities as coffee, tobacco, peanut butter, spice, candy, popcorn, baking powder, potato chips, typewriter ribbons, and other items.
- Petretti, Alan. *Petretti's Coca-Cola Collectibles Price Guide,* Nostalgia Publications, Hackensack, New Jersey, and Wallace Holmstead, Radnor, Pennsylvania, 1994. If it is Coca-Cola related, this book covers it—or at least it seems to. There is a section on every imaginable type of Coca-Cola advertising, with prices, plus discussions of reproductions and fantasy items that Coke never made.

ASIAN

- Andacht, Sandra. *Collector's Value Guide to Oriental Decorative Arts,* Antique Trader Book, Dubuque, Iowa, 1997. This book covers a great deal of territory from ceramics and cloisonné to hardstone carvings, carpets, snuff bottles, metalwares, lacquerware, paintings, and textiles. There is a great deal of helpful information, but many times the number of objects that are specifically discussed is frustratingly small.
- Andacht, Sandra. *Collector's Value Guide to Japanese Woodblock Prints,* Krause Publications, Iola, Wisconsin, 2000. A wonderful introduction to this complicated subject. As usual, Ms. Andacht's scholarship is flawless and the information is presented in an easy-to-understand manner.

ART AND ARTISTS

- ADEC. *Art Price Indicator International "Chiner malin,"* Ehrmann, St-Romain-au-Mont d'Or, France, 2001. This book used Artprice.com's data bank for its source, and lists thousands of artists in a variety of media (paintings, drawings, prints, sculpture, and photographs, among others), giving auction results for their work. This book is very inexpensive and is a great quick reference to carry around for ballpark values while shopping for art.
- Arwas, Victor. *Art Deco,* Academy Editions, London, England, 1980. Historical survey of this popular style in furniture, metal, jewelry, sculpture, glass, ceramics, paintings, and posters with biographies of the artists and a bibliography.
- Bishop, Robert. *American Folk Sculpture,* E. P. Dutton, New York, 1974. Survey of the field of American folk art including

weathervanes, ships' figureheads, cigar-store Indians, circus fig-
ures, whirligigs, and other wooden sculptures.

- Benezit, Emmanuel. *Dictionnaire Critique et Documentaire des
Peitres, Sculpteurs, Dessinateurs et Graveurs,* 10 volumes, Grund,
Paris, France, 1976. They are *the* reference for finding profes-
sional artists, their biographies, and the museums that hold their
work. If art is being researched, Benezit is one of the first places
to go for basic knowledge. There are, however, two problems
with these books: First, they are much too expensive to be
included in most home libraries. Second, they are written in
French. The first of these problems is solved by using these
books in the library, and the second problem can really be a
problem. We manage (barely) with our college French, but those
who do not read French might try asking the librarian for help.

- Fahr-Becker, Gabriele. *Art Nouveau,* Konemann, Cologne,
Germany, 1997. This late-19th-century style of furniture and
decorative arts is traced through its expressions in England,
Scotland, France, Belgium, Italy, Russia, Spain, Germany, Scan-
dinavia, Austria, and the United States in pictures and history.

- Feder, Norman. *American Indian Art,* Harry N. Abrams, New
York, 1965. This is a survey book of North American Indian art
and artifacts. It includes history as well as photographs from
museums and private collections.

- Flayderman, E. Norman. *Scrimshaw and Scrimshanders: Whales
and Whalemen,* Flayderman & Co., New Milford, Connecticut,
1972. A history of the decorative arts produced during the
reign of the whale-fishing industry, including decorated whale
teeth, household items, furniture, and shell work.

- Hemphill, Herbert W., Jr., and Weisman, Julia. *Twentieth-
Century American Folk Art and Artists,* E. P. Dutton, New York,
1974. Chronological history of what is today called outsider art

by two major figures in the field who pioneered the study of American naive art made during the 20th century.

- Volpe, Tod M., and Cathers, Beth. *Treasures of the American Arts and Crafts Movement 1890–1920,* Harry N. Abrams, New York, 1988. Historical survey of furniture, pottery, metalware, lighting, and fabrics made in this style and period with information about the makers.

AUTOGRAPHS

- Baker, Mark Allen. *The Standard Guide to Collecting Autographs: A Reference and Value Guide,* Krause Publications, Iola, Wisconsin, 1999. Extensive listing of autograph prices, with a wide range of facsimile signatures to help in identifying fakes. This book contains an interesting analysis of the autograph market.
- Sanders, George and Helen, and Roberts, Ralph. *The Sanders' Price Guide to Autographs,* Alexander Books, Alexander, North Carolina, 1997. A good, basic primer on collecting autographs and the prices they bring. Thousands of names from entertainment, literature, sports, politics, military, and much more. There are some facsimile signatures.

BASKETS

- Teleki, Gloria Roth. *The Baskets of Rural America,* E. P. Dutton, New York, 1975. Comprehensive survey of the making of baskets including Native American, Nantucket, and other baskets produced across America. This book also includes research sources for the collector.
- Turnbaugh, Sarah Peabody, and Turnbaugh, William A. *Indian Baskets,* Schiffer Publishing, West Chester, Pennsylvania, 1997.

A thorough exploration of Native American baskets divided by region (Southeast, Northeast, Plains. Subartic and Arctic, Southwest, Great Basin, Northern California, Central California, Southern California), with a discussion of the way they were made and decorated. Extensive photographs help in the identification process.

Clocks and Watches

- Distin, William H., and Bishop, Robert. *The American Clock,* E. P. Dutton, New York, 1976. Includes a comprehensive survey with photographs of clocks from 1723 to 1900, with a listing of over 6,000 clock makers.
- Shugart, Cooksey, Engle, Tom, and Gilbert, Richard. *Complete Price Guide to Watches,* Cooksey Shugart Publications, Cleveland, Tennessee, 2001. We always take this book to appraisal clinics because of its almost comprehensive listing of pocket and wristwatches. It is far more than a mere price guide and contains vast quantities of information about American pocket watches, European pocket watches, and wristwatches. The focus is on the 19th and 20th centuries, but earlier watches are discussed as well.
- Swedberg, Robert W. and Harriet. *Encyclopedia of Antique American Clocks,* Krause Publications, Iola, Wisconsin, 2001. This book is more about popular clocks than it is about earlier, finer examples such as tall case and banjo clocks. There is good information about some of the most often encountered manufacturers and a large number of helpful photographs.

DOLLS

- Foulke, Jan. *15th Blue Book: Dolls and Values,* Hobby House Press, Inc., Grantsville, Maryland, 2001. We are sure that by the time this is published there will be a *16th Blue Book: Dolls and Values* out, and it will be just as good as all the others have been. This standard reference lists both antique and more modern dolls by manufacturer and has good photographs. Historical information is adequate but sketchy.
- Moyer, Patsy. *Doll Values: Antique to Modern,* Collector Books, Paducah, Kentucky, 1999. This book is similar to the entry above, but it offers slightly different prices and some additional information that can be helpful. We usually use these two books together.

KITCHEN COLLECTIBLES

- Dickingson, Linda J. *Price Guide to Cookbooks and Recipe Leaflets,* Collector Books, Paducah, Kentucky, 1990. This is a little book that tries to cover a very big subject. It does a very respectable job, but of course there are omissions.
- Franklin, Linda Campbell. *300 Years of Kitchen Collectibles,* Books Americana, Florence, Alabama, 1991. This is a good general book that discusses more than 7,000 items and has more than 1,800 pictures. It covers such diverse topics as kitchen furniture, gardening implements, and cookbooks plus items used to cook, clean, measure, and preserve.
- Greguire, Helen. *The Collector's Encyclopedia of Granite Ware Colors, Shapes and Values: Book 2,* Collector Books, Paducah, Kentucky, 1993. We have never seen book 1 in this series, but book 2 has a plethora of information about both 19th- and

20th-century granite ware. The variety is astonishing and the photographs are great identification guides. There is a brief discussion on how to separate new from old granite ware.

- Greguire, Helen. *Collector's Guide to Toasters and Accessories: Identification and Values,* Collector Books, Paducah, Kentucky, 1997. This book pictures hundreds of toasters alphabetically by maker. There is also a brief look at accessory items such as toast forks, toast racks, and toy toasters plus some catalog reprints.

- L-W Book Sales. *Griswold Cast Iron,* 2 volumes, L-W Book Sales, Marion, Indiana, 1993. There are those who believe that Griswold is the Tiffany of cast iron, and some of the products of this company can be quite expensive. These two volumes picture and price this company's products from mailboxes and aluminum wares to restaurant equipment and fruit and lard presses. In between there is an extensive listing of the skillets, muffin pans, Dutch ovens, and waffle irons that are so popular with many collectors.

- Mauzy, Barbara E. *Bakelite in the Kitchen,* Schiffer Publishing, Atglen, Pennsylvania, 1998. The range of this book is enormous and it covers such diverse objects as corn-on-the-cob holders, napkin rings, ice-cream scoops, and pizza cutters. The section on flatware with Bakelite handles is particularly helpful.

- Mauzy, Barbara E. *The Complete Book of Kitchen Collectibles,* Schiffer Publishing, Atglen, Pennsylvania, 1997. Of course, this book is not actually complete, but it does present a good overview of such items as wooden-handled kitchen utensils, and it examines a wide variety of collectible forms such as canisters, corn poppers, sifters, spatulas, shakers, rolling pins, and refrigerator dishes.

SPORTS

- Kangas, Gene and Linda. *Decoys: A North American Survey,* Hillcrest Publications, Spanish Fork, Utah, 1983. Survey book detailing the use of duck decoys from their first use by Native Americans through and including fishing decoys, with significant carvers described.

- Murphy, Dudley, and Edmisten, Rick. *Fishing Lure Collectibles: An Identification and Value Guide to the Most Collectible Antique Fishing Lures,* Collector Books, Paducah, Kentucky, 1995. Beautifully illustrated book that lists by manufacturer a large number of lures. Each lure is pictured separately and identified by company, date, and size. Each entry is also accompanied with the authors' notes and a price.

- Olman, John M. and Morton W. *The Encyclopedia of Golf Collectibles,* Books Americana, Florence, Alabama, 1985. Not only does this book discuss a vast array of golf balls and golf clubs, but it also explores golf-related items in ceramics, silver, bronze, and paper.

- Quertermous, Russel and Steve. *Modern Guns: Identification and Values,* Collector Books, Paducah, Kentucky, 1999. This book covers shotguns, rifles, and handguns made from the turn of the 20th century to the present. Very thorough. It examines the types of firearms that most people are likely to have in their homes.

- Traister, John E. *Antique Guns: The Collector's Guide,* Stoeger, South Hackensack, New Jersey, 1989. Broken down into categories such as handguns, rifles, shotguns, and black powder replicas, this book is a good basic reference. There is a section on obsolete cartridges.

TEXTILES, FASHION, AND RELATED ITEMS

- Bays, Carter. *The Encyclopedia of Early American Machines,* Carter Bays, Columbia, South Carolina, 1998. Vintage sewing machines can be cherished heirlooms, but most of them have little monetary value. This book separates the very few that are worth tens of thousands of dollars from the vast majority that are worth a relatively small amount. The listings are alphabetical by company. Many people will be surprised by how many makers and models there are.

- Black, David, editor. *The Atlas of Rugs and Carpets: A Comprehensive Guide for the Buyer and Collector,* Tiger Books International, London, England, 1994. The emphasis in this book is on Oriental carpets, and there is wonderful introductory information about how these rugs are made and their history. The rest of the book explores the making of rugs around the world in such places as Turkey, China, Iran (Persia), India, Pakistan, and the designs and types made in the different regions.

- Dolan, Maryanne. *Vintage Clothing 1880–1980: Identification and Value Guide,* Books Americana, Florence, Alabama, 1995. Even Joe, who is not into vintage clothing, finds this book fascinating and useful. It traces the evolution of style from the 1880s to the 1980s and pictures a vast array of clothing for women, children, and men, with illustrations from advertising media and photographs of actual items.

- Ettinger, Roseann. *Handbags,* Schiffer Publishing, Atglen, Pennsylvania, 1998. This book begins with a survey of the history of bags, then continues with such topics as chatelaine bags, beaded bags, mesh bags, and handbags of the 1930s, 1940s, and 1950s. This book presents a very useful overview of the subject.

- Heisey, John W. *A Checklist of American Coverlet Weavers*, The Colonial Williamsburg Foundation, Williamsburg, Virginia, 1978. A history of the craft of coverlet making, with a listing of all known American makers, their years, and place of production; also a glossary, bibliography, and museum listing.

- Johnson, Frances. *Collecting Household Linens*, Schiffer Publishing, Atglen, Pennsylvania, 1997. This book begins with a discussion of spinning devices, but the emphasis is on 20th-century linens that are commonly found around American homes—everything from afghans to doilies and decorator pillows.

- Kopp, Joel and Kate. *American Hooked and Sewn Rugs: Folk Art Underfoot*, E. P. Dutton, New York, 1985. Comprehensive study of popular floor coverings with photographs, and a discussion of bed ruggs, hearth rugs, and table covers.

- Luscomb, Sally C. *The Collector's Encyclopedia of Buttons*, Schiffer Publishing, Atglen, Pennsylvania, 1997. Who knew that there were so many different kinds of buttons and that some of them could be so expensive? Arranged alphabetically by button type, this book is full of photos and great information.

- Montgomery, Florence M. *A History of English and American Cottons and Linens 1700–1850*, Thames & Hudson, London, England, 1970. History of printed textiles including a catalog distinguishing among block-printed, blue-resist, copperplate, and roller-printed fabrics with a discussion of how these were used in English and American homes.

- Orlofsky, Patsy and Myron. *Quilts in America*, McGraw-Hill, New York, 1994. Survey book from the 17th through the 20th centuries describing the history of quilts, with important clues regarding the dating of fabrics and construction.

- Ring, Betty. *American Needlework Treasures: Samplers and Silk Embroideries from the Collection of Betty Ring,* E. P. Dutton in association with the Museum of American Folk Art, New York, 1987. State-by-state survey of one of the major collections of needlework in the United States.
- Safford, Carleton, and Bishop, Robert. *America's Quilts and Coverlets,* Bonanza Books, New York, 1980. This book goes far beyond quilts and coverlets and discusses linsey-woolsey, candlewick spreads, stencil spreads, bed ruggs, and other forms of bed coverings. Beautifully illustrated and meticulously researched, this book is a good general reference.
- Swan, Susan Barrow. *Plain and Fancy: American Women and Their Needlework, 1700–1850,* Rutledge Books/Holt, Reinhart and Winston, New York, 1977. A history of one of the sole means of expression for American women in the 18th and 19th centuries, with special attention paid to schoolgirl academies, styles of stitchery, a glossary of terms, and a bibliography for further information.
- Thompson, Helen Lester. *Sewing Tools and Trinkets: Collector's Identification and Value Guide,* Collector Books, Paducah, Kentucky, 1997. An extensive survey of such items as needle cases, thimbles, chatelaines, scissors, darners, tape measures, and sewing boxes and baskets. Extensive photographs and a bibliography.

Toys

- Barenholtz, Bernard and McClintock, Inez. *American Antique Toys 1830–1900,* Harry N. Abrams, New York, 1980. Good survey of the history of 19th-century American toys with photographs taken from one man's extensive collection.

- Hultzman, Don. *Collecting Battery Toys (Batteries Not Included): A Reference, Rarity and Value Guide,* Books Americana, Florence, Alabama, 1994. This is essentially an exploration of battery-operated toys made from the end of World War II through the 1960s. Rarity is listed on a scale of 1 to 10.

- Manos, Paris and Susan. *Collectible Action Figures: Identification & Value Guide,* Collector Books, Paducah, Kentucky, 1996. Included are a wide range of action figures, both famous (G.I. Joe) and not so famous (Buddy Charlie and Johnny Apollo). Lots of photographs and prices.

- O'Brien, Richard. *Collecting Toy Trains: Identification and Value Guide,* Krause Publications, Iola, Wisconsin, 1997. Listed are trains made by Lionel, Ives, American Flyer, Marx, Barclay, Buddy L, and others. Company histories and a range of prices by condition are given.

- Pope, Gail, and Hammond, Keith. *Fast Food Toys,* Schiffer Publishing, Atglen, Pennsylvania, 1998. The range of toys given away by fast-food establishments is truly astonishing, and this book covers this Blake's Lotta Burger to Winchell Donuts, with Burger King, McDonald's, and Wendy's in between. Also covered are a few outlets that might be overlooked such as 7-Eleven, Baskin-Robbins, Wal-Mart, Kmart, and Target.

- Thomas, Glenda. *Toy and Miniature Sewing Machines: Identification and Value Guide, Book II,* Collector Books, Paducah, Kentucky, 1997. We have not seen Book I, but Book II is a very good reference for miniature sewing machines made from the late 19th century through the 1990s. The price guide portion of this book is flawed somewhat because of all the notations of NPA—no price available.

Other

- Chervenka, Mark. *Antique Trader Guide to Fakes and Reproductions,* Krause Publications, Iola, Wisconsin, 2001. We think this book is a must-read. It is an excellent and extensive exploration of fakes in such diverse categories as art glass, Depression glass, art pottery, Nippon, R. S. Prussia, bronze, silver, lamps and lighting, and toys. The scholarship and research is impressive, and this book should save collectors significant amounts of money.
- Kovel, Ralph and Terry. *Know Your Antiques* and *Know Your Collectibles,* Crown Publishers, New York, 1981. If you are interested in antiques in general, these two books are a good place to start a basic education. They are classics in the field and they concisely cover a wide range of items including furniture, glass, ceramics, silver, prints, needlework, clocks, and toys.
- Mace, O. Henry. *Collector's Guide to Early Photographs,* Wallace-Homestead, Radnor, Pennsylvania, 1990. This is a good get-your-feet-on-the-ground introduction to daguerreotypes, Ambrotypes, tintypes, cartes de visites, and other types of photographs made in the 19th century.
- Osborne, Jerry, *Official Price Guide to Records,* 15th Edition, House of Collectibles, New York, 2001. This book has so much information that it is mind-numbing. At 900 pages, it covers a huge range of releases, as well as bootlegs and counterfeits (discussed but not priced), and defines the different types of records.
- Rosson, Joe L., and Fendelman, Helaine. *Treasures in Your Attic,* HarperResource, New York, 2001. At the risk of self-promotion, we feel that this book is one of the best antiques primers available for homeowners and beginning antiquers. It explains how the world of antiques works and includes a glos-

sary to help everyone understand the general language of collecting. Perhaps the most valuable part is the room-by-room exploration of the average American home with an extensive discussion of what is valuable and what is not.

- Waldsmith, John. *Stereo Views: An Illustrated History and Price Guide,* Wallace-Homestead, Radnor, Pennsylvania, 1991. The heart of this book is the listing of stereo view makers and the evaluation of stereo views by subject (disasters, Christmas, circus, Niagara Falls). There is also a discussion of more modern stereo viewers such as View-Master and Tru-Vue.

- Witt, John M. *Collector's Guide to Electric Fans: Identification and Values,* Collector Books, Paducah, Kentucky, 1997. It is surprising how many attics have vintage electric fans in them. This book outlines which are valuable and which are not. The history and other information is excellent.

- Wood, Jane. *The Collector's Guide to Post Cards,* L-W Book Promotions, Gas City, Indiana, 1984. This is a very difficult subject to cover because it is so extensive. This book offers a good introduction to the field, with many examples and prices.

- Wood, Scott, editor. *Classic TVs with Price Guide Pre-War Through 1950's,* L-W Book Sales, Gas City, Indiana, 1992. Collector interest in this field is growing. This book offers catalog reprints and numerous photographs of vintage television sets with their values.

Many of the books in this long list represent themselves as price guides, and the problem with price guides is that they are generally out-of-date before the ink dries on their pages. This situation is dealt with by the writers of the book issuing updated prices every few years, but the connoisseur/appraiser must keep up with changing prices and trends in the same

way that a doctor must keep up with changing standards of treatment out-lined in medical journals.

The price guides we have listed are not there for the prices per se but for the general information and photographs they contain. We have not listed general price guides such as *Schroeder's Antiques Price Guide, Kovels' Antiques and Collectibles Price List,* or *Miller's Antiques Price Guide* because we feel that those who are serious about pricing art and antiques need fresher data than these can provide.

The prices in these books are usually a year or so old before they find their way into the collector's hands, and in that period of time, a lot can change. Joe, who owns a number of these general price guides, finds them helpful for background information but would never dream of using one to establish an actual value.

Helaine, who actually admits to having written price guides, cautions that the prices should be used sparingly and as guides only. Most often, price guides will offer ranges of values that must be interpreted within the context of the time in which the piece was sold, whom it sold to, where and when it was sold. These factors, and the many that influence prices, must be taken into consideration when placing a value on any object.

Always keep in mind that building a library is not something that is done once, then it is over. Building an antiques library is an ongoing pro-cess that goes on as long as a person's interest in understanding and valuing antiques continues.

Important Periodicals and Magazines

Antique Review
700 E. State St.
Iola, Wisconsin 54990

Antique Trader Weekly
700 E. State St.
Iola, Wisconsin 54990

Antique Week
Box 90, 27 N. Jefferson
Knightstown, Indiana 46148

Antiques & Arts Weekly
P.O. Box 5503, The Bee Publishing Co.
Newtown, Connecticut 06470

Antiques & Auction News
P.O. Box 500, 1425 W. Main St.
Mt. Joy, Pennsylvania 17552

Antiques and Collectables
1000 Pioneer Way
P.O. Box 1565
El Cajon, California 92022

Antiques and Collecting
1006 S. Michigan Avenue
Chicago, Illinois 60605

The Antiques Journal
4 Church Street
Ware, Massachusetts 01082

The Magazine Antiques
575 Broadway
New York, New York 10012

Antiques Trade Gazette
115 Shaftsbury Avenue
London, England WC2H8AD

Art & Antiques
2100 Powers Ferry Road
Atlanta, Georgia 30339

Art & Auction
11 E. 36th Street
New York, New York 10016

Collector's Journal
Box 601
Vinton, Iowa 52349

Collector's News
Box 306
Grundy Center, Iowa 50638

Maine Antiques Digest
911 Main Street
P.O. Box 1429
Waldoboro, Maine 04572

Renniger's Antique Guide
P.O. Box 495
Lafayette Hill, Pennsylvania 19444

Treasure Chest
P.O. Box 1120
Attleboro, Massachusetts 02703

Conclusion

Having read this far, it is doubtful that many of you now believe that appraising art and antiques is easy to do or something that can be learned in a matter of days or weeks. As we said in the beginning, acquiring connoisseurship and learning to evaluate antiques is a process that requires a great deal of study, research, and a sincere commitment to finding the truth.

Appraising can be a wonderful voyage of discovery or a frustrating journey down dead-end streets. Which one it is depends largely on how diligently the researcher investigates every clue and follows every lead using the tools and insights we have tried to provide.

The real difficulty that most nonprofessional appraisers have when trying to evaluate their own art and antiques is knowing where and how to begin, which should no longer be a problem after reading this book. We have explored at great length what to look for, the questions to ask, and how to do an unbiased evaluation. Most important, however, are the lists of books, periodicals, web sites, and other resources that provide the sought-after answers to your specific questions.

One tool that can be very helpful in the appraisal process is the camera, and one important thing that you can do today is photograph all the art and antiques in your home. Do this as a protection against loss from fire

and theft, and to use as a guide and memory jogger while doing research. Be sure to store a set of photos somewhere safe outside the house.

Having a good in-focus photograph of an item being researched can be a huge help. Show the photo to antiques dealers and ask their opinion because they can often provide good leads. Have the photograph handy when exploring a museum or shopping an antiques show to compare the image of what is being evaluated with what is being seen—after all, memory of what an item looks like can be faulty. Take a photograph with you when doing research in a library. This makes the comparison process more mistakeproof.

As a final thought, do not forget to enjoy yourself while doing research. Learning about antiques should be fun! Develop a habit of thumbing through books, magazines, and periodicals on antiques with no particular purpose in mind. It is amazing how much you will learn and how many serendipitous discoveries you will make.

Be sure to look for us on your local Public Broadcasting Station and in your newspaper, where we will be helping you find "Treasures in Your Attic."

Appendix

Appraisal Valuations

Lot 1: Furniture

Item 1: Gateleg Table
Fair market value: $2,000
Insurance replacement value: $3,500 to $4,500

Item 2: Corner Cupboard
Fair market value: $6,500
Insurance replacement value: $12,000 to $15,000

Item 3: Pier Table
Fair market value: $2,000
Insurance replacement value: $3,500 to $4,500

Item 4: Sofa
Fair market value: $20,000
Insurance replacement value: $35,000 to $50,000

Item 5: Set of Six Bow-Back Windsor Chairs
Fair market value: $4,500
Insurance replacement value: $8,000 to $10,000

Item 6: Tall Chest
Fair market value: $10,000
Insurance replacement value: $18,000 to $25,000

Item 7: Worktable
Fair market value: $3,500
Insurance replacement value: $6,000 to $8,500

Item 8: Set of Four Victorian Side Chairs
Fair market value: $7,000
Insurance replacement value: $12,000 to $16,000

Item 9: Tilt-Top Piecrust Table
Fair market value: $3,500
Insurance replacement value: $6,000 to $9,000

Item 10: Armchair
Fair market value: $2,000
Insurance replacement value: $3,500 to $5,000

Lot 2: Glass

Item 1: Burmese Fairy Lamp *Epergne*
Fair market value: $1,250
Insurance replacement value: $2,000 to $3,000

Item 2: Art Glass Vase
Fair market value: $6,000
Insurance replacement value: $10,000 to $14,000

Item 3: Ruby Glass Punch Bowl on Stand
Fair market value: $2,500
Insurance replacement value: $4,000 to $6,000

Item 4: Miniature Enameled Acid-Cut Back Vase
Fair market value: $900
Insurance replacement value: $1,500 to $2,000

Item 5: Perfume Bottle
Fair market value: $2,200
Insurance replacement value: $4,000 to $5,000

Item 6: Silver Overlay Pitcher
Fair market value: $2,500
Insurance replacement value: $4,000 to $5,000

Item 7: Paperweight
Fair market value: $750
Insurance replacement value: $1,400 to $1,600

Item 8: Vase
Fair market value: $2,000
Insurance replacement value: $3,000 to $4,000

Item 9: Cordial Glass
Fair market value: $1,000
Insurance replacement value: $1,600 to $2,000

Item 10: Pair of Cornucopia Vases
Fair market value: $900
Insurance replacement value: $1,600 to $1,800

Lot 3: Pottery and Porcelain

Item 1: Porcelain Figure Group
Fair market value: $2,000
Insurance replacement value: $3,500 to $4,000

Item 2: Porcelain Basin
Fair market value: $850
Insurance replacement value: $1,500 to $2,000

Item 3: Pair of Ewers
Fair market value: $3,500
Insurance replacement value: $6,000 to $8,000

Item 4: Pottery Jug
Fair market value: $2,500
Insurance replacement value: $4,500 to $6,000

Item 5: Covered Bowl and Stand
Fair market value: $4,500
Insurance replacement value: $8,000 to $10,000

Item 6: Pottery Jug and Circular Tray
Fair market value: $900
Insurance replacement value: $1,600 to $2,000

Item 7: Four Candlesticks
Fair market value: $750
Insurance replacement value: $1,200 to $1,800

Item 8: Pottery Pitcher
Fair market value: $650
Insurance replacement value: $1,000 to $1,400

Item 9: Pottery Vase
Fair market value: $850
Insurance replacement value: $1,400 to $1,800

Item 10: Porcelain Plate
Fair market value: $1,000
Insurance replacement value: $1,800 to $2,000

Lot 4: Silver and Other Metals

Item 1: Silver Cup with Lid
Fair market value: $12,500
Insurance replacement value: $20,000 to $30,000

Item 2: Sterling Silver Partial Flatware Service
Fair market value: $7,500
Insurance replacement value: $12,000 to $16,000

Item 3: Soup Tureen
Fair market value: $24,000
Insurance replacement value: $40,000 to $50,000

Item 4: Pair of Candlesticks
Fair market value: $1,500
Insurance replacement value: $2,500 to $3,500

Item 5: Bowl
Fair market value: $15,000
Insurance replacement value: $25,000 to $35,000

Item 6: Pair of Covered Bottles
Fair market value: $2,500
Insurance replacement value: $4,000 to $6,000

Item 7: Weathervane
Fair market value: $14,000
Insurance replacement value: $25,000 to $35,000

Item 8: Lion Statue
Fair market value: $8,000
Insurance replacement value: $15,000 to $20,000

Item 9: Pair of Two-Light Candelabra
Fair market value: $7,500
Insurance replacement value: $12,000 to $18,000

Lot 5: Miscellaneous

Item 1: Wall Clock
Fair market value: $2,500
Insurance replacement value: $4,500 to $5,500

Item 2: Shelf Clock
Fair market value: $175
Insurance replacement value: $350 to $400

Item 3: Quilt
Fair market value: $7,000
Insurance replacement value: $12,000 to $16,000

Item 4: Sampler
Fair market value: $45,000
Insurance replacement value: $75,000 to $100,000

Item 5: Hooked Rug
Fair market value: $5,000
Insurance replacement value: $8,000 to $10,000

Glossary

AIR TWIST: An air twist stem is similar to an opaque twist stem except it is made by twisting a column or columns of air within a rod of glass. Basically, an air twist stem starts with a "tear" or elongated bubble of glass that is pulled and twisted until it forms a corkscrew. Air twist stems are earlier than opaque twists and originated about 1735.

ALPHABET SAMPLER: The name given to samplers whose decoration consists mainly of the alphabet and the numbers from 1 to 10, with very little or no pictorial content. The earliest known American alphabet sampler is dated 1610, but most were made after 1720. Alphabet samplers are the most commonly found samplers, and the simpler ones are the least valuable, with prices that sometimes do not exceed $100.

ANILINE DYE: This type of dye is made from coal tar rather than vegetable matter and provides a wider range of color that can be a bit harsh and unnatural. It was first used around 1860.

APRON: The band of wood below the seat rail of a chair or sofa, or the band of wood below the drawers on a chest that stretches between the legs.

ART DECO: This artistic style was popular primarily just before the beginning of World War I and during the 1920s. There are actually two branches of this style. The first featured lush designs with geometrically stylized fruit and flowers, and its icon was the bobbed-hair flapper. The second centered around industrial design and espoused straight, clean lines, squares, and rectangles. Chrome and glass were favored materials.

ART NOUVEAU: A decorative style that originated in France in the 1880s and persisted until just before the beginning of World War I. It is based on organic forms (plants, animals, the human form), and embraced the sinuous, undulating curves found in nature.

BALL-AND-CLAW FOOT: A foot shape that was probably derived from a Chinese model of a dragon's claw clasping the celestial pearl of wisdom.

BALUSTER: This term was derived from architecture and refers to a turned column or shaft such as the one used in balustrades, which is the rail and row of posts found along the edge of an outdoor porch or along the edge of a staircase. Often the columns have a profile that resembles a vase.

BAMBOO TURNINGS: An elongated cylinder or stick of wood turned on a lathe to create segments that resemble those associated with the bamboo plant.

BERGÈRE: A French term for a type of upholstered armchair with closed arms and a loose seat cushion. It was perfected during the popularity of the Louis XV style.

BLACKAMOOR: The full-length or kneeling representation of an African or Moor initially used as a furniture component in the 17th cen-

tury. The first use may have been in French candlesticks known as *guéridons,* which was the name of a young Moor who was brought to France to serve as a page. The *guéridon* consisted of a colorfully dressed African youth holding a candlestick or supporting a small tabletop on his head. Later, this or similar images were popular in both metalwork and ceramics. Representations of blackamoors enjoyed a great deal of popularity throughout the 18th century and were in vogue in the mid-19th century in both England and the United States.

BLANK: This term is used to describe either a piece of glass or a piece of pottery or porcelain that was sold by the manufacturer in an undecorated state with the idea that someone else would embellish it later.

BLEEDING: This term is applied to the copper areas that show through on Sheffield plate when the top silver layer becomes worn through use or overpolishing. Collectors like to see a little bleeding and tend to think of it as being patina. Bleeding is a serious deduction when it becomes so extensive that it is unsightly. The bleeding on pre-1838 Sheffield plate should *never* be repaired by electroplating.

BLOWN-IN-MOLD: The process of blowing molten glass into a mold in order to impart a pattern to the outer surface. This procedure is different from the more mechanical method of making pressed glass, which involves injecting molten glass into a mold using a plunger. The two manufacturing methods can be distinguished by examining the interior surface of the glass. The interiors of pressed-glass pieces are smooth, but blown-in-mold objects have inside surfaces that echo the pattern on the outside.

BOBECHE: A French term referring to a disk or small round or square insert that fits on the top of a candle cup on a candlestick or chandelier to catch wax drippings.

BOW-BACK WINDSOR: A chair with a loop or elongated arch-shaped back with spindles of varying lengths attached within the interior of the loop. These chairs originated in the late 18th century.

BRITANNIA STANDARD: In the 17th century, English coins were of the sterling standard (92.5 percent pure silver) and they were being melted down at an alarming rate to make wrought silver objects. To halt this practice, the British government changed the standard for wrought silver items from 92.5 percent to 95.54 percent pure silver. This new standard was called the Britannia standard and was in general use in England from 1697 to 1719. Britannia-standard pieces were made after 1719, and all English silver of this grade can be identified by the impressed figure of a woman holding a shield instead of the more familiar lion passant. It should also be stated that the term Britannia may be used in reference to a pewter-like alloy used as a base for silver plating.

BRONZE: An alloy of copper that may contain either 90 percent copper and 10 percent tin or 90 percent copper, 7 percent tin, and 3 percent zinc. If the tin is left out of the recipe, the metal becomes brass (copper plus zinc).

CABRIOLE: A leg shaped like an inverted S that was very popular during the Queen Anne and Chippendale periods. It has an outcurved "knee" near the top and an incurved "ankle" that terminates in a shaped foot such as a pad or ball-and-claw foot.

CAMEO GLASS: A type of glass that is composed of a thick layer that had been flashed or cased with one or more additional layers of differing colors. The various layers are then cut or carved through in such a way as to juxtapose them to form a design or image. This is similar to the process used to make cameo jewelry from shells.

CANTED: An angled surface.

CANTON: When collectors use this word alone, they are usually referring to a Chinese blue-and-white ware made during the 18th, 19th, and 20th centuries in and around the city of Canton. Typically, Canton has a central pattern that consists of an outdoor scene with buildings, an island, one or more bridges, flying birds, trees, rocks, clouds, boats, a river, mountains, and human figures. Many people associate this with the famous Blue Willow pattern, but this is an English interpretation of the standard Canton pattern.

CAUDLE CUP: Caudle is a rich broth reportedly made from gruel, wine or ale, spices, and sugar. It was traditionally given to women recovering from childbirth. Caudle cup and porringer are often used interchangeably, but some sources say that a caudle cup should be shaped slightly differently and have a bulbous or baluster-shaped form rather than the straight-sided profile normally associated with a porringer. A caudle cup usually has a cover; a porringer may not.

CHAMFERED: This name is given to a surface that has had its edges cut away to form an angle. American drawer bottoms of the 18th and early 19th centuries are often chamfered to fit into the runners, and the sides of the corner cupboard in the furniture section have been chamfered to form an angled flat surface between the pilaster and the end of the back boards.

CIRE PERDUE: This term literally means "lost wax" and is most often associated with casting bronze or glass. The process involves making an exact model in wax of the object to be created, then forming a mold around it. Heat is then applied to make the wax melt and run out; thus, the lost wax process. After the wax is gone, the mold is filled with molten bronze or

glass to produce a very finely detailed final product. Lalique, Steuben, and a few other glassmakers used this process, but it was much too expensive and labor-intensive for most.

CLOISONNÉ: This term is derived from the French word *cloison,* which means "cell." It is an art form associated with Asia, particularly China and Japan, but it was also done in Russia, France, and in some Middle Eastern countries. Cloisonné is typically done on a metal body, but examples on ceramic, wood, and lacquer bodies can be found. Normally, the process starts with laying out a design with wires affixed to a metal background in such a way that little pockets or cells are formed. Colored, powdered glass called enamel is then placed in these cells and heated until it melts and fuses. The enamel is ground smoothly and the resulting decoration is usually a depiction of flowers, animals, or mythological beasts such as dragons.

CONTINUOUS-ARM WINDSOR: Similar to a bow-back Windsor except the end of the loop or elongated arch that encompasses the spindles is not attached to the seat. Instead, it sweeps forward on either side of the chair's seat to form arms, which are attached to the chair's seat, by spindles and arm stiles.

CORNICE: On furniture, a cornice is the top of a cabinet, cupboard, bookcase, secretary, highboy, tall chest, or tester bed and typically projects over the top of the piece of furniture it surmounts. Today, the term is also used to describe a wooden frame surrounding curtains or draperies.

COVE: In furniture it is a large convex molding used on the cornice.

CRANBERRY: Name commonly applied to a type of transparent pinkish-red glass that reportedly has been made since the 1820s and is still

in production. Cranberry glass is usually distinguished from ruby glass by its distinctively lighter tone. Both cranberry and ruby glass were often made using minuscule amounts of gold, and many people believe that the use of this precious metal makes the glass more intrinsically valuable than other types of glass. This, however, is not the case.

DROP-LEAF TABLE: A table similar to a gateleg, but it generally has only two stationary legs affixed to opposite corners of the central section and two that swing out to support the drop leaves hinged to either side of the central panel. In some cases, there may be four swinging legs. Unlike the gateleg, the legs of drop-leaf tables are not separated by stretchers and are not turned (as a general rule).

ENGRAVING: The process of decorating a piece of glass by cutting a series of lines into the surface using a copper wheel. The lines are usually not polished after they are made, which means they have a frosted or gray appearance.

EPERGNE: A table centerpiece consisting of a frame (usually metal) with extended arms or branches that support vessels designed to hold flowers, fruit, or sweetmeats.

FAUTEUIL: A French term for a type of upholstered armchair with open arms and an integral seat. The lolling chair is a variety of fauteuil.

FAZZOLETTO: This Italian term refers to a vase that is shaped like a handkerchief. It is one of the most famous of the Italian designs of the 1950s and was the 1949 creation of Fulvio Bianconi for Venini. The irregularly ruffled vase in this book was also made by other companies and has been widely reproduced.

FLASHING: The process of coating a thick layer of glass with a much thinner layer of a different color. This is usually done by dipping the thicker piece of glass into the colored glass while the colored glass is in a molten state.

FOLIATE CARVING: Carving done in a leaf-like form.

FRIEZE: Area just below the cornice on a piece of furniture.

FRIGGER: Glassmaking term that is applied to any glass item made to showcase a maker's skill. The item is usually one of a kind, can be very elaborate, and can be thought of as a "bragging" piece. Friggers were made after regular working hours and were sometimes meant to be given to loved ones. A frigger might be a specially made paperweight or it might be a cane designed to be carried in a parade or a chain of glass lengths. A frigger also can be a piece made by an apprentice for practice, and these are customarily cruder than the friggers made by the master craftsmen.

GATELEG TABLE: A table with four stationary turned legs connected with stretchers, and, depending on the size, either one or two swinging gates on each side (also with turned legs) that can be pulled out to support hinged leaves.

GLOSSY AND SATIN FINISH: Victorian art glass often had one of two distinct types of surfaces. One was glossy, which was a shiny, untreated finish obtained naturally as the piece was made. The other, called a satin or acid finish, was a nonreflective, slightly grainy surface caused by exposing the glass to a bath in hydrofluoric acid.

GROUND: A single color used as the background on a piece of ceramic, then enhanced with further enameling or gilding. Professionals speak of this as the ground or ground color and never use the word background.

HARD PASTE PORCELAIN: A Chinese invention (no one is sure exactly when) composed of fusible silicates of aluminia (called petuntse or china stone) and nonfusible silicates of aluminia (called kaolin or china clay). This material is nonporous, whitish in color, may be translucent (although it is not always), and cannot be scratched with a steel knife blade.

IMARI: *See* KINRANDE IMARI and NISHIKIDE.

IRIDESCENCE: The rainbow play of colors across the surface of a piece of glass. Iridescence can occur naturally when a piece of glass is buried in moist soil for centuries or millennia. It is caused by chemical decomposition of the surface and is often associated with excavated Roman or ancient Syrian glass. In the 19th century, there was an attempt to duplicate this beautiful surface artificially, and in 1863, J. & L. Lobmeyer of Vienna, Austria, was the first to produce it commercially. Loetz and Tiffany are said to have perfected this type of glass.

JOIN: A place where two wooden elements of a piece of furniture are united. The woodworker who does this kind of work is called a joiner. This term is most often used in reference to furniture made in the 18th century or earlier on the Continent or in the Colonies.

KINRANDE IMARI: Japanese Imari with a red enameled background decorated with gold designs in the Chinese taste.

KNOP: A decorative knob.

LATTICINO: A glass-decorating technique associated with glass made on the Venetian Island of Murano. This kind of design is made from thin glass canes or rods arranged in stripes or in a net-like pattern.

Originally, *latticino* was done primarily in white, but later it was also made in colors.

LIMOGES: Generally, this term refers to a town in France noted for its nearby deposits of porcelain-making clays and for fine pottery and porcelain makers. However, when the word is used in reference to Rookwood pottery, it signifies a type of early Rookwood ware made using either dark red or light-colored clay-slip decoration under a high-gloss glaze. The name Limoges in this instance refers to the art pottery made by the Haviland Company, which was an inspiration for the founders of Rookwood.

MENDING OR DARNING SAMPLER: A very practical sampler devoted to the various stitches used in mending. Sometimes the names of the stitches are identified, but usually the mending or darning sampler is very plain and utilitarian.

MITER: This refers to the stone wheel used to cut glass, but it also is applied to the V-shaped cut it makes into the surface of the glass. Miter cuts are most associated with cut glass of the Brilliant period, which was made from the late 1870s (some say 1880) to the early 1900s, pre–World War I.

MORTISE AND TENON: A construction method used to join two pieces of wood together by inserting a tenon, which is a tongue-like projection, into a mortise, which is simply a hole shaped to receive the tenon and hold it tightly. Often, this type of joint is held together by driving a peg through both the mortise and the tenon.

NISHIKIDE OR BROCADE IMARI: This type of Imari is an interpretation of Chinese Ming Dynasty five-color wares. To the Japanese, a brocade is a display of brilliant colors, and old brocade or nishikide Imari

is decorated with underglaze blue that is accented with overglaze red, yellow, green, purple, and gold. Usually, the design is rather lavish and covers almost the entire surface of the object on which it occurs.

PAD FOOT: A very plain oval-shaped terminus for a cabriole leg.

PAPIER-MÂCHÉ: The term is French for "mashed paper," and it is made from paper pulp or strips of paper mixed with adhesive (it can also have chalk and sand in it). This product starts out wet and can be molded, but when it is baked, it dries and becomes hard enough to be sawed.

PATINA: The color and texture of a surface acquired through years of use and cleaning. In copper and bronze, patina refers to the green- and sometimes other-colored verdigris that appears on the surface; on silver, it is the myriad of fine scratches that are a result of repeated polishing. Genuine patinas are highly prized by collectors, but beware, patinas can be artificially induced.

PENNYWEIGHTS: In the Troy system of weights and measures, there are 20 pennyweights in an ounce of precious metal. The abbreviation for this term is dwts.

PICTORIAL SAMPLER: These can be the most glorious of the samplers. They may contain verses, the alphabet, and the numbers, but a large part of the design is devoted to a detailed needlework rendering of a landscape, a building, a whole town, shops, military campaigns, historical events, and the like.

PIECRUST TABLE: Modern term that refers to a table that has a top with a raised scalloped edge said (rather fancifully in our opinion) to resemble the crimped edge of a pie's crust.

PILASTER: This term is commonly used in architecture to describe a flat column attached to a surface and is a style of ornamentation that has been used as an element of furniture design since the 16th century. Technically, the column should represent one of the three classic orders—Doric, Ionic, or Corinthian—but in furniture some license is taken with this rule. A pilaster should start with a base and end with a capital.

PINYIN SYSTEM: This system of spelling and pronouncing Chinese words and names in English is closer to the sounds the words have in Chinese. It is slowly replacing the Wade-Giles system that has been the standard for some time, but although the pinyin system is gaining ground rapidly, one is not yet considered to be more correct than the other. However, most appraisers, international auction houses, and recently written scholarly books now use pinyin. In Wade-Giles, the current capital city of China is Peking; in pinyin it is Beijing. In Wade-Giles, the Chinese dynasty that ruled from 1644 to 1911 is the Ch'ing; in pinyin it is the Qing.

PLINTH: A base that supports a statue, column, or pedestal.

PRUNT: Blobs of glass usually found scattered on the side of a handleless drinking vessel of the 16th or 17th century. They were placed there for decorative purposes and to provide a firm grip in the absence of a handle. Prunts came in a variety of shapes; sometimes they are just globular, sometimes they are pointed, and sometimes they can be impressed with a lion's-head mask. On occasion, prunts will be globular with little droplets of glass protruding above the surface. These look like raspberries and are appropriately known as raspberry or berry prunts. Although these originated earlier, they are occasionally found on Victorian and later glass.

PUNT OR PUNTY: A cut circular indention used as a decorative element on a piece of glass. This is not to be confused with an iron pontil or punty rod, which, as we have said, is used as a sort of handle to hold molten glass while a vessel or other object is being finished.

PUTTI OR PUTTO: An Italian term given to infant cherubs. The plural is *putti;* the singular is *putto.* An alternate term for the same sort of cherubic representation is *amorini* (plural) or *amorino* (singular).

QUEEN'S WARE: A trade name given by Josiah Wedgwood to his creamware after George III's wife, Queen Charlotte, ordered a dinnerware set in this material from his company. It is often used today as a generic term for creamware, but for appraisers creamware is the more correct designation unless the object being evaluated is an actual Queen's Ware product of the Wedgwood factory.

REGULATOR: Generically, this term refers to any clock that is specially made to be accurate, but more specifically, it is applied to clocks used to time the accuracy of other clocks. In addition, a regulator is the device within a clock that allows the length of the balance spring to be adjusted and thus make the clock run faster or slower, which allows for more precise timekeeping.

REPOUSSÉ: In metalwork, the process of making relief designs by beating from the reverse side with hammers or punches. This raises certain areas but leaves the background untouched.

ROSE CANTON: A type of Chinese porcelain that looks very much like Rose Medallion (for a discussion of this type of ware, see Item 2 in the pottery and porcelain evaluations) except all the panels and the central medallion are decorated with floral designs and there are no human figures.

ROSEHEAD NAIL: Handwrought square nails with flattened round heads that look a bit like a flower. These are thought to be early, but sources report they were available right up to World War II. Their presence is not a reliable judge of age.

SLIP: Clay mixed with water. In a method called slip casting, it can be poured into a mold to produce a piece of pottery or it can be colored and used as a medium with which to paint designs on pottery, which is called slip decorating.

SOFA (ALSO SPELLED SOPHA): This is an Arabic term that refers to a platform in a carpeted and cushioned alcove raised above the surrounding floor and used by the grand visier to meet and entertain visitors. In Europe, this term was applied to any richly upholstered seat for two or more. A settee is much the same piece of furniture, only it is usually smaller, for two people, and less elaborate.

SOFT PASTE: A type of ceramic body developed in Europe during the 16th century in an attempt to imitate Chinese hard paste porcelain. It is made by adding such ingredients as glass, bone ash, and soapstone to a white clay that may or may not be kaolin.

TROY: A system of weights and measures often used in precious metals in which 12 ounces equals a pound rather than 16 ounces in the more familiar avoirdupois system by which we measure the weight of everything from tomatoes to ourselves. One troy ounce is equal to 1.0971 avoirdupois ounces.

ZOUAVE: A member of a French army infantry unit largely composed of Algerians. They were noted for their hardiness and their fancy uniforms. This term was applied to certain troops in the Federal army during the Civil War.

Index

HarperReso

Don't miss this valuable guide from Joe L. Rosson and Helaine Fendelman!

TREASURES IN YOUR ATTIC

An entertaining, informative, and down-to-earth guide to the world of collectibles and antiques from the hosts of the popular PBS show.

ISBN 0-06-019827-3

Interest in antiques and collectibles has never been greater, and *Treasures in Your Attic* taps into this burgeoning market by offering information and advice on identifying, evaluating, buying, selling, and caring for many types of valuables. This book will help you to put a price tag on almost any collectible—especially on items that might not appear to be worth much or valuable—and provides an inside look at traditional auctions, flea markets, and buying and selling on the Internet.

TREASURES IN YOUR ATTIC

An Illustrated Guide to a Wide Range of Collectibles
As Seen on the Television Show Seen on PBS Stations

JOE L. ROSSON HELAINE FENDELMAN

www.treasuresinyourattic.org